GRAPHIC WORK FROM THE BAUHAUS

EDITED BY HANS M. WINGLER
TRANSLATED BY GERALD ONN

NEW YORK GRAPHIC SOCIETY LTD.
Greenwich, Connecticut

SBN 8212–0321–5
LIBRARY OF CONGRESS CATALOG CARD NO. 68–31179
COPYRIGHT © 1965 BY FLORIAN KUPFERBERG VERLAG, MAINZ
ENGLISH TRANSLATION COPYRIGHT © 1969 BY LUND HUMPHRIES, LONDON
MADE AND PRINTED IN GREAT BRITAIN BY LUND HUMPHRIES

In memory of Lyonel Feininger, Ludwig Hirschfeld-Mack
and their colleagues in the printing shop
and also of the artists who contributed to the
'Neue europäische Graphik'

CONTENTS

ABOUT THIS BOOK

This book was prompted by the research which is being undertaken by the members of the Bauhaus Archive, who are trying to establish a complete inventory of the graphic works processed at the Institute. It is the first of a series of publications in which the achievements of the Bauhaus printing shop are to be commemorated and which will ultimately provide a critical catalogue of its entire output. By and large only the prints actually produced in the workshop will be listed in this catalogue. This means of course that works by members of the Bauhaus, which were processed elsewhere, will not be included while works by outside artists, which were processed in the workshop, will be. To catalogue these 'alien' prints as Bauhaus products is legitimate since no design would have been accepted for processing if it had run counter to the artistic and theoretical aims pursued by the Institute. In fact, every print to emerge from the workshop had something of the Bauhaus quality. But, because of the difficult conditions obtaining in the early 1920's, there were a few occasions when the Institute was obliged to seek the aid of outside printers and in such cases the general criterion laid down by the Bauhaus Archive has been relaxed.

The subject matter of this present book is the five-part series of portfolios: 'Neue europäische Graphik' (New European Graphics). Later publications will catalogue the individual prints made by both masters and students, the prints executed for outside artists and a group of five individual series. It is also hoped to produce a facsimile edition of the lithographed post cards made for the festivals and exhibitions held at the Bauhaus. In all, about 400 prints were processed between 1919 and 1925, most of them woodcuts, lithographs and etchings but with a sprinkling of monotypes. The five series, which have been edited and arranged in albums, will be considered in conjunction with the work of the bookbinding shop.

The idea of preparing a catalogue of the graphic work processed at the Bauhaus was rendered feasible as a result of the research work undertaken by the members of the Bauhaus Archive in Darmstadt in connexion with the exhibition of Bauhaus prints which they staged in 1963 ('Arbeiten aus der graphischen Druckerei des staatlichen Bauhauses'). They were greatly aided in this task by collectors and former members of the Institute, who furnished them with a considerable amount of additional information. The second part of the 'New European Graphics' had already been discovered prior to this exhibition as a result of research carried out by the present author. This discovery has made it possible to trace the evolution of the series. It goes without saying that every effort has been made to ensure absolute accuracy and, where possible, the facts presented in this book have been substantiated by quotations from the Bauhaus files and other source material.

Unsupervised artistic activities were an important factor in the development of 9

the Bauhaus, although — or perhaps because — they were never regarded as an end in themselves; certainly this was the case for as long as Gropius was in charge. Art and craftsmanship always went hand in hand: during the Weimar period the workshops, in which the practical training was given, were under the joint control of a 'Master of Form', i.e. an artistic director, and a 'Master of Craft', i.e. a technical director, and all students were required to pass trade tests equivalent to the intermediate and final examinations prescribed by the national trade associations. Consequently, in the first phase of their training the students concentrated on the technical aspects of relief, planographic, and intaglio work, for the printing shop in Weimar had been specially equipped for the production of art prints; most of the work turned out consisted of single and multi-coloured lithographs, woodcuts, and etchings. The printing shop provided no facilities for experimental typography and the pioneer work undertaken in this field by Laszlo Moholy-Nagy and Herbert Bayer was all done off the premises. At the Bauhaus in Dessau the roles were reversed. There no art prints were produced and the printing shop was given over entirely to composition and commercial design. Both in Dessau and in Berlin typography and printing techniques formed part of the practical curriculum.

The graphic printing shop at the State Bauhaus in Weimar existed from 1919 to 1925. The Bauhaus itself was founded in April 1919 and the shop was opened some six months later. It was one of the first workshops to become fully operational and, despite the many difficulties caused by the need to combine teaching with creative activities and also by the general shortage of money and materials during the inflationary period, its achievements were of a very high order. The artistic director was Lyonel Feininger: he was not a systematic teacher; he proceeded by way of personal example, inspiring the students by the force of his own works and so guiding them towards independent creative activity. Feininger was passionately interested in graphic techniques, especially woodcuts, which he frequently employed both for his splendid prints and also as illustrations for his personal correspondence. If no other wood was to hand he was quite content to use a cigar box by way of a block.

Carl Zaubitzer, a master craftsman of proven ability, ran the technical side of the printing shop. He was a tireless worker who would undertake his assistants' duties in addition to his own when necessary. At the time of his appointment in the autumn of 1919 he was 51 years of age. He remained with the printing shop until the Weimar Bauhaus was closed and then stayed on for a further year as technical director of the Institute which succeeded it. The most important members of the student body were Ludwig Hirschfeld-Mack and Rudolf Baschant. Apart from their manual skills these two men possessed notable artistic gifts. This enabled them to take an active part in the organization of the workshop and to bring a certain influence to bear on its development, especially after they had passed their intermediate examinations and attained the rank of *Geselle*. Mordekai Bronstein and Gerhard Schunke, who entered the workshop in 1924 as apprentices, were two other young artists with very distinctive personalities.

As a result of the work on the portfolios a fairly close relationship was established with the bookbinding shop, which was affiliated to the Bauhaus as a teaching workshop in 1919 and was run by Otto Dorfner, a master craftsman with an intimate knowledge of bookbinding techniques. But Dorfner also had very marked views about the formal aspects of his craft and, since these were grounded in the classical

tradition, they ran counter to the plans evolved for the bookbinding shop by its artistic adviser, Paul Klee. Consequently the affiliation was broken off in 1922, although Dorfner continued to execute commissions for the Bauhaus after that date. These testify to a period of harmonious collaboration based on mutual respect.

Like all the other workshops the printing shop served a variety of purposes. Basically, of course, it was used for training the apprentices and for the production of art prints (which the Bauhaus hoped would furnish an additional source of revenue). But any members of the Institute who were interested in graphic processing techniques and wished to carry out experiments in this sphere were free to do so and could also seek advice from the workshop staff. Many students from other departments tried their hand with stone and wood engravings, and also with etchings. It is hardly surprising to find that a large proportion of the works turned out in this way were immature. What is surprising, however, is their relative independence from the works of the Bauhaus masters. But then during the early years in Weimar expressionism was at least as influential in determining the students' artistic attitudes. This apparent imbalance between external and internal influences was due to the fact that the students undertook these engravings of their own accord as an extra-curricular activity. And of course the Bauhaus was always open to new ideas and maintained close intellectual contact with every German, if not indeed every European, artist of note. The full extent of these contacts was revealed by the demonstrations staged in support of the Bauhaus when it was subjected to political pressure. The list of names in the prospectus announcing the publication of the 'New European Graphics' also furnishes eloquent testimony to this wide-ranging sympathy. The opening of the printing shop was warmly welcomed by the painters and graphic artists on the Bauhaus staff, who were eager to experiment in this field. Like Feininger, Gerhard Marcks revealed a fine understanding for the specific possibilities of woodcuts and produced many memorable prints. In the paper lithograph Klee discovered a medium which was admirably suited to his needs while Schlemmer tried to establish new techniques by experimenting with the 'splutter' process. Georg Muche obtained poetically subtle effects in his lithographs despite the use of deep incisions. Von Itten, Schreyer, Kandinsky and Moholy-Nagy also worked in the printing shop, although not all of these artists attempted to come to terms with the problems of graphic technique which such work involved; some of them regarded the art print simply as a means of reproducing their original works. The high quality of Zaubitzer's craftsmanship was also appreciated by outside artists such as Mondrian, who had a large coloured lithograph made at the Bauhaus of a painting which he had created a few years before.

Detailed production reports are given in the workshop records, which were stored in the Thuringian archives (Landeshauptarchiv) in Weimar. Further information can be obtained from the Gropius collection in the Bauhaus Archive, which was set up in Darmstadt in 1960. The best sources for the Weimar period are: 'Bauhaus-Mappen', 'Mappen Müller & Co.' and 'Monatsberichte der Werkstätten – Graphische Druckerei' ('Bauhaus Files', 'Files of Müller & Co.' and 'Monthy Workshop Reports – Graphic Printing Shop'). The monthly work reports submitted by Zaubitzer, as head of the printing shop, to the Bauhaus management, which cover the period from the autumn of 1921 to February 1925, give a hint of the milieu and the atmosphere. On one occasion – because of the pressure of work – Zaubitzer complained that the 11

apprentices showed little inclination for the mechanical side of printing and were too intent on their own artistic productions, while on another he suggested that 'in future it might be preferable if the fair sex were not admitted to the printing shop'. But when, as sometimes happened, his ambitious young assistants left him in the lurch, Zaubitzer simply carried on without them.

THE PORTFOLIOS–
THE CONCEPTION OF THE 'NEW EUROPEAN GRAPHICS'

The printing shop received its most important commissions between 1921 and 1924. During that period it was not only asked to execute large numbers of individual prints and small series but was also required to produce the prints for ten large portfolios. These were: Lyonel Feininger's 'Twelve Woodcuts' (1920/1), Wassily Kandinsky's 'Little Worlds' (1922), Oscar Schlemmer's 'Game With Heads' (1923), Gerhard Marcks's series of woodcuts 'The Song of Wayland in the older Edda' (1923), a 'Masters' portfolio from the State Bauhaus 1923' and, above all, the five-part series 'New European Graphics' (1921 ff.), which can justly claim to be the finest collection of prints produced in the immediate post-war period. The Feininger portfolio was published by the Bauhaus itself and the 'New European Graphics' by the Bauhaus in collaboration with the Potsdam publishing house of Müller & Co., which took over the distribution; the 'Song of Wayland' and the 'Masters' Portfolio' appeared in the 'Bauhaus-Verlag GmbH', a printing house with offices in Munich and Weimar which was founded in 1923 for the express purpose of issuing Bauhaus publications but which soon went out of business. The Kandinsky portfolio was brought out by the Propyläenverlag in Berlin while Schlemmer's series of lithographs, 'Game with Heads', was published by the artist himself.

Avant-garde artists from the Germanic, Latin, and Slavonic countries were invited to contribute to the 'New European Graphics'. The prospectus printed in the autumn of 1921 listed seventy-five names, including those of seven Bauhaus masters and five artists who had recently died and whose executors had undertaken to submit unpublished works. The selection testifies to the remarkable catholicity of the Bauhaus in artistic matters, for this list contained the names of abstract painters, cubists, futurists and expressionists. Artistic quality appears to have been the only criterion applied by the editors. Their view of artistic quality incidentally was essentially the same as that held by Herwarth Walden, for from 1912 onwards in his *Sturm* gallery in Berlin he had been hanging paintings – and in some cases collections of paintings – by most of the artists concerned. With the single exception of Gerhard Marcks this applied even to the members of the Bauhaus staff. But, quite apart from presenting a panorama of contemporary artistic trends, the 'New European Graphics' were also meant to show the world that the Bauhaus enjoyed the support of all these international artists. This support was demonstrated at a purely material level by the fact that the Bauhaus, which was existing on an extremely tight budget, was allowed to reproduce the works printed in the portfolios free of charge and was to receive all profits from sales. From the financial point of view, however, the 'New European Graphics' proved a failure, for by November 1923 the devaluation of the German

currency had reached such a pitch that the income from the portfolios was not even covering the cost of production. In 1921 the U.S. dollar had stood at between 180 and 200 (paper) Marks; by the end of June 1922 it stood at 375 and by the end of November of the same year 7,650. On 30 June 1923 an exchange rate of 154,113 Marks for one American dollar was recorded. Two months later it rose to 10 million and by mid-November 1923, when the inflation reached its peak, it stood at 4 billion, 200 million Marks. Since the selling price of the portfolios was geared to the exchange rate, the booksellers were always one step behind on the inflationary spiral. At the end of 1923, when the currency was stabilized, sales immediately dropped off, for the art market was one of the first to be hit by the ensuing shortage of capital. And so the Bauhaus incurred a loss on its portfolios.

In 1921, when the project was first conceived, it was decided to devote the first portfolio to the masters of the Bauhaus, the second to the artists from the Latin countries, the third and fifth to the Germans, and the fourth to the Slavs. Each artist was to be represented by a single print with the exception of the Bauhaus masters – Feininger, Itten, Klee, Marcks, Muche, Schlemmer, and Schreyer – who would each contribute two works for presentation in the first portfolio. A graphic work by Wassily Kandinsky, who had not yet joined the Bauhaus at that time, was booked for portfolio IV. Laszlo Moholy-Nagy was not included, for the editors had not yet established contact with him.[1] It was also decided that portfolios I and III would each contain fourteen prints. If this procedure had been adopted for the remaining three portfolios as well there would have been a total of seventy prints in all. If, on the other hand, all seventy-five artists named in the prospectus had actually contributed to the project then, with the seven Bauhaus masters contributing two works each, the total number of prints would of course have risen to eighty-two. But in drawing up their prospectus the editors had been carried away by wishful thinking, for it simply was not the case that 'nearly all' those invited to collaborate – as they put it in their euphemistic statement – had either agreed to do so or had already sent their contribution to Weimar. The only portfolios whose contents and *format* could be stated with certainty were Nos.I and III. Portfolio V turned out to be a much slimmer volume than had been planned. And when portfolios I, III and V were already completed the editors suddenly found themselves obliged to replan portfolios II and IV. No.II was then reserved for the French and for foreign artists living in France (e.g. Coubine and Marcoussis) while No.IV was devoted to the Russians and Italians. All in all fifty-six prints were made, fifty-two of which were published in portfolios I, II, IV and V.

THE GET-UP OF THE PORTFOLIOS

Considerable thought was given to the get-up of the portfolios at the planning stage. Each edition was limited to 130 numbered copies, consisting of ten *de luxe* copies bound in vellum (Nos.1 to 10) and 100 standard copies in half-vellum (Nos.11 to 110), all of which were offered for sale. A further twenty presentation copies were reserved for the artists and a few unnumbered copies were made by the technical assistants in the workshop for their private use. Genuine Japanese paper

1 Kandinsky was invited to join the Bauhaus in 1922; Moholy-Nagy replaced Itten in 1923.

was used for the prints in the *de luxe* copies while in the standard copies a mixture of Japanese and hand-made or imitation hand-made German papers was employed. The times were hard and they were fortunate to get quality paper at all. Since the prints were mounted it was possible to keep to a regular *format*. In principle all the paper used for the prints should have received a blind stamp to show that it was a genuine Bauhaus product. This stamp was the 'Sternenmännchen', which had been the winning entry in a students' competition held in 1919 and was then adopted as the first official Bauhaus signet. But this stamping process was frequently overlooked. The three pages of text — title page and table of contents with a colophon — were printed by the lithographic process on machine-made paper obtained from a reputable firm (van Gelder Zonen). The texts were written by Lyonel Feininger in a highly expressive script, in which the individual letters and words combined to form an artistic whole; the title page was dated 1921. The dedication was also lithographed from a block made by Feininger and was accompanied by the second Bauhaus signet, which had been designed by Schlemmer and depicted an abstract head; from the end of 1921 onwards this signet was also used as an official Bauhaus stamp. The bookbinding was all done by hand in the workshop run by Otto Dorfner. A subtle, restrained, and yet extremely forceful effect was obtained on the paper binding of the half-vellum covers by printing with starch paste to form abstract designs on the tinted ground. The ornamentation on the paper binding of portfolio III was probably designed by Klee, since he was responsible for the artistic direction of the bookbinding shop.[2] The design on the cover of portfolio V appears to be the work of Josef Albers. Ludwig Hirschfeld made two designs, one of which was used for portfolio IV.[3] He also played a leading part in the development of the starch paste process, although it seems that it was Feininger who first suggested this type of cover design. Certainly the woodcut used for the front and rear covers of portfolio I was by Feininger.[4] Taken all in all, the technical standard achieved by the Bauhaus in the get-up of its graphic portfolios is comparable to that of the splendid editions produced by art publishers like Cassirer and Gurlitt and it greatly enriches the art of bookbinding. As was only to be expected the quality of the prints was a little uneven. The works by Bauhaus masters were processed from beginning to end in one and the same workshop. Consequently it was possible to use every conceivable technical refinement[5] in the production of these particular prints. But the production of the lithographs, etchings and woodcuts submitted by outside artists was often beset with difficulties and it seems that in a number of instances it would not have been possible to send the blocks to Weimar for processing there. The prints taken from the woodcuts by Kirchner and Pechstein, for example,

2 Cf. 'Fesselung' (Oil/Water Colour/Paper), Catalogue of Works 1920/168, Klee-Stiftung in Berne. According to the minutes of the 'Master's' meeting of 31 October 1921 Klee and Feininger were asked to make designs for the 'original covers'.

3 Albers confirms that he created this design (in a letter dated 20 April 1964). Hirschfeld has stated both verbally and in writing (letter of 13 February 1963) that he created two designs, one of which was used for portfolio IV. The other will presumably have been intended for portfolio II.

4 Cf. Feininger's letters to his wife of 15 and 17 November 1921 quoted in the excerpts from the files. According to Hirschfeld the design in this starch paste technique was transferred from the woodblock to the lithographic stone before the print was made. Leona Prasse of Cleveland has indicated (verbally) the close connexion between this print and a woodcut entitled 'Fugue' which Feininger made in 1922 and published privately.

5 See Felix Brunner's *Handbuch der Druckgraphik* (Manual of Prints), Teufen 1962, pp.214/15 for an account of Klee's lithographic technique.

appear to be of doubtful provenance. Despite the clear statement made in the colophon that the prints were all produced at the Bauhaus the possibility that some of them were processed by outside firms cannot be precluded, while it is quite certain that such firms helped in the preparation of the stones and plates. How many of the etched plates were steel-faced prior to transit? Did these include the plates by Coubine, Marcoussis, Chagall, and Beckmann?[6] Transporting lithographic stones over long distances – in some cases from one country to another – was a hazardous and costly undertaking. It goes without saying that, with perhaps just a few exceptions, recourse was had to transfer paper. On the other hand the Bauhaus was able to make transfers from only a limited variety of papers. If photo-mechanical transfers were needed they had to be commissioned from a specialist firm. Unfortunately there are no detailed records dealing with the question of transfers. In his monthly reports Zaubitzer refers on only one occasion to a 'stone copy', which was made for Léger's lithograph. But, on the face of it, it seems probable that – save in the case of Kandinsky – the stones used for the coloured lithographs in portfolio IV will not have been prepared at the Bauhaus. Having said all this, however, the fact remains that the great majority of the processes involved in the production of the portfolios were performed at the Bauhaus while any fluctuations in quality were minimal. And if we consider the amount of heterogeneous material which is welded together in these portfolios into an ideational whole then, of course, such fluctuations lose all significance.

THE RESULTS

Two of the portfolios were published as planned, two appeared in a modified form and the other – which was never issued – has survived as a fragment. But before any of them were ready for presentation to the public a number of problems had to be dealt with which often appeared insoluble and sometimes were. The causes of these difficulties were many and varied: the prospectus was published too soon, subscriptions were asked for prematurely, many of the artists were late in sending their work in; social and political upheavals also threatened the venture, which was further undermined by inadequate organization. The syndicate in charge of Bauhaus management at the time when the 'New European Graphics' were evolved proved totally incompetent and had to be dismissed. It was succeeded by an extremely capable body which, however, was immediately confronted with the unpredictable situation created by the inflation. Subscribers were always complaining about delays in delivery schedules, and on more than one occasion the distributors (Müller & Co.) were advised of the despatch of portfolios, for which the models had yet to be obtained. It seems that in the end Müller & Co. also lost track of events while public demand fell off as supplies failed to materialize. None the less, the question as to when or whether the series would be completed was not unimportant. Only two portfolios were delivered on schedule: No.I ('Masters of the State Bauhaus in

6 Cf. letter from Ludwig Hirschfeld to the Bauhaus Archive dated 27 June 1964: 'In the Bauhaus printing shop in Weima we only had about 15 (lithographic) stones, which were cleaned – by hand – after every print. We had no means of making photo-mechanical transfers, which is presumably why an outside firm was commissioned to process the work of those artists who were not members of the Institute. At the Bauhaus we could only make transfers from works which had been executed in lithographic ink on buff coloured lithographic paper.'

Weimar') and No.III ('German Artists'). These came on the market at the beginning of 1922. Portfolio V (also 'German Artists') did not appear until March 1923 while portfolio IV ('Italian and Russian Artists') was not ready until the beginning of 1924; it would have been held up even longer had it not been reduced in size. The story of portfolio II – which was to have included artists from a number of Latin countries but was eventually restricted to French artists only – is symptomatic of the whole tragic development of the Bauhaus in Weimar. Time and again this project had to be deferred because of the strained relations which existed between France and Germany and which were due partly to the recent war and partly to the contemporary dispute over the Ruhr. By the late summer of 1924 only four artists had submitted contributions and these were duly processed. Of the four, only one – Léger – was a Frenchman. The others – Coubine, Marcoussis, and Survage – were all foreign artists who lived in France and were members of the French school. But Delaunay, Gleizes, Jeanneret, and Ozenfant had also agreed to participate (although Braque, Matisse, and Picasso had not) and at the beginning of September 1924 Gropius wrote again to all those whose collaboration has been promised or might reasonably be expected, hoping that this would enable him to complete the series. His list also included Juan Gris, Marie Laurencin, André Lhote, and Francis Picabia. The letters were already franked and ready for the post when the right wing government of Thuringia 'provisionally' cancelled the contracts of the Bauhaus masters. As a result the letters were never sent. Productive work then became virtually impossible and long-term planning utterly pointless. At the end of the year, after the government had effectively blocked every attempt to ensure the continued existence of the Institute, the masters decided to leave. This, of course, spelt the end of the Weimar Bauhaus for, although in principle it was a state institution, in reality it was the brainchild of Gropius and his colleagues. When the Bauhaus moved to Dessau in the spring of 1925, where it was able to operate under more favourable conditions, the French portfolio was still only a fragment and the remaining stocks of the other portfolios had to be thrown on to the market for whatever price they would fetch.

Although incomplete, this series constitutes a considerable achievement on the part of the Bauhaus and remains a unique collection. The only great artists of the 1920's not invited to contribute to the 'New European Graphics' were Nolde and the leading members of the *de Stijl* movement, Mondrian and van Doesburg, and in excluding the two Dutchmen at that time (1921/2) the Bauhaus will no doubt have been motivated by personal considerations. These apart, there were only six or seven really great artists who were not represented in the finished portfolios, e.g. Delaunay, Picasso and the members of the cubist group, Max Ernst and Edvard Munch. Virtually all the other artists of the period whose names have survived – from Beckmann, Kirchner, Kokoschka, and Schwitters to Carrà, Chirico and Severini, Archipenko, Jawlensky, and Chagall – entered the lists with the masters of the Bauhaus. By contrast, the number of contributors who have been forgotten in the course of the years is relatively small. The high standard of the series is due to the discernment of the editors and the enterprising spirit which was so characteristic of the Bauhaus. The great artistic wealth of the 'New European Graphics' has not been matched by any collection of prints which has appeared since.

SIGNET OF THE STATE BAUHAUS
from 1919 to 1921. This was used as a blind
stamp for the prints in the 'New European
Graphics'. 17

BAUHAUS MANIFESTO

Excerpt from the 'Programme of the State Bauhaus in Weimar', a pamphlet published in 1919

Art comes into being above all methods; it cannot be taught as such, although the craft can. Architects, painters, sculptors are craftsmen in the original sense of the word; consequently all students are expected to acquire a thorough training in the workshops and on the practice and work sites, since this is the indispensable basis of all creative activity. The Institute's own workshops will be gradually fitted out and apprenticeship agreements concluded with outside workshops.

The school is there to serve the workshop and one day will be absorbed into it. Consequently there will be no teachers and pupils at the Bauhaus but masters, *Gesellen* and apprentices.

The style of teaching will evolve from the nature of the workshop:

Organic creation to be developed from craftsmanship.

Avoidance of all rigidity; emphasis on creativity; freedom of individual expression, but strict application to studies.

Masters' and *Gesellen* trade tests at guild level to be held before the Bauhaus masters or masters from outside.

Students to contribute to the works executed by the masters.

Students to be offered commissions.

Communal planning of extensive, utopian building projects — civic and religious buildings — on an ambitious scale. All masters and students — architects, painters, sculptors — to collaborate on these designs in order that the various components and sections of the building may gradually be brought into a state of harmony. Constant contact with the leaders of trade and industry in the country.

Contact with the public and with the people by means of exhibitions and other gatherings.

Experiments in exhibition arrangement with a view to solving the problem of picture and statue display within an architectonic framework.

Cultivation of friendly relations between masters and students outside the working sphere — theatre, lectures, poetry, music, fancy dress balls. Development of cheerful ceremonial for such occasions.

BAUHAUS PRESS

Excerpt from 'Rules of the State Bauhaus in Weimar', July 1922 Appendix 3

Unlike the other workshops, the printing shop at the State Bauhaus in Weimar does not accept articled apprentices but it does train Bauhaus members on request in all the techniques of print processing.[1] Bauhaus members can learn planographic

1 Those students who worked in the printing shop on a permanent basis were none the less referred to as apprentices or *Gesellen*, according to their standard of proficiency, although only the artistic and technical directors were accorded the rank of master. (Ed.)

printing (lithography), intaglio printing (etching and engraving), and relief printing (woodcuts, linoleum cuts and zinc etching) including all phases of the work on the stone, the plate and the block and all aspects of the work on the press.

Essentially the printing shop is a production workshop which executes commissions for art prints of all kinds and even produces whole editions. A large number of leading artists have their graphic works printed in our workshop.

The Bauhaus press is a practical consequence of the printing shop. Artists in the Bauhaus and outside artists both at home and abroad, who are in sympathy with the artistic aims of the Bauhaus, use the Bauhaus press for the publication of graphic works which have been printed in our workshops. A prospectus listing the publications of the Bauhaus press will be sent free on request.

A gradual expansion of the press is planned with the object of propagating and publicizing the ideas and work of the Bauhaus and related enterprises by means of pamphlets and prints.

BAUHAUS PRINTS
NEW EUROPEAN GRAPHICS

Compiled and edited by the State Bauhaus in Weimar
Müller & Co. / Publishers / Potsdam
(Excerpt from the prospectus (undated, 8 pp.) which was issued in the autumn of 1921)

For the first time ever we are offering the collector an opportunity — one which is quite unique in the present economic situation — of acquiring an international collection of really significant graphic works, in which Germany, France, Holland, Italy, and Russia are represented by their leading artists. The success of this enterprise has been due to the generosity of the artists from these various countries and of the widows of artists who have died. The composition of the portfolios will meet with the approval of all who acknowledge the leadership of any of the following artists and wish to support it :

Archipenko / Bauer / Baumeister / Beckmann / Beneš / Boccioni (posthumous publication) / Braque / Burcharzt / Campendonk / Carrà / Chagall / Chirico / Coubine / Delaunay / Derain / Dexel / Max Ernst / Le Fauconnier / Feininger / Filla / Fiori / Oskar Fischer / de la Fresnaye / Gleizes / Gontcharova / Gris / George Grosz / van Heemskerck / Heckel / Hoetger / Itten / Jawlensky / Jeanneret / Kandinsky / Kirchner / Klee / Kokoschka / Kubin / Larionov / Laurencin / Lehmbruck (posthumous publication) / Léger / Lhote / Lipschitz / Macke (posthumous publication) / Marc (posthumous publication) / Marcks / Marcoussis / Matisse / Meidner / Mense / Metzinger / Molzahn / Morgner (posthumous publication) / Muche / Mueller (Otto) / Munch / Ozenfant / Pechstein / Picabia / Picasso / Prampolini / Rohlfs/ Scharff / Schlemmer / Schmidt-Rottluff / Schreyer / Schwitters / Severini / Soffici / Survage / Stuckenberg / Topp / Tour-Donas / Wauer.

Nearly all of these artists, including some of the most important, have either agreed to participate or have already sent their contribution for processing. In this con- 19

nexion we wish to draw special attention to the woodcut by Franz Marc, the last he ever made, which is now being published for the first time.

These prints will be produced by hand in the printing shops of the State Bauhaus (artistic director Lyonel Feininger, technical director Carl Zaubitzer); the book-binding work will be carried out in the bookbinding shop (artistic director Paul Klee, technical director Otto Dorfner).

The *format* of the portfolios will be 46×58 cm, and each portfolio will contain ten to fourteen original prints: woodcuts, etchings, and lithographs. Each print will be mounted and will be signed by the artist. Five portfolios are planned. Each of these will be produced in a single edition consisting of 130 numbered copies, of which Nos. 1–110 will be offered for sale. Twenty copies will be reserved for the artists and these will be numbered in Roman numerals.

The prints in portfolios 1–10 will be produced on Japanese paper and the portfolios bound in vellum. Whenever possible the plates for the etchings will not be steel-faced.

Price per portfolio Mk 5,000.–[1]

Nos 11–110 will be printed on quality paper of German manufacture and bound by hand in half-vellum.

Price per portfolio Mk 2,200.–

Those who subscribe for all five portfolios before the first is published will be offered special terms: Mk 10,000.– for the standard edition (Nos.11–110) and Mk 22,500.– for the *de luxe* edition (Nos. 1–10).

The contents of each portfolio will be announced on completion.

Subscriptions are now invited.

.

The State Bauhaus / Weimar
Müller & Co. / Publishers / Potsdam

The State Bauhaus in Weimar is the first public institute in Germany to reunite the teaching of artistic form and the teaching of craftsmanship and to treat them as fundamental and inseparable components of creative activity. Its object in doing so was to avoid the onesidedness of the Academies and Industrial Schools of Art.

We know that artistic ability cannot be taught. But we can be craftsmen and we can work as craftsmen with the young people who come to us; this is what we want to do. If a work of art should then grow out of this craftsmanship, it will be a gift which has been bestowed on us. We know that craftsmanship has its roots in building. Building is the be all and end all of our communal work. The rhythm of the integrated building determines the rhythm and form of every object which we work in our individual workshops. This has enabled us to find our way back from the world of play, the world of chance, to a world of obligation and necessity, which provides the only conditions in which intellectual freedom can operate. Not many have made a conscious attempt to act on these ideas, which were evolved in the face of the physical and spiritual collapse of our people. But a benevolent fate decreed that the Thuringian states, which have always taken new movements to their heart, would be able to offer us a State Institute for our work.

We have spent the first two years of the Institute's existence creating what we consider to be the right basis for that work. In order to be able to do this in an atmosphere

1 In November 1921 5,000 Marks were worth approximately 25 U.S. dollars (Ed.).

of complete calm we have tried, as far as was possible, to keep ourselves out of the public eye, even though this could have meant that the true purpose of our endeavours might be misconstrued. Those who share our views know that we had no choice in this.

But now we are turning to the public with a document which shows that the artists of the present generation are in sympathy with the ideas being pursued by the Bauhaus and are even prepared to make a personal sacrifice by donating their works in order to help us.

We decided to publish these portfolios because we need to obtain more funds than the state of Thuringia is able to furnish us with. This we have to do, for the Bauhaus is far more important than a normal State Institute. We are able to publish these portfolios because we were assured of the backing and generous co-operation of a whole generation of German and foreign artists. And so this unique series has evolved, without regard for personal considerations or particular trends, as a demonstration of support on the part of the artists of our day for the concept underlying the Bauhaus.

It is also hoped that this publication will enlighten all who, through no fault of their own, are ignorant of the work being done by the Bauhaus. We incline to the belief that those who feel an inner bond with us will not be few in number. We are counting on their support.

The Masters of the State Bauhaus in Weimar

Lyonel Feininger	Gerhard Marcks
Walter Gropius	Georg Muche
Johannes Itten	Oskar Schlemmer
Paul Klee	Lothar Schreyer

ABSTRACTS AND QUOTATIONS FROM FILES

These abstracts and quotations have been taken from the following sources:

I Letters from Lyonel Feininger to his wife Julia. In the possession of Mrs Julia Feininger, New York.

II Minutes of the meetings of the Masters' Council of the State Bauhaus. Bauhaus files. Thuringian Archives (Landeshauptarchiv), Weimar

III 'Files of Müller & Co.', 1921 to 1 October 1925. Thuringian Archives, Weimar.

IV 'Bauhaus Files'. Thuringian Archives, Weimar.

V 'Files of the Bauhaus Press'. Thuringian Archives, Weimar.

VI 'Monthly Workshop Reports: IX Graphic Printing Shop.' Thuringian Archives, Weimar.

AUTUMN–WINTER 1921

(II) Meeting of the Masters' Council of 12 October 1921 : The Council decided that a new Bauhaus stamp should be designed ; the masters were asked to submit their designs by 1 November. Meeting of Masters' Council of 31 October : A contract was concluded with the publishing house of Müller & Co. in Potsdam for the distribution of the projected series of portfolios 'New European Graphics'. Itten and Schreyer had

still to submit their contributions for portfolio I. Klee and Feininger had not yet completed their designs for the 'Original Covers' (i.e. for the albums of portfolios I and III, which were to be produced first).

(III) Contract concluded on 25 October 1921 between the State Bauhaus and the publishing house of Müller & Co.: It was proposed to publish portfolios of works by important European artists arranged according to nationality. Each edition would consist of ten *de luxe* copies (Nos.1–10) in vellum, 100 standard copies (11–110) in half-vellum and a further twenty standard copies (I–XX) for presentation to the artists. The State Bauhaus would compile and edit the portfolios; the publishing house of Müller & Co. would be responsible for distribution. The publishing house would sell the portfolios on its own account and receive a profit margin of 50% of the retail price, which was to be fixed at 5,000 Marks for the *de luxe* and 2,200 Marks for the standard edition. Advance publicity was to be taken in hand at once. If sales were not satisfactory the Bauhaus reserved the right to make alternative arrangements after a period of one year. Letter of 2 November 1921 from the Bauhaus to Müller & Co.: A few 'sample prints' from portfolio I were despatched to the publishing house on 31 October for publicity purposes.

(I) Letter of 15 November 1921 from Lyonel Feininger to his wife: '... I was in the studio at 8.15 this morning and worked solidly all day, but the script is making a lot of work and I am held up by it far more than I was by the large woodcut, the one on the cover of the portfolio. Incidentally, the print has turned out well, it really is particularly impressive. Everyone is very pleased with it . . .' Letter of 17 November: '... The covers of the masters' folio are coming along beautifully. Hirschfeld is printing the woodcut just like the small sample prints, straight on to the paper with the roller, but to really get an idea of this dark, mysterious structure with its few highlights standing out in sharp relief you would need to see it for yourself...'

(VI) Undated monthly report from Zaubitzer to the Bauhaus management: Apart from the numerous private commissions 'we are also working on the prints for the Bauhaus portfolios'; in view of the many difficulties encountered in trying to keep production running smoothly while instructing the students at the same time, 'it might be preferable if the fair sex were not admitted to the printing shop'.

END OF 1921 –BEGINNING OF 1923

(V) Despatch note: Portfolios I and III to be despatched as from 3 January 1922.

(III) Various reminders from Müller & Co. to the Bauhaus: Customers were annoyed at delays and defective consignments; many were also disturbed by the fact that 'the most extreme trends' had not yet been overcome. Bauhaus memo: On 22 March 1922 the bookbinding shop was instructed to despatch portfolio III.

(III) Letter of 30 June 1922 from the Bauhaus to Müller & Co. stating that contributions had been received from the following Russian and Italian artists: Archipenko, Chagall, Jawlensky, Larionov, Gontcharova, Kandinsky, Boccioni, Carrà, Chirico, Fiori, Prampolini, Soffici, and Severini. (This list was completely arbitrary; Fiori and Soffici, for example, never did submit contributions.)

(III) Letter of 8 July 1922 from Müller & Co. to the Bauhaus: Since there was evidently going to be further delay in the publication of the French portfolio it was felt that, despite various misgivings, 'the Russian and Italian prints should be issued now in a third portfolio, to be followed by the other German prints in a fourth'. The

subscribers considered it to be most important that the five-part series should appear in full and fears had already been expressed to the effect that 'the French artists will never be printed'. Letter of 25 August 1922 from Beyer (one of the Bauhaus trustees) to Müller & Co.: '... the completion date for portfolio II will have to be deferred since many of the artists are away from home at present and so cannot sign the prints ...'

(V) List of artists who had undertaken to contribute to the French portfolio dated 12 October 1922: Undertakings had been received from Coubine, Delaunay, Gleizes, Jeanneret, Léger, Marcoussis, Ozenfant, and Survage. The other French artists who had been asked to contribute were: Braque, Le Fauconnier, de la Fresnaye, Gris, Laurencin, Lipschitz, Lhote, Matisse, Metzinger, Picasso, Picabia, Tour-Donas, and Derain.

(V) Undated memo: The prices paid by foreign subscribers for the whole series were 400 Swiss Francs (for the standard edition) and 900 Swiss Francs (for the *de luxe* edition). In October 1922 these prices were increased by 200%; by the end of October the basic price in Germany had risen to 90,000 Marks. (In calculating the new prices insufficient allowance had been made for the drop in purchasing power. Whereas in the previous year one U.S. dollar had been worth approximately 200 Marks, in late October 1922 it was worth 4,500.)

(VI) Monthly Report for October 1922: Most of the work done in the printing shop had been on Kandinsky's portfolio 'Little Worlds'; but 'a number of contributions for the Bauhaus portfolio' had also been received and so it had been possible to make good headway with this. Report for November: The contributions by Archipenko and Kandinsky for the Bauhaus portfolio had still be be printed, partly because Kandinsky had not yet designed his colour plates. December: the printing shop had been very busy finishing Bauhaus portfolios (this presumably means that all the available work on portfolio IV had been completed): 'unfortunately we are still waiting for Chagall's contribution'. Monthly Report for January 1923: Dorfner requested further prints of the tables (of contents) for the Bauhaus portfolios.

1923, THE YEAR OF THE GREAT EXHIBITION

(III) Despatch note of 21 March: Instructions given for the despatch of portfolio V. Further notes of 20 June and 24 September authorized the despatch of portfolios I, II and V. Letter of 11 April from the Bauhaus to Müller & Co.: Two copies of portfolio V were sent to the *Galerie Cometer* in Hamburg in the middle of March. According to the records for mid-April copies of portfolio V could be delivered to the publishing house as required. (III) Letter of 19 April 1923 from Müller & Co. to the Bauhaus complaining that the Bauhaus was supplying them with contradictory information. On 29 January they had been told that portfolios IV and V were ready and on 6 March that portfolio IV was not yet completed; on 12 March the Bauhaus had raised the price of the portfolio by 50%, the increase to take immediate effect, and on 11 April it had suddenly stipulated completely new conditions of payment. 'If we are to advise our clients of your wishes on each and every occasion we shall have to open a special department to handle your correspondence.' Letter of 14 June from the Bauhaus to Müller & Co.: Only a few copies (seemingly of portfolio V) had been sold to date and this was unsatisfactory. On 19 June a clause was added to the contract between the State Bauhaus and the publishing house of Müller & 23

Co.; from then on Müller & Co. were to sell on a commission basis only and the Bauhaus was entitled to dispose of portfolios direct to interested parties.

(VI) Monthly Reports from the Printing Shop: From these detailed reports we learn that, like the other workshops, the printing shop was actively engaged in preparing for the great Bauhaus exhibition, which took place in the summer of 1923. Among other things it undertook the preliminary processing for twenty lithographic post cards (most of which were in two or three colours). In the spring it executed large commissions for Kandinsky, Schlemmer and Schreyer (coloured prints) and in June began processing the 'Masters' Portfolio from the State Bauhaus 1923' (which was completed in July) and Schlemmer's lithographic series 'Game with Heads' (which was continued in August). Between the autumn and the end of the year Gerhard Marcks's woodcuts illustrating 'The Song of Wayland' were printed and various commissions executed for Klee (coloured lithograph of the 'Tightrope Walker'), Schlemmer, Schreyer, and Mondrian. No reference was made to any work for the 'New European Graphics' during this period.

1924

(V) Post card of 31 January from Gropius to Archipenko informing him that portfolio IV was about to be published. Undated inventory of surplus prints, i.e. prints processed in excess of requirements: Archipenko 10, Baumeister 17, Boccioni 13, Dexel 12, Itten 12, Jawlensky 10, Klee (Hoffmannesque Scene) 13, Macke 10, Marc 10, Schwitters 10; the number of surplus prints made of the works by the other artists were far smaller. Despatch notes of 20 and 21 March authorizing the despatch of presentation copies of portfolio V to Schmidt-Rottluff, Grosz, Beckmann, Kokoschka, Kubin, Mense, Rohlfs, and Scharf.

(III) In its correspondence with the publishing house of Müller and Co. the Bauhaus was constantly complaining about the way in which the commercial side of the enterpise was being conducted. The Institute was making no more than about 10 Reichsmarks on each portfolio and this low profit margin was partly due to the fact that the distributors were slow in settling their accounts. But the distributors were also dissatisfied. On 26 April Müller and Co. informed the Bauhaus that their clients were threatening to report the Institute to the Exchange Association and denounce it for profiteering; they were also demanding immediate delivery of portfolio IV and an assurance that portfolio II would still be sold at the subscription price despite the new market situation. Letter of 31 May from Müller & Co. to the Bauhaus management stating that a certain section of the book trade was boycotting the Bauhaus portfolios and suggesting that this was to some extent due to the false assessments made by the Bauhaus itself. Müller & Co. then quoted from a letter which they had received from the Exchange Association: 'Having failed to persuade the firms who subscribed to the portfolios to participate in the loss sustained by yourselves (or the Bauhaus) and also having regard to the legal position, we consider that further mediation would be pointless. The Bauhaus has only itself to blame for having fixed an unrealistic price and, although we would naturally be only too pleased to mitigate this loss by mediating on your behalf, there is nothing we can do once the other party adopts a legal attitude . . .' On the strength of this letter Müller & Co. expressed the opinion that the portfolios would have to be handed over even though this meant that the Bauhaus would suffer a loss as a

result of the devaluation of the Mark. This, they suggested, was the consequence of the inept procedure which had led to the price being fixed at far too low a level in the first place and consequently it would simply have to be borne.

(VI) In the monthly reports of the printing shop no mention was made of any work being carried out in connexion with the 'New European Graphics' up to September. During this period the shop concentrated on the production of individual prints (including some for Mondrian and Rodchenko). Hirschfeld was working on his 'colour top' and his 'colour projections' while the other students were either on vacation or else made themselves scarce, so that Zaubitzer had good cause to complain.

(V) Letter of 3 September 1924 from Gropius to Gleizes informing him that the prints by Coubine, Marcoussis, and Survage, which were intended for portfolio II, had already been processed and that Léger's contribution (in this case a design) had arrived in Weimar. Gropius then asked Gleizes to send his own contribution as quickly as possible. Similar letters were written to La Fresnaye, Gris, Mme Tour-Donas, Marie Laurencin, Metzinger, Picabia, and Lhote. But, as we have already seen, none of these letters was actually sent.

(VI) In the monthly report from the printing shop for October Zaubitzer stated among other things that a 'stone copy and 4 sample prints of the Léger' had been made.

(V) Memo: On 17 October Léger was said to have received a sample print.

(VI) In his report for December Zaubitzer stated that '140 Léger prints' had been made.

(V) Undated memo: 130 prints had been made of Léger's lithograph on German paper and ten on Japanese paper.

1925—THE CLOSING OF THE WEIMAR BAUHAUS

(VI) The last monthly report to come from the printing shop, which was dated 15 February 1925, referred to numerous commissions — individual prints which were processed for Marcks, Moholy-Nagy, Muche, and other artists — but made no further reference to the contributions for the 'New European Graphics'.

(III) Letter of 7 February 1925 from the Bauhaus to the Thuringian Ministry of Education suggesting that it might be preferable if the remaining portfolios were sold *en bloc* since it would scarcely be possible to dispose of them individually. In a letter dated 30 April the Ministry of Education asked the Institute which had succeeded the Bauhaus in Weimar (and which still bore its name) the cost price of the individual portfolios; the Ministry assumed that it would not be less than 13 Reichsmarks. On 2 May the State Bauhaus in Weimar informed the publishing house of Müller & Co. that the wholesale price had been readjusted; it was proposed to charge 18 Reichsmarks each for the *de luxe* and 15 Reichsmarks for the standard portfolios.

(IV) Letter of 27 November 1925 from the Ministry of Education to the (new) Weimar Bauhaus stating that the portfolios returned by Gropius, i.e. by the Bauhaus in Dessau, could only be sold when it had been ascertained how many were available (after supplementary prints had been provided, etc.) At the stock-taking on 13 November 1925 the following unsold copies were listed:

	Edition A (*de luxe*)	Edition B (standard)
Portfolio I	1	23 plus 8 unnumbered copies
Portfolio III	–	40 copies
Portfolio IV	4	57 copies
Portfolio V	4	35 plus 6 unnumbered copies

BIBLIOGRAPHY

Early Publications on the Bauhaus and the Portfolios:

State Bauhaus in Weimar and Karl Nierendorf (Ed.): 'Staatliches Bauhaus Weimar 1919–1923' (State Bauhaus in Weimar 1919–23), Weimar and Munich undated (1923) – see especially Plate 94, which shows articles produced in the printing and bookbinding shops.

Erich Wiese: 'Bauhaus-Drucke. Neue Europäische Graphik' (Bauhaus Prints. New European Graphics). Published in the magazine, *Der Cicerone*, XIV Jhg (Februar) 1922, pp.169/70 – Review of portfolios I and III.

Erich Wiese: 'Bauhaus-Drucke. Neue Europäische Graphik, Fünfte Mappe (Fifth Portfolio), published in the magazine, *Der Cicerone*, XV Jhg (Juli) 1923, pp.617/18.

Later Assessments of the Bauhaus:

Herbert Bayer, Walter Gropius and Ise Gropius: 'bauhaus 1919–1928'. English editions New York 1938, Boston, 1952, German edition Stuttgart 1955. Hans M. Wingler. 'Das Bauhaus 1919–1933 Weimar Dessau Berlin', Bramsche and Cologne 1962 (source book for this publication); 2nd revised edition 1968; English edition Cambridge/Mass. 1968 (a well-documented, critical account with a bibliography). Eberhard Roters: 'Maler am Bauhaus' (Painters at the Bauhaus), Berlin 1965. Walther Scheidig: 'Bauhaus Weimar 1919–1924, Werkstattarbeiten', Leipzig 1966; English edition, London 1966.

Descriptions of the working milieu and the people at the Bauhaus are to be found in a number of memoirs, e.g. Lothar Schreyer's 'Erinnerungen an Sturm und Bauhaus' (Memories of the *Sturm* and the Bauhaus), Munich 1956, and Georg Muche's 'Blickpunkt Sturm – Dada – Bauhaus – Gegenwart (Viewpoint *Sturm* – Dada – Bauhaus – Present Day), Munich 1961. The most important contemporary comment on the structure and essence of the Bauhaus was given by Oskar Schlemmer in his 'Briefe und Tagebücher' (Letters and Journals), Munich 1958.

Works in which Bauhaus prints have been catalogued:

Heinz Peters: 'Die Bauhaus-Mappen, 'Neue Europäische Graphik' 1921–23' (The Bauhaus Portfolios, 'New European Graphics' 1921–23), Cologne 1957 – Monograph with introduction and catalogue of portfolios I, III, IV and V together with reproductions of the title pages and the prints. When this edition was published the prints of portfolio II and the Bauhaus files had not yet been discovered.

Galleria del Levante (Eds.): 'Edizione d'arte della Bauhaus', Milan 1963 – Exhibition catalogue with an introduction by Heinz Peters and an inventory of twenty-seven of the prints from the 'New European Graphics'.

Bauhaus-Archiv (Eds.): 'Arbeiten aus der graphischen Druckerei des Staatlichen Bauhauses in Weimar 1919–1925' (Graphic Works from the Printing Shop at the State Bauhaus in Weimar 1919–25), Darmstadt 1963 – Exhibition Catalogue of 208 prints, bookbinding work and various documents. This cata-

logue (which is not illustrated) affords a provisional survey of the artistic aims and achievements of the bookbinding shop at the Bauhaus.

All catalogues of works and monographs on individual artists (e.g. Paul Klee) will be listed at the foot of the appropriate biographical sketches and also in the catalogue of the prints contained in the five portfolios.

Dictionaries of Artists:

Ulrich Thieme and Felix Becker (Eds.): Allgemeines Lexikon der bildenden Künstler, Vols.1–37, Leipzig 1907–50. Hans Vollmer (Ed.): Allgemeines Lexikon der bildenden Künstler des XX Jahrhunderts, Vols.1–6, Leipzig 1953–62.

ARTISTS AND CRAFTSMEN IN THE PRINTING AND
BOOKBINDING SHOPS

FEININGER, LYONEL (Printing Shop, 'Master of Form', i.e. Artistic Director)
Born 17 July 1871, died 13 January 1951, in New York. His parents were German
emigrants and in 1887 Feininger himself went to Germany to study music but
decided to become a painter instead. He trained at the Industrial School of Art in
Hamburg, the Berlin Academy, and a private school in Paris. From the 1890's on-
wards Feininger worked in Berlin and – for a short time – in Paris as a caricaturist. In
1913 he was invited by the *blaue Reiter* to take part in the 'First German Autumn
Salon', the great exhibition organized in Berlin by Herwarth Walden. As soon as the
Bauhaus was founded Gropius asked Feininger to join the staff, which he did in May
1919. He then remained with the Institute as a 'Master of Form' and artistic director
of the printing shop until 31 March 1925. He was highly regarded in Weimar both
as an artist and as a man. When the Bauhaus moved to Dessau in 1925 Feininger
was offered a position at the new Institute without any teaching responsibilities. In
1926 he accepted the offer and rejoined his friends. In Dessau he moved into one of
the 'master's houses' which had been designed by Gropius and where he continued
to live for a short while even after the Institute had been closed down. During his
Dessau period Feininger made a series of architectural paintings in Halle (Saale).
From 1933 onwards his social situation became more and more intolerable. In
1936 he visited the United States and in 1937 returned there for good. Literature:
Hans Hesse, 'Lyonel Feininger', Stuttgart 1959 (with a bibliography). A catalogue
of his prints is being prepared by Leona Prasse in Cleveland.

ZAUBITZER, CARL (Printing Shop, 'Master of Craft', i.e. Technical Director)
Born 30 January 1868, lived in Upper Weimar near the town of Weimar, where he
died on 5 March 1955. Zaubitzer's basic trade was lithography. In July 1919 he
applied for the post of technical director of the printing shop, was accepted and
signed a contract with the Bauhaus on 30 September 1919. He began his duties on
19 October of the same year. On 1 April 1921 his contract was renewed at a higher
salary. After the Bauhaus closed down in Weimar Zaubitzer stayed on with the
Institute which succeeded it until 30 April 1926. His later activities are unknown.
For further information see the Thuringian Archives, Weimar: Contract between the
Bauhaus and Zaubitzer (Filing Cabinet No.160); Personal files of technical staff
(not indexed).

HIRSCHFELD (-MACK), LUDWIG (Printing Shop, *Geselle*)
Born 11 July 1893 in Frankfurt/Main, died 7 January 1965 in Sydney (Australia).
In 1912 Hirschfeld went to Munich to study under Debschitz only to be called to the
28 colours in 1914. After four-and-a-half years' military service he resumed his studies,

first under Hölzel in Stuttgart, then at the Bauhaus in Weimar (1920–5), where he was attached to the printing shop. In 1922 he passed his intermediate examination and was promoted *Geselle*. He worked on most of the large projects undertaken by the printing shop and also carried out noteworthy experiments on his own account, in which he showed a preference for monotype and starch paste techniques. With his mature personality and inventive mind Hirschfeld was a prominent member of the student body; his fertile imagination also enriched the social life of the Institute, for he could always be relied upon to produce novel ideas for the Bauhaus festivals. He was one of the initiators of the system of 'colour projections' (in which coloured abstract designs were projected on to a screen); he also established the theoretical premises of this system and, together with a group of Bauhaus colleagues, toured the country, giving practical demonstrations at public lectures. He made systematic analyses of individual and variegated colours, in which he studied their specific qualities and interactions. When the Bauhaus moved to Dessau he stayed on in Weimar and gave a course of introductory lectures at the new Institute, which was eventually given the name of the 'Staatliche Bauhochschule'; in 1927 he was engaged as a teacher of design by an experimental school of art in Wickersdorf in Central Germany and remained there until he emigrated, first to England and then to Australia, where he entered a new sphere as a teacher of aesthetics at a College in Geelong in the state of Victoria.

Literature: H. M. Wingler, 'The Bauhaus 1919–1933', esp. pp.96 ff. and 340/1. Ludwig Hirschfeld-Mack, 'The Bauhaus – An Introductory Survey', Croydon (Victoria) 1963.

BASCHANT, RUDOLF (Printing Shop, *Geselle*)
Born 29 August 1897 in Salzburg, died 1 July 1955 in Linz. Childhood spent in Breslau and Essen. Baschant began his studies at the Folkwangschule in Essen in 1917. From 1919 he attended the Industrial School of Art in Frankfurt and from 1921 to 1924 the Bauhaus in Weimar, where he worked chiefly in the printing shop. In 1923 he passed his trade test as a printer and acquired the rank of *Geselle*. From 1925 onwards he continued his studies at the Academy for Book Production in Leipzig, where he passed his master's examination. From 1930 to 1933 he taught at the School of Art in Burg Giebichenstein near Halle (Saale); from 1934 until he was conscripted for military service in 1942 he worked as a botanist and scientific draughtsman for the University Institutes in Halle and Innsbruck. After the war he lived first in Klaus on the Pyhrn, and then in Linz. Baschant visited Brazil, Africa, and most of the countries of Europe. He left a large number of graphic works, chiefly etchings, the majority of which were produced either singly or in strictly limited editions, for Baschant liked to keep the copies of his prints to a minimum. Examples of his work are to be found in various large European and American museums.

Literature: A monograph is being prepared by the Bauhaus Archives.

BRONSTEIN, MORDEKAI (Printing Shop, Apprentice)
Born 13 July 1896 in Tuchov (Poland), now lives under the name of Mordecai Ardon in Jerusalem and Paris. Trained at the Bauhaus from 1920 to 1925, where he joined the printing shop as an apprentice after having first studied in various other workshops. In 1926 he went to Max Doerner in Munich to learn painting 29

technique and then, in 1929, joined Johannes Itten's Art School in Berlin as a teacher. In 1933 he emigrated to Jerusalem, where he taught at the Bezalel School of Art from 1935 and was appointed Director of the school in 1940. He resigned this post in 1952 to become artistic adviser to the Israeli Ministry of Education and Culture. His reputation as one of Israel's leading artists has been fully justified by the exhibitions of his works, which have been held in museums in Amsterdam, New York, and various other cities. The Stedelijk Museum in Amsterdam, the Museum of Modern Art in New York, the Musée Nationale d'Art Moderne in Paris, and numerous other collections have acquired works by Ardon.

Literature: Catalogues of exhibitions in Amsterdam (1960–61) and Jerusalem (1963) etc.

SCHUNKE, GERHARD (Printing Shop, Apprentice)
Born 17 August 1899 in Naumburg (Saale); died 31 October 1963 in Speicher (Switzerland). Schunke joined the Bauhaus soon after it was founded and entered the printing shop as an apprentice in 1924. In Weimar he came into close contact with Gertrud Grunow, who was engaged as psychological adviser to the Institute and who introduced him to the doctrine which she herself had evolved concerning the influence of colour and light on human beings. Schunke then developed this doctrine with special regard to its therapeutic possibilities and subsequently applied his findings in a sanatorium in Switzerland after he had emigrated there from Germany. He was honoured for his work by the Swiss Universities, who conferred a doctorate on him and various other distinctions. Schunke's name was changed by adoption to Schunke von Mannstedt.

Literature: Gerhard Schunke von Mannstedt, 'Der Krebs und seine Farb- und Hell-Dunkel-Therapie' (Cancer and its Treatment by Colour Therapy and Light and Dark Therapy), Berne and Freiburg im Breisgau 1953.

KLEE, PAUL (Bookbinding Shop, 'Master of Form', i.e. Artistic Director)
Born 18 January 1879 in Münchenbuchsee near Berne, died 29 June 1940 in Muralto-Locarno. Began to study painting in Munich in 1898 (first under Knirr, then Stuck). 1901 visited Italy, 1905 Paris. During this period Klee made minute anatomical studies and produced his first etchings. In 1906 he settled in Munich, where he established contact with the *blaue Reiter* in 1912. In the same year came the important meeting with Delaunay in Paris. In 1914 he was in Kairouan (with Macke and others). From 1916 to 1918 he saw Army service and contributed to Walden's *Sturm*. Between 1920 and 1931 he was a Master at the Bauhaus, where he directed the bookbinding shop up to 1922 and subsequently the glass-painting shop. From 1927 to 1929, after the Bauhaus had moved to Dessau, Klee also taught in the weaving shop. But his most comprehensive lectures were those on fundamental principles which were given as part of the introductory course and subsequently formed the basis of the 'Pedagogical Sketchbook'. It was not until 1928 that he began to teach painting at the Bauhaus. In 1931 he transferred to the Düsseldorf Academy, where he also had a painting class. Then in 1933, after being dismissed from his post for political reasons, he returned to Switzerland to spend the final period of his life in his hometown of Berne. Although seriously ill towards the end he was free from all external obligations.

Literature: Will Grohmann, 'Paul Klee', Stuttgart 1959 (with a bibliography). W. W Kornfeld, 'Paul Klee – Catalogue of Graphic Works', Berne 1963

PRINTING SHOP

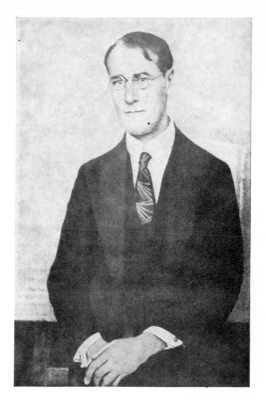

LYONEL FEININGER. Studio photograph
taken about 1922 by Hugo Erfurth

Master of Form

Lyonel Feininger's signature. *c.*1922

Master of Craft

Carl Zaubitzer's signature. *c.*1922

PRINTING SHOP

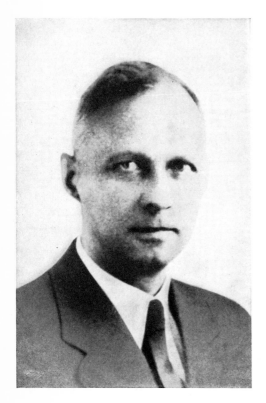

LUDWIG HIRSCHFELD-MACK. Photograph
taken in the late 1920's

Geselle

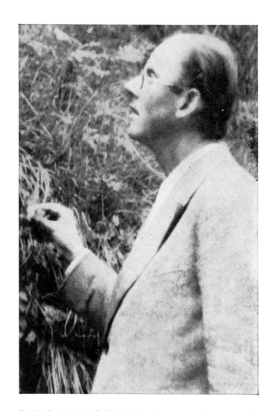

RUDOLF BASCHANT. Photograph taken in
the late 1920's

Geselle

PRINTING SHOP

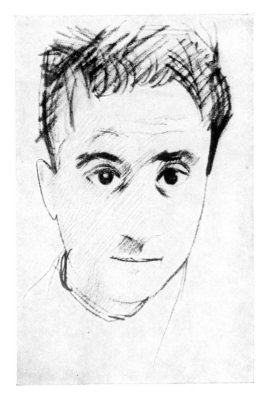

MORDEKAI BRONSTEIN. Reproduction of a
drawing by Paul Citroen. *c.*1924

Apprentice

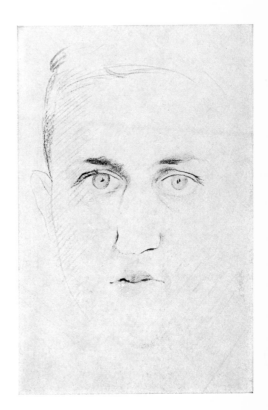

GERHARD SCHUNKE. Reproduction of a
drawing by Paul Citroen. *c.*1924

Apprentice

BOOKBINDING SHOP

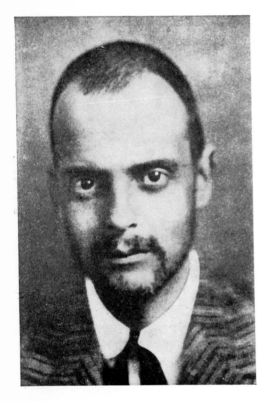

PAUL KLEE. Studio photograph taken about
1920 and published as a post card by the *Sturm*
publishing house

Master of Form

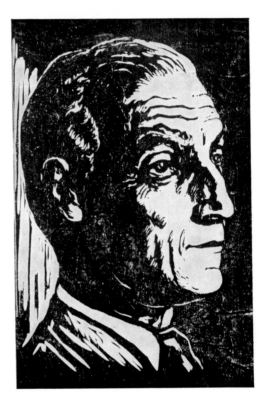

OTTO DORFNER. Reproduction of a woodcut
by Walther Klemm

Master of Craft

DORFNER, OTTO (Bookbinding Shop, 'Master of Craft',
 i.e. Technical Director)
Born 13 June 1885 in Kirchheim-Teck (Württemberg), died 3 August 1955 in
Weimar. After training as a bookbinder Dorfner was appointed Director of the
Grandducal Industrial School of Art in Weimar by Henry van de Velde. When the
school was closed in 1915 Dorfner continued to run the bookbinding department
on his own account. In 1919 this department was affiliated to the State Bauhaus as
a training workshop and Dorfner — who remained the proprietor — was made a
'Master of Craft' at the Bauhaus. Even after the affiliation was rescinded in 1922
Dorfner continued to work for the Institute on a commission basis. In 1926 he was
given a professorship at the *Staatliche Bauhochschule*. Thanks both to its technical
and its pedagogical achievements Dorfner's private 'industrial bookbinding shop'
acquired an international reputation.
Literature: Wolfgang Eckhardt, 'Otto Dorfner', Stuttgart 1960.

THE ARTISTS WHO CONTRIBUTED TO THE PORTFOLIOS

ALBERS, JOSEF (Cover Design V)
Born 19 March 1888 in Bottrop (Westphalia), now living in New Haven (Con-
necticut). Studied at the Royal School of Art in Berlin (1913–15), the Industrial
School of Art in Essen (1916–19), the Art Academy in Munich (1919–20) and the
State Bauhaus in Weimar (1920–23). In 1923 Albers was placed in charge of the
technical side of the glasspainting shop and asked to teach workshop practice in
the introductory course. In Dessau the *Jungmeister* (probationary master) was
made a fully fledged member of the teaching staff and continued with his teaching
activities. Then in 1928, when Moholy-Nagy left the Institute, he was put in charge
of the whole of the introductory course. From 1928 to 1929 he also took over the
furniture shop, which had previously been run by Breuer. He remained with the
Bauhaus until the very end, which came in Berlin in 1933. Albers's achievement was
essentially a pedagogic one; the teaching methods which he evolved later enabled
him to exercise a world-wide influence. But during his Bauhaus period he also made
a distinctive contribution in glasspainting and in the design of furniture and scripts.
In 1933 he was invited to join the staff of Black Mountain College in North Carolina,
where he remained until 1949; during these sixteen years he also gave summer
courses at Harvard University. From 1949 to 1950 he was visiting lecturer at the
Cincinnati Art Academy, Yale University, and the Pratt Institute in New York. In
1950 he was given a chair at Yale and appointed head of the faculty of fine arts.
During the following ten years he further extended and refined his teaching methods
and began a series of systematic investigations of colour interactions, which he
also pursued after his retirement in 1960.
Literature: François Bucher, 'Trotz der Geraden' (The Defiance of the Stalwart),
Berne 1961 (with a bibliography). Josef Albers, 'Interaction of Color', New Haven
1963. 31

ARCHIPENKO, ALEXANDER (Lithograph IV/1)

Born 30 May 1887 in Kiev, died 25 February 1964 in New York. Studied from 1902 to 1905 in Kiev, then in Moscow. In 1908 he went to Paris, where he attended the Ecole des Beaux-Arts. His first plastic works were produced in 1903. From 1913 onwards he was associated with Herwarth Walden's *Sturm* and exhibited in Walden's Berlin gallery. From 1920 to 1923 Archipenko had his own school of sculpture in Berlin. In 1923 he emigrated to the United States, where he worked in New York, Chicago, Washington, and Kansas City. He was active as a teacher and for a while ran the sculpture classes in Moholy-Nagy's 'New Bauhaus' and 'School of Design' but, above all, he emerged as an *avant-garde* sculptor. Although increasingly given to decorative and elegant effects, his chief concern was to abstract the principles of cubism and apply them to sculpture.

Literature: Erich Wiese, 'Alexander Archipenko', Leipzig 1923. For bibliography see Vollmer, Vol.1, Leipzig 1953.

BAUER, RUDOLF (Lithograph III/1)

Born 11 February 1889 in Lindenwald, died 28 November 1953 in Deal (New Jersey). Bauer studied in Berlin, where he joined the circle centred on Walden's *Sturm*. Beginning with impressionism he went through the whole cycle of modern painting, progressing via expressionism and cubism to abstract art. In 1929 he founded his own museum of non-objective art, which he called *'Geistreich'* (literally 'rich in intellect', by extension 'intelligent', 'clever', 'witty'). After emigrating to the United States he exercised a powerful influence (through Hilla von Rebay) on the basic thinking of the 'Museum of Non-objective Art' (Guggenheim Foundation) in New York, which acquired many of his pictures.

Literature: Solomon R. Guggenheim Collection (Eds.), 'Art of Tomorrow', New York 1939. For further bibliography see Vollmer, Vol.1, Leipzig 1953.

BAUMEISTER, WILLI (Lithograph III/2)

Born 22 January 1889, died 31 August 1955, in Stuttgart. Began as painter's apprentice, attended the Stuttgart Academy as a *Gasthörer* (unqualified student allowed to attend lectures but banned from discussions) and made contact with Hölzel's circle. In 1912 he made his first visit to Paris and had an exhibition in Zürich and in 1913 he took part in the 'First German Autumn Salon' in Berlin. In 1914 he was again in Paris, this time with Schlemmer. Baumeister's style, which derived ultimately from Cézanne, was compounded of cubist and constructivist elements; his 'wall pictures', which were painted after the first world war, are typical. From the 1920's onwards he was in contact with Léger. In 1928 he was given a professorship at the Frankfurt School of Art; in 1930 he became a member of the *Cercle et Carré* and in 1932 of the *Abstraction-Création* groups. In 1933 he was removed from his post and left Frankfurt to return to Stuttgart. Between 1939 and 1944 he carried out experiments in Herberts' paint factory in Wuppertal. From 1946 onwards he was a Professor at the Stuttgart Academy. Thanks to his moral and artistic integrity Baumeister, the 'degenerate artist', developed into a man of immense stature during the period of Nazi defamation.

Literature: Will Grohmann: 'Willi Baumeister, Leben und Werk' (Life and Work), Cologne 1963 (with a bibliography). Heinz Spielmann, 'Willi Baumeister, das

graphische Werk' (Willi Baumeister: Graphic Works) published in the *Jahrbuch der Hamburger Kunstsammlungen* (Annual of Hamburg Art Collections), Vols.8, 10 and 11, 1963, 1965, and 1966.

BECKMANN, MAX (Etching V/1)
Born 12 February 1884 in Leipzig, died 27 December 1950 in New York. Studied painting in Weimar from 1899 to 1903; visited Paris 1903–4 and 1908. 1906 exhibition with the Berlin Secession, which he joined in 1908, two years after settling in Berlin. At this time Beckmann's work was basically impressionist, although it did reveal traces of Munch's influence. In 1911 he left the Berlin Secession and in 1914 and 1915 served on the Western front as a medical orderly. In trying to come to terms with his devastating wartime experiences Beckmann turned to expressionism. In 1915 he went to live in Frankfurt/Main, where he remained until 1933, working first as a freelance artist and then, from 1925 onwards, as a teacher at the Frankfurt School of Art. From 1928 he paid frequent visits to Paris. In 1933 he accepted an appointment at the Berlin School of Art but was dismissed almost immediately by the new regime. In 1937 he was in Paris and from 1938 to 1947 in Amsterdam. During the final period of his life he tried to establish himself in America, where he gave painting classes at the University of St Louis and, from 1949 to 1950, at the Brooklyn Museum in New York. In 1950 he received the Carnegie prize and also a prize at the Venice Biennale. Beckmann's large triptychs on mythological themes are the crowning achievement of his extremely expressive work, which includes some quite outstanding prints; his etchings are particularly fine.
Literature: Benno Reifenberg and Wilhelm Hausenstein, 'Max Beckmann', Feldafing 1959 (with a bibliography). C. Glaser, J. Meier-Graefe, W. Fraenger and W. Hausenstein, 'Max Beckmann', Munich 1924 (with a catalogue of Beckmann's graphic works). Catalogues of the Beckmann exhibitions staged by the Badischer Kunstverein in Karlsruhe in 1962 and 1963. Stephan Lackner, 'Ich erinnere mich gut an Max Beckmann' (I well remember Max Beckmann), Mainz 1967 (with reproductions of thirteen prints).

BOCCIONI, UMBERTO (Lithograph IV/2)
Born 19 October 1882 in Reggio-Calabria, died 16 August 1916 in Verona. Boccioni was a self-taught painter. In 1889 he went to live in Rome, where he met Giacomo Balla, who converted him into an enthusiastic neo-impressionist. He also became friendly with Severini. Between 1902 and 1904 he was in Paris and Berlin, from 1907 onwards in Milan. In 1909 he met the poet Marinetti and in 1910 put his name to the first futurist manifesto. Later the same year he published his *Manifesto tecnico della scultura futuristica* (Manifesto of the Technics of Futuristic Painting). In 1911 he came into contact with Apollinaire and the cubists in Paris and in 1912 took part in the futurist exhibition mounted by the *Sturm* in Berlin. In 1913 there was an exhibition of his sculpture in Paris. Two years later he volunteered for war service and was killed when he fell from his horse in August 1916. Boccioni contributed both as a thinker and as an artist to the realization of futurism; in his sculptures he successfully represented 'universal dynamism' as 'dynamic sensation', which was the fundamental tenet of the movement.
Literature: Giulio Carlo Argan, 'Umberto Boccioni', Rome 1953. 33

BURCHARTZ, MAX (Lithograph V/2)

Born 28 July 1887 in Elberfeld, died 31 January 1961 in Essen. Studied in Düsseldorf, Munich, and Berlin from 1906 to 1908. Visited Paris in 1910. After the first world war he lived first in Hanover and then in Weimar. The contacts which he established with Schwitters and El Lissitzky in Hanover and with van Doesburg, Klee and Kandinsky in Weimar were important for his future development. In 1926 he was invited to join the staff of the Folkwangschule in Essen, where he remained until his dismissal in 1933 and to which he returned in 1949. Burchartz also worked as an industrial designer. But he is best known for his later writings, in which he elaborated on ideas first conceived in the 1920's.

Literature: Max Burchartz, 'Selbstbiographisches' (About my Life), published in 'Deutsche Graphik des Westens' (Graphic Work in West Germany), edited by H. von Wedderkop, Weimar 1922. 'Gleichnis der Harmonie' (Similitude of Harmony) Munich 1949. 'Gestaltungslehre' (Theory of Formative Art), Munich 1953. 'Schule des Schauens' (School of Perception), Munich 1962.

CAMPENDONK, HEINRICH (Woodcut III/3)

Born 3 November 1889 in Krefeld, died 9 May 1957 in Amsterdam. Attended the Industrial School of Art in Krefeld from 1905 to 1909; studied under Thorn-Prikker. Campendonk then acquired practical experience as a painter's apprentice in Osnabrück. In 1911 Franz Marc invited him to come to live in Sindelsdorf (Upper Bavaria), where he met Kandinsky, Klee, Jawlensky, and other artists; in December 1911 he took part in the Munich exhibition of the *blaue Reiter* and in 1913 in Walden's 'First German Autumn Salon'. From 1914 to 1916 Campendonk served with the forces, then went to live at Seeshaupt (Starnberger See). In 1922 he worked as a scenic designer in Krefeld, in 1923 he joined the staff of the Industrial School of Art in Essen and then transferred to the State Academy of Art in Düsseldorf in 1926, where he taught until his dismissal in 1933. Campendonk then emigrated and spent the whole of 1934 in Belgium, moving to Amsterdam in 1935 to teach at the 'Rijksakademie van beeldende Kunsten'. While he was being pilloried in Germany as a 'degenerate artist' he received important commissions and high honours abroad: at the International Exhibition held in Paris in 1937 he was awarded a Grand Prix. From 1946 onwards Campendonk again executed commissions in Germany and his stained glass windows in Münster, Düsseldorf, and Bonn date from this late period of his life. Strong colours and a preference for fairy-tale motifs are distinctive features of his work.

Literature: G. Biermann, 'Heinrich Campendonk', Leipzig 1921. Wilhelm Mayer, 'Heinrich Campendonk', published in *Deutsche Graphik des Westens* (edited by H. von Wedderkop), Weimar 1922. Mathias T. Engels, 'Heinrich Campendonk', Recklinghausen 1958.

CARRÀ, CARLO (Lithograph IV/3)

Born 11 February 1881 in Quargnento (Piedmont), lived in Milan, died 13 April 1966 in Rome. Started life as a scene painter, then spent a brief period as a student at the Brera in Milan. Visited Paris and London in 1900. In 1909 came the crucial meeting with Marinetti and Boccioni, as a result of which Carrà put his name to the 'Manifesto of Futuristic Painting' issued in 1910. In the following year he went to Paris,

where he came into contact with Apollinaire and the cubists. In 1915 he adopted an archaistic form of painting which culminated 'in the *Pittura metafisica* when he met de Chirico in Ferrara in 1917 and then, from 1919, led on to a kind of "archaic realism" based on Masaccio' (Haftmann). When he became a teacher at the Milan Academy Carrà was able to extend his sphere of influence. He also published numerous written works.

Literature: Carlo Carrà, 'La mia vita', Milan 1943. G. Pacchioni, 'Carlo Carrà', Milan 1945 (with a bibliography).

CHAGALL, MARC (Etching IV/4)

Born 7 July 1887 (or 1889) in Liosno near Vitebsk, now lives in Vence (France) Began his studies at the Academy in St Petersburg in 1907, then went to Paris in 1910, where he made contact with Apollinaire and his circle. In 1914 Chagall exhibited in Walden's *Sturm* gallery in Berlin before returning to Russia at the outbreak of war. In 1917 he was appointed Commissar for the Fine Arts by the government of Vitebsk; he also founded an art school and in 1919 joined the Jewish Theatre inMoscow. Three years later, in 1922, he moved to Berlin and in 1923 paid a visit to Thuringia. He then went to live in Paris again, where Vollard commissioned him to execute a number of important illustrations. In 1931 he travelled in the Middle East and in 1935 visited Poland. In 1941 he emigrated to the United States, remaining there until 1947, when he returned to Paris before taking up residence in Vence two years later. In 1951 he visited Israel. While still continuing to produce pictures and series of graphic works Chagall turned his hand to ceramics in the later period of his life and also designed a number of stained glass windows.

Literature: Marc Chagall, 'Ma Vie', Paris 1931. J. J. Sweeney, 'Marc Chagall', New York 1946 (with a bibliography). Franz Meyer and Hans Bolliger, 'Marc Chagall Das graphische Werk' (Marc Chagall: Graphic Works), Stuttgart 1957 (fully documented). Franz Meyer, 'Marc Chagall, Leben und Werk' (Marc Chagall, Life and Work), Cologne 1962.

CHIRICO, GIORGIO DE (Lithograph IV/5)

Born 10 July 1888 in Volo (Greece), now living in Rome. Began to train as an engineer but changed over almost immediately to painting, which he studied, first at the Academy in Athens, and then, from 1908 to 1910, at the Academy in Munich. Chirico was a great admirer of Arnold Böcklin and Richard Wagner. From 1911 to 1915 he was in Paris, where he was in touch with Apollinaire, Max Jacob, and Picasso. In 1915 he went to Italy and served in the forces. In 1917 Chirico met Carrà in Ferrara and together they founded the *Pittura Metafisica*, which Chirico had been working towards from about 1910 onwards. In 1919 he joined the *Valori Plastici* group and from then onwards his work revealed a classicistic trend, which became more marked in the course of time but which was always coloured by his romanticising disposition. In 1924 Chirico moved to Paris, where he collaborated with André Breton and the surrealists, taking part in their first exhibition in 1925. He created the *décor* for various theatre productions in Paris in 1926 and for the Kroll Opera in Berlin in 1930. 1929 saw the publication of a phantastic novel. Then, at the beginning of the 1930's, Chirico made a complete break with his past; his late works, most of which were created after his return to Italy in 1938, were in the classical mould.

Literature: Giorgio de Chirico, 'Memorie della mia vita', Rome 1945. J. Faldi, 'Giorgio de Chirico', Venice 1949 (with a bibliography). J. Th. Soby, 'Giorgio de Chirico', New York 1955.

COUBINE, OTHON (OTAKAR) (Etching II/1)
Born 22 October 1883 in Boskovice (Moravia), now lives chiefly in France. Attended the school for sculpture in Hořice from 1898 to 1900, the Prague Academy from 1900 to 1905 and subsequently the Ecole des Beaux-Arts in Paris. Educational journeys to France, Belgium, and Italy before settling in Paris in 1913. After an initial cubist phase Coubine passed on to line work, which was inspired by Ingres and was strangely reminiscent of Renaissance art; this kind of work, in which the artist revealed a preference for female nudes, portraits and pastoral scenes, leant itself particularly well to pastels and etchings. In the 1920's Coubine's fame in Germany — where he was regarded as a member of the Paris school — rested primarily on his graphic work.
Literature: Georg Biermann, 'Coubine', Leipzig 1923. Charles Kunstler, 'O. Coubine', Paris 1929. For bibliography see Vollmer, Vol.1, Leipzig 1953.

DEXEL, WALTER (Woodcut III/4)
Born 7 February 1890 in Munich, now living in Brunswick. Began to study the History of Art in 1909 in Munich, where he acquired his doctorate in 1916. During the last four years of his University course he also attended drawing classes. From 1916 to 1918 he was chairman of the Art Association in Jena and from 1928 onwards taught commercial art in Madgeburg. Thanks largely to his posters and his illuminated signs, which he put up in Jena and Frankfurt/Main, Dexel became a prominent figure in the second half of the 1920's, when he also enjoyed a certain reputation as an exponent of the fine arts. In 1935 he was made a Professor at the Staatliche Hochschule für Kunsterziehung (State College of Art) in Berlin. Since 1942 he has been working on his 'collection of forms', in which he is attempting to document artistic productions from all periods of history. Dexel is one of the best informed authorities in this sphere and has published a considerable number of investigations into the historical development of artistic form.
Literature: Walter Dexel, 'Der Bauhausstil — ein Mythos' (The Bauhaus style — a Myth), published in *Bauhaus: Idee — Form — Zweck — Zeit* (Bauhaus: Idea — Form — Purpose — Time), a catalogue of the 'göppinger galerie', Frankfurt/Main 1964; numerous treatises including 'Das Wohnhaus von heute' (The modern dwelling), Leipzig 1928. Eckhard Neumann, 'Dexel-Typo, ein Beispiel funktioneller Typographie um 1924' (Dexel typography, an example of functional typography c.1924), published in the journal 'Der Druckspiegel', Stuttgart (October) 1962. Catalogue of the Dexel Exhibition in the Municipal Museum, Brunswick 1962, and the Municipal Museum, Treves 1965 (with a short biography).

FEININGER, LYONEL (Cover Design 1; Title Pages I, III, IV, V; Table of
 Contents I, III, IV, V; Colophon I, III, IV, V; Woodcut
 I/1; Woodcut I/2)
36 See under: Artists and Craftsmen in the Printing and Bookbinding Shops.

FISCHER, OSKAR (Lithograph III/5)

Born 4 August 1892 in Karlsruhe, died 3 February 1955 in Berlin-Köpenick. Started life as an apprentice painthand. Attended an Industrial School of Art from 1910 to 1913, then transferred to the Karlsruhe Academy. Military service from 1915 to 1918. After the war Fischer worked chiefly in Karlsruhe and Berlin, where he was backed by Walden's *Sturm* (reproductions printed in the journal, works shown in the 1938 exhibition). He was a member of the *Novembergruppe*. Following the Nazi campaign against 'degenerate art' in 1937 his works were removed from public collections in Germany. Fischer worked in East Berlin after the second world war.
Literature: Catalogue of the exhibition 'Der Sturm' staged by the German National Gallery in the *Orangerie* of *Schloss Charlottenburg* in 1961. For bibliography see Vollmer, Vol.2, Leipzig 1955.

GLEICHMANN, OTTO (Lithograph V/3)

Born 20 August 1887 in Mainz, died 2 November 1963 in Hanover. Studied at the Colleges of Art in Düsseldorf, Breslau and Weimar. Then moved to Hanover. Gleichmann, an expressionist, had a high reputation both as a painter and as a graphic artist. He revealed a preference for figure compositions (e.g. circus scenes) and phantasy landscapes. He had exhibitions in Berlin, Hanover, Paris and various other cities. Flechtheim and Cassirer have both produced portfolios of his works.
Literature: Theodor Däubler, 'Otto Gleichmann', published in *Deutsche Graphik des Westens* (edited by H. von Wedderkop) Weimar 1922. R. Lange, 'Otto Gleichmann', Göttingen and Berlin 1963. For bibliography see Vollmer, Vol.2, Leipzig 1955.

GONTCHAROVA, NATHALIE (Coloured Lithograph IV/6)

Born 4 June 1881 (?) on the Ladogino estate in the district of Tula (Russia), died 18 October 1962 in Paris. Studied art from 1898 at the Academy in Moscow, where she met her husband, Michel Larionov. Between 1900 and 1904 she travelled to England, Spain, Italy and Greece. From about 1910 onwards she came under the influence of Larionov's 'rayonism'. She took part in the second exhibition staged by the *blaue Reiter* in Munich in 1912 and in the 'First German Autumn Salon' in Berlin in 1913. In 1914 she had a joint exhibition with Larionov in Paris, where she then took up residence. Her reputation, which was considerable, was due in no small measure to the *décors* which she created for the Diaghilev Ballet.
Literature: E. Eganburi, 'M. Larionov i N. Gontcharova', Moscow 1913 (Russian text). N. Gontcharova, M. Larionov, and P. Vorms, 'Les Ballets russes', Paris, 1955. Camilla Gray, 'The Great Experiment' (The Russian *avant-garde* in modern art), London 1963 (contains sections on Gontcharova and Larionov and also a bibliography).

GROSZ, GEORGE (Lithograph V/4)

Born 26 July 1893, died 6 July 1959, in Berlin. Studied art for two years in Dresden, then became a caricaturist for satirical magazines (e.g. *Lustige Blätter, Ulk*). Towards the end of the first world war Grosz joined the ranks of the Dadaists. He also drew on futurism, whose influence made itself felt in the composition of his pictures. Grosz's political commitment is immediately apparent in his drawings 37

(illustrations). But he was more than a keen observer of the contemporary scene with a gift for biting satire, for he was able to depict that scene in terms that were intrinsically true. Around about 1925, when he sought contact with the 'New Objectivity', Grosz moderated the style of his drawings. In 1933 he left Berlin to emigrate to New York, which he had visited in the previous year at the invitation of the Art Students' League. In America he taught and in 1937 acquired American nationality; in 1938 he was repudiated in Germany as a 'degenerate artist' and deprived of his citizenship rights. During his late period Grosz concentrated on allegorical paintings. He died shortly after returning to Germany, where he had hoped to spend his old age.

Literature: George Grosz: 'Ein kleines Ja und ein grosses Nein' (A little Yes and a big No), Hamburg 1955. Herbert Bittner (Ed.), 'George Grosz', Cologne 1961 – Catalogue of the George Grosz Exhibition at the Akademie der Künste, Berlin 1962 (with a bibliography). For a more detailed bibliography see Vollmer, Vol.2, Leipzig 1955.

HECKEL, ERICH (Woodcut V/5)

Born 31 July 1883 in Döbeln (Saxony), now living in Hemmenhofen on the Lake of Constance. In 1904, when he was studying architecture in Dresden, he met E. L. Kirchner. He then taught himself painting and in 1905 shared a studio with Kirchner, Bleyl and Schmidt-Rottluff; between them they formed *die Brücke*. From 1907 to 1910 Heckel and his companions lived either in Dresden or in Dangast (Oldenburg). In 1909 he visited Italy and in 1911 moved to Berlin. From 1915 to 1918 he served as a medical orderly in Flanders, where he met James Ensor and Max Beckmann. From the end of 1918 he again lived in Berlin but made educational journeys through Germany, Italy, and France. During the Hitler period his works were proscribed as 'degenerate' and removed from German Museums. Between 1941 and 1943 he lived in Carinthia; then in 1944, when his Berlin studio was destroyed, he settled on Lake Constance. From 1949 to 1955 he held a chair at the Academy of Art in Karlsruhe. Heckel's speciality was the art print; his woodcuts (especially those of his early and middle periods) constituted one of the peaks of expressionist art.

Literature: H. Köhn, 'Erich Heckel', Berlin 1948. Lothar-Günther Buchheim, 'Die Künstlergemeinschaft Brücke' (Die Brücke, a Community of Artists), Feldafing 1956 (contains a chapter on Heckel and a bibliography); 'Erich Heckel – Holzschnitte aus den Jahren 1905–1956' (Erich Heckel – Woodcuts 1905–56), Feldafing 1957. For a more detailed bibliography see Vollmer, Vol.2, Leipzig 1955.

HEEMSKERCK, JACOBA VAN (Linocut III/6)

Born 1 April 1876 at The Hague, died 3 August 1923 in Domburg. Daughter of the painter Jacob Eduard van Heemskerck. Attended the Academy in The Hague from 1897 to 1901 and then, from 1904 onwards, spent some time in Paris, working under E. Carrière. Resident in Domburg from 1908, where Jan Toorop was her artistic adviser. Starting with impressionism she passed through a pointillist phase before turning to expressionism. Jacoba van Heemskerck received the wholehearted support of Herwarth Walden and his wife Nell; in 1913 she was invited to contribute to 'The First German Autumn Salon' and from 1914 to 1920 she had a one-man show in the *Sturm* every year.

Literature: Herwarth Walden (Ed.) and M. T. van Poortvliet, 'Jacoba van Heemskerck', Sturm Bilderbuch 7 (*Sturm* Picture Book 7), Berlin 1924 — Catalogue of the *Sturm* Exhibition staged by the German National Gallery in the *Orangerie* of *Schloss Charlottenburg*, Berlin 1961 (contains quotations from the artist's writings). For bibliography see Vollmer, Vol.2, Leipzig 1955.

HIRSCHFELD (-MACK), LUDWIG (Cover Design IV)
See under: Artists and Craftsmen in the Printing and Bookbinding Shops.

HOETGER, BERNHARD (Lithograph III/7)
Born 4 May 1874 in Hörde (Westphalia), died 18 July 1949 in Interlaken (Switzerland). Studied at the Düsseldorf Academy, then lived chiefly in Paris from 1904 to 1907: impressed by Maillol, established contact with Henri Rousseau and Carl Hofer. In 1907 Hoetger settled in Eberfeld but returned to Paris in 1909, where he met Lehmbruck in the following year. In 1911 he moved to Darmstadt to join the 'Artists' Colony' and created most of the statues for the *Mathildenhöhe*. Between 1914 and 1933 he lived in Worpswede. In 1917 he was commissioned by Bahlsen, the Hanover manufacturer, to design the 'TET' town (factory buildings, church, museum, theatre, playgrounds, etc. on a 40-acre site), which, however, was never built. After 1918 he received numerous large commissions, most of them from Dr Roselius, the Bremen contractor (e.g. Böttcherstrasse). By this time Hoetger was working as a sculptor, an architect, a graphic and an industrial artist and enjoyed considerable success in each of these spheres. He travelled in southern Europe and Egypt and in 1934 built his own house in Frohnau, which was destroyed in 1943. In 1938 Hoetger's artistic works were proscribed by the Nazi regime. In 1944, after the loss of his house, he sought refuge, first in the *Riesengebirge*, then in southern Bavaria. In 1946 he went to live in Beatenberg near Interlaken.
Literature: C. E. Uphoff, 'Bernhard Hoetger', published in *Deutsche Graphik des Westens* (edited by H. von Wedderkop), Weimar 1922 (deals with Hoetger's graphic work). Albert Theile, 'Bernhard Hoetger', Recklinghausen 1960 — Catalogue of the Memorial Exhibition of Hoetger's works held in 1964 in the Böttcherstrasse in Bremen and in the Westphalian Kunstverein in Münster. For bibliography see Vollmer. Vol.2, Leipzig 1955.

ITTEN, JOHANNES (Coloured lithograph I/3; lithograph I/4)
Born 11 November 1888 in Südern-Linden (Bernese Oberland), died 25 March 1967 in Zürich. Started life as a primary school teacher; attended the Ecole des Beaux-Arts in Geneva for a single term; then, after taking a science degree (principal subject mathematics), Itten opted for painting in 1912 following journeys to Munich and Paris, where he had seen works by the *blaue Reiter* and the cubists. His outstanding ability as a teacher of art was developed still further when he met Adolf Hölzel in Stuttgart in 1913. Hölzel also introduced him to Ida Kerkovius, Schlemmer and Baumeister. In 1915 Itten painted his first non-objective pictures and in 1916 had an exhibition in the *Sturm* in Berlin. In the same year he left Stuttgart to live in Vienna, where he remained until 1919 and opened the 'Itten School'. In the course of his teaching activities he discovered 'the importance of automatism in artistic work'. His course on fundamental principles included the study of form, of 39

colour contrasts and of textural compositions. While he was still living in Vienna he established contact with Gropius through the latter's wife, Alma Mahler, and was invited to come to Weimar as a 'Master of Form' in 1919. He accepted and, once there, proceeded to introduce his pedagogic principles, which were soon recognized – both in and beyond the Bauhaus – as essential elements in any course of artistic training. Itten also urged Gropius to invite Muche, Schlemmer, Klee, and Kandinsky to join the Bauhaus staff. But in 1923, because of his somewhat undue insistence on philosophical considerations (at the expense of experimental work), Itten left the Institute. From then until 1926 he worked in Zürich, after which he spent the following eight years in Berlin, where he had his own school. From 1934 to 1938 he was Director of the School of Textile Design in Krefeld. He then left Germany and, after a short stay in Amsterdam, settled in Zürich. There he was appointed Director of the School and Museum of Industrial Art and later – in 1943 – of the School of Textile Design and the Rietberg Museum as well. He relinquished the first two posts in 1953 and the second two in 1960. From 1953 onwards he devoted most of his time to painting and the theory of art.

Literature: Johannes Itten, 'Tagebuch' (Diary), Berlin 1930; 'Kunst der Farbe' (The Art of Colour), Ravensburg 1961. For bibliography see H. M. Wingler, 'Das Bauhaus 1919–1933', Bramsche and Cologne 1962.

JAWLENSKY, ALEXEI VON (Lithograph IV/7)

Born 13 March 1864 in Torzhok in the government of Tver (Russia), died 15 March 1941 in Wiesbaden. Jawlensky went to the Military Academy in Moscow and passed out as an officer but gave up his military career to become a painter. In 1898 he joined the Academy of Art in St Petersburg, where he studied under Ilje Repin. In 1896 he left Moscow for Munich, attended classes at Azbe's school of art and established close contact with Marianne von Werefkin. His acquaintance with Kandinsky also dates from this period. In 1903 he contributed to the exhibition staged by the Munich Secession. In 1905 he visited Brittany and Provence and became interested in Van Gogh, Cézanne, and Matisse. In 1909 he joined with Kandinsky, Erbslöh, Kanoldt, Kubin, Münter, and Werefkin in establishing the 'New Artists' Association'. Those invited to contribute to the Association's exhibitions (in 1909 and 1910) included Derain and Vlaminck, Braque and Picasso. In 1911, when the *blaue Reiter* evolved from the 'New Artists' Association', Jawlensky did not join the new group. When war broke out he went to Switzerland, where he lived on the Lake of Geneva until 1917, then in Zurich (where he associated with Arp, Marie Laurencin, Lehmbruck, and Busoni) and finally, from 1918 to 1921, in Ascona. Following a successful exhibition in Wiesbaden he moved there in 1921 and found both friends and promoters. From 1924 onwards he joined with Feininger, Kandinsky, and Klee to form the *blaue Vier* and the group then staged many successful exhibitions in Europe and even in America. In 1934 he developed progressive arthritis, after which he simplified his compositions, reducing the technical demands to a minimum. For as long as he was able to hold a brush Jawlensky continued to paint the human face in abstract form.

Literature: Clemens Weiler, 'Alexej Jawlensky', Cologne 1959 (includes a catalogue of works).

40

KANDINSKY, WASSILY (Coloured lithograph IV/8)

Born December 1866 in Moscow, died 13 December 1944 in Neuilly-sur-Seine. When he was thirty years old Kandinsky gave up his scientific career to become a painter. From 1897 to 1899 he studied under Azbe in Munich and then for a further year under Stuck. The paintings of his early period were influenced by impressions of Russian folk art and the Munich *Jugendstil*. Kandinsky was accepted as a member by the Berlin Secession, the German *Künstlerbund* and other progressive associations. In 1903 he began to travel and in the course of the next few years visited Tunisia, Italy, and France. Up to the outbreak of war he was based on Munich and Murnau. Together with Jawlensky and others he founded the 'New Artists' Association' in 1909. This was a forerunner of the *blaue Reiter* group which he formed in 1911 with Franz Marc. It was at about this time that Kandinsky painted his first abstracts. In 1912 he issued his prophetic manifesto 'Concerning the Spiritual in Art', and (in concert with Franz Marc) the publication, *Der blaue Reiter*. He was also in close contact with Macke, Klee, Kubin and Delaunay. In 1913 both he and the friends of the *blaue Reiter* exhibited in Walden's 'First German Autumn Salon' in Berlin. During the first world war he was in Moscow, where he became Director of the new State Museum of Painting in 1919 and Professor of Art at Moscow University in 1920. In 1921, when the cultural reaction set in, he left Moscow for Berlin and in the following year was invited to come to Weimar. He accepted and remained with the Bauhaus as a member of the teaching staff until the very end (1922–25 in Weimar, 1925–32 in Dessau, 1932–summer of 1933 in Berlin). He had reached the peak of his powers as a graphic artist when he joined the Bauhaus. As a 'Master of Form' he was responsible for murals in Weimar. His investigations into the problematics of painting, which he dealt with in his book *Punkt und Linie zu Fläche* (Bauhaus publication 1926), were of the utmost significance and greatly benefited his students, especially those taking 'analytic drawing'. From 1926 to 1928 in Dessau he gave a painting class. Then, in 1933, Kandinsky emigrated from Germany, where he had lived for thirty years and taken out citizenship papers, to live in France. During the last eleven years of his life, which he spent outside Paris, he devoted himself entirely to his own works.

Literature : Will Grohmann, 'Wassily Kandinsky', Cologne 1958 (with a bibliography of works by and on Kandinsky) ; 'Kandinsky – Œuvre gravé' (Kandinsky – Engravings), Paris 1954. Peter Anselm Riedl, 'Wassily Kandinsky – Kleine Welten' (Little Worlds), Stuttgart 1962.

KIRCHNER, ERNST LUDWIG (Woodcut V/6)

Born 6 May 1880 in Aschaffenburg, died 15 June 1938 near Frauenkirch (Switzerland). Kirchner started to paint at an early age but then, in 1901, embarked on a four-year course of architecture at the Technical College in Dresden, where he met Fritz Bleyl in 1902, Erich Heckel in 1904, and Karl Schmidt-Rottluff in 1905. He interrupted his studies for two terms in 1903/4 in order to attend the School of Art run by Debschitz and Obrist in Munich and gave up architecture entirely in 1905 when he and his companions founded *die Brücke*. These three young artists shared a studio and worked in a style which was both hectic and exalted. In the summer months of 1907, 1908, and 1909 Kirchner went to the *Moritzburger Seen* in order to paint in the open air. In 1911 he moved to Berlin, where he entered into a loose 41

association with the *Sturm.* Together with Pechstein he then founded the 'Muim Institute' and in 1912 he and Heckel created murals for the *Sonderbund* exhibition in Cologne. In 1913 the *Brücke* was dissolved. In 1915 Kirchner joined the forces and served in Halle (Saale), but in the following year suffered a mental and physical breakdown, which required sanatorium treatment in Königstein (Taunus) and in Switzerland. From 1917 onwards he lived near Davos and in 1923 settled near Frauenkirch in the Sertig valley. From 1927 to 1934 Kirchner was designing murals for the Folkwang Museum in Essen only to have the commissions withdrawn when Hitler came to power. In 1931 he was elected to the Prussian Academy and in 1933 had a large retrospective exhibition in Berne. Schlemmer visited him and later he made contact with Klee. In 1937 he had an exhibition in Detroit. But in Germany he was deprived of his membership of the Prussian Academy and 639 of his works, which were in public ownership, were confiscated by the state. In despair, and racked with pain, Kirchner committed suicide.

Literature: Will Grohmann, 'Ernst Ludwig Kirchner', Stuttgart 1958 (with an extensive bibliography). Gustav Schiefler, 'Die Graphik Ernst Ludwig Kirchners' (Graphic Works by Ernst Ludwig Kirchner), Vol.1 (up to 1916), Berlin-Charlottenburg 1931. Annemarie Heymig, 'Ernst Ludwig Kirchner, Graphik' (Ernst Ludwig Kirchner: Graphic Works), Munich 1961.

KLEE, PAUL (Cover Design III; Coloured Lithograph I/5;
 Coloured Lithograph I/6)
See under: Artists and Craftsmen in the Printing and Bookbinding Shops.

KOKOSCHKA, OSKAR (Lithograph V/7)
Born 1 March 1886 in Pöchlarn on the Danube (Austria), now living in Villeneuve on the Lake of Geneva (Switzerland). Kokoschka matured at an early age and had already developed his distinctive personality during his student days at the Industrial School of Art in Vienna; in 1908 he went over to expressionism and then discovered the medium which he was to make his own: the psychological portrait. Drawing on the symbolic force of gesture and mime he sought to lay bare the psychic and instinctual life of his models in paintings, in which the purity of the line was accentuated by the highly individual brushwork, for Kokoschka used his brush almost as if it were a pencil (cf. portrait of Auguste Forel, 1910). In the plays and prose works which he wrote at this time (cf. 'Mörder Hoffnung der Frauen' [Murderer Hope of Women] and 'Der gefesselte Columbus' [The Chained Columbus]) he contributed to the development of important new literary techniques, breaking up the syntax and isolating individual words in order to establish a more direct and more ecstatic mode of expression. In this early period he also created large series of graphic works, some of which were conceived as illustrations. Kokoschka's second period began in 1917 when he moved to Dresden, where he was made a Professor at the Academy of Art in 1919. From 1924 to 1931 he travelled in Europe, Africa, and the Near East. After a short phase, in which he moved towards the contrast painting practised by the artists of North Germany, he returned to the palette of the impressionists, which remained the basic feature of his style even in his late period, when he concentrated more on land- and town-scapes (Venice, London, Prague).
42 Most of these works were painted from a bird's-eye view. Both in Prague (1934 to

1938) and especially in England (1938 to 1953) he worked on allegorical compositions, which reveal his militant humanism. In 1947 Kokoschka became a British citizen. In 1953 he moved to Villeneuve and from then until 1963 ran summer courses in Salzburg (Schule des Sehens [School of Perception]). He toured America on several occasions. Between 1961 and 1964, inspired by his experiences of Greece and the ancient world, he created various series of lithographs on Greek themes. These include his 'Hellas' and 'The Return of Odysseus'.

Literature: Hans Maria Wingler, 'Oskar Kokoschka – Das Werk des Malers' (Oskar Kokoschka – The Painter's Work), Salzburg 1956 (with a comprehensive bibliography); 'Oskar Kokoschka. Sein Leben, sein Werk' (Oskar Kokoschka. His Life and Works), Mainz 1968; 'Oskar Kokoschka – Das graphische Werk' (Oskar Kokoschka – Graphic Works), to be published shortly. Ernst Rathenau, 'Der Zeichner Kokoschka' (Kokoschka the Draughtsman), New York 1961 and 1966. J. P. Hodin (Ed.), 'Bekenntnis zu Kokoschka' (Acknowledgement of Kokoschka), Berlin and Mainz. 1963. Oskar Kokoschka, 'Schriften' (Writings), Frankfurt/Main and Hamburg 1964.

KUBIN, ALFRED (Lithograph V/8)

Born 10 April 1877 in Leitmeritz (Bohemia), died 20 August 1959 at the castle of Zwickledt near Wernstein (Upper Austria). Kubin's nervous condition made the choice of a career difficult and he was eventually trained as a photographer by relatives. In 1896 he joined the forces but had a nervous breakdown after only a few weeks' service. In 1898 he attended the Academy in Munich for a short while. He was influenced by Ensor, Klinger, Munch, Redon, Rops, and the old masters. He studied in Vienna and – in 1905 – in Paris. In 1906 he bought the estate of Zwickledt and made it his permanent residence. In 1907 he visited Dalmatia, in 1909 he travelled in the Balkans and returned there on repeated occasions after the war. From 1910 onwards he was in contact with Kandinsky and Marc and collaborated with the *blaue Reiter*. In 1913 he exhibited drawings at the 'First German Autumn Salon' in Berlin. In later life Kubin received many honours. He also illustrated numerous books and made several thousand drawings. By contrast, the number of his graphic works is relatively small: 162 lithographs and four trial etchings. His novel *Die andere Seite* (The Other Side), which was published in 1909, is a significant work and exercised a powerful influence on the artistic *avant-garde* of his day. Kubin opened up a dream world; he groped his way through the border lands of perceptible reality, where he focused his gaze on the macabre and the abstruse. He also had an exceptional gift for expressing the significant aspects of a subject with just a few strokes of his pencil.

Literature: Wolfgang Schneditz, 'Alfred Kubin', Vienna 1956. Paul Raabe (Edited by Kurt Otte, Kubin Archives) 'Alfred Kubin – Leben, Werk, Wirkung' (Alfred Kubin – Life, Works, Influence), Hamburg 1957 (with a catalogue of works and a detailed bibliography).

LARIONOV, MICHEL (Coloured lithograph IV/9)

Born 4 June 1881 in Piraspol in the government of Cherson (Russia), lived in Paris, died 10 May 1964 in Fontenay-aux-Roses. From 1891 onwards he studied painting and architecture in Moscow and in 1898 attended lectures at the Moscow Academy, where he met Natalie Gontcharova, his future wife. In 1906 he visited London, 43

where Turner's paintings made a deep impression on him. After returning to Moscow he founded the *Vjenok* group in 1907, the *Dubnovij Valett* group in 1910 and the *Osslinij Kvost* association in 1911. Larionov started as an impressionist, passed through an abstract phase and then arrived at 'rayonism' in 1910, three years before he published its manifesto (Moscow 1913). Just as cubism had reduced reality to stereometric forms, so rayonism reduced it to straight lines and bands. In 1912 Larionov contributed to the second exhibition of the *blaue Reiter* in Munich and in 1913 to the 'First German Autumn Salon' in Berlin. At the same time he made arrangements for programmatic exhibitions in Moscow. In 1914 he and Gontcharova had a joint exhibition in Paris, which met with Apollinaire's enthusiastic approval. Subsequently Larionov left Moscow, going first to Lausanne and then to Paris, where he painted a number of important pictures and also designed stage sets for Dhiagilev.

Literature: Waldemar Georges, 'Larionov', Paris 1966, Lucerne and Frankfurt/Main 1968.

For further information see under Gontcharova.

LÉGER, FERNAND (Lithograph II/4)

Born 4 February 1881 in Argentan (Orne), died 17 August 1955 in Gif-sur-Yvette near Paris. In 1897 Léger started work as a draughtsman for an architect in Caen. In 1900 he moved to Paris, where he studied, first at private schools and then, from 1903 to 1904, at the Ecole des Beaux-Arts. In 1905 he established himself in 'La Ruche', a primitive studio block, where Chagall, Archipenko, and Modigliani also took studios at a later date. Léger came to terms with the impressionists, the neo-impressionists, Cézanne, and the Fauves one after the other. He also made contact with Picasso, Braque, and Apollinaire. In 1910 and 1911 he collaborated with the cubists in the *Salon des Indépendants.* In 1911 he also became a founder-member of the *Section d'or* group (together with Jacques Villon and others). He remained a member of this group throughout 1912 and exhibited with it in the autumn of that year. In 1913 nine of his paintings and six of his drawings were exhibited in the 'First German Autumn Salon'. In 1917, after his return from the war, Léger entered upon his mechanistic period and became the principal representative of 'mechanistic romanticism'. In the early 1920's he designed stage sets for the Swedish ballet in Paris and in 1924 made a film called *Ballet mécanique* (which was important for its experimental work in trick photography). In conjunction with Ozenfant, Léger also opened a private school of painting. In 1937 he designed a mural for the International Exhibition. From 1931 onwards he had travelled extensively and from 1940 to 1945 he lived in the U.S.A. His late works include a mosaic in the church in Assy and a stained glass window in Audincourt (1951). After his death a *Musée Léger* was opened in Biot.

Literature: E. Tériade, 'Fernand Léger', Paris 1928. P. Descargues, 'Fernand Léger', Paris 1955. For full bibliography see Vollmer, Vol.3, Leipzig, 1956.

MACKE, AUGUST (Linoleum Cut III/8)

Born 3 January 1887 in Meschede (Sauerland), killed on active service 26 September 1914 near Perthes-les-Hurlus (Champagne). From 1904 to 1906 Macke studied at the Düsseldorf Academy and visited Italy, Holland, Belgium, and England. In 1907

he stayed in Paris, where he saw paintings by the Fauves. From the winter of 1907 to 1908 he studied under Lovis Corinth in Berlin. In 1908 he revisited Paris and Italy. Then came a year's military service, which was immediately followed by a further visit to Paris. In 1909 Macke married and settled in Bonn, but moved in the following year to the *Tegernsee*. Franz Marc then introduced him to Kandinsky and Jawlensky and put him in touch with the 'New Artists' Association' in Munich, where he soon established himself as one of the most powerful painters in the group. In 1911 Macke was with Moilliet in Thun and with Marc in Sindelsdorf. He took part in the two exhibitions staged bv the *blaue Reiter* in 1911 and 1912 and also contributed to the *Sonderbund* exhibition in Cologne in 1912 and the 'First German Autumn Salon' in 1913. It seems that he was also one of Walden's principal advisers on the planning of the Berlin exhibition. Together with Marc he visited Delaunay in Paris. The Frenchman's colourism had a delayed effect on Macke, which is to be seen in the works which he created on the *Thuner See* in 1913 and 1914 (when he was staying with Moilliet) and in Tunis in the spring of 1914 (when he was travelling with Moilliet and Klee). By the time he joined the forces in 1914 Macke had painted nearly 600 canvases.

Literature: Gustav Vriesan, 'August Macke', Stuttgart 1953 (with a catalogue of works and a bibliography). August Macke, 'Die Tunisreise' (Journey to Tunis), Cologne 1958. Günter Busch, 'August Macke, Handzeichnungen' (August Macke, Drawings), Mainz 1966.

MARC, FRANZ (Woodcut III/9)

Born 8 February 1880 in Munich, killed on active service 4 March 1916 at Verdun. Marc studied at the Munich Academy of Art from 1900 onwards. In 1902 he visited Italy and in 1903 Paris and Brittany. In 1904 he began working as an independent artist in Upper Bavaria. In 1905 came the important meeting with Jean Bloé Niestlé, the animal painter, and in 1906 a visit to Greece (Mt Athos). In 1907 Marc visited Paris — where he came to appreciate the works of van Gogh — and Berlin. In 1910 he met Macke and Kandinsky in Munich and moved to Sindelsdorf. In 1911 he joined the 'New Artists' Association' in Munich and subsequently became a founder-member of the *blaue Reiter*. In conjuction with Kandinsky he prepared the 1911 and 1912 exhibitions of the *blaue Reiter* and also helped bring out their manifesto. He was in contact with Delaunay in Paris in 1912 and later corresponded with him; Marc gave considerable thought to the insights which Delaunay had gained into the nature of colour. In 1913 he advised Walden on the organization of the 'First German Autumn Salon', in which he also exhibited. In 1914 he moved to Ried in Upper Bavaria and, when war broke out, volunteered for active service. Apart from his artistic works Marc bequeathed his aphorisms and letters, from which it would seem that the fusion of artistic ideas and philosophical speculations was probably more pronounced with him than with any other important artist of his generation.

Literature: Franz Marc, 'Briefe, Aufzeichnungen und Aphorismen' (Letters, Papers and Aphorisms), Berlin 1920. Alois Schardt, 'Franz Marc', Berlin 1936 (with a catalogue of works and a bibliography). Klaus Lankheit, 'Franz Marc', Berlin 1950; 'Franz Marc im Urteil seiner Zeit' (Franz Marc as seen by his Contemporaries) Cologne 1960.

MARCKS, GERHARD (Woodcut I/7 ; Woodcut I/8)

Born 18 February 1889 in Berlin, now living in Cologne. Marcks studied from 1907 onwards under Richard Scheibe (who was then still a painter) and the sculptors Gaul and Kolbe. He established contact with Gropius before the first world war : at the *Werkbund* exhibition in Cologne he and Scheibe provided a number of terracotta reliefs for the decoration of the vestibule, which Gropius had designed. Together with Feininger and Itten he was invited to join the Bauhaus as a 'Master of Form' in 1919, i.e. at the very outset, and was made artistic director of the pottery. This was set up in Dornburg on the Saale, a small town some 30 kilometers from Weimar, which had long been a pottery centre. Marcks received many stimulating ideas from this traditional craft and also from the sphere of folklore in general. As a sculptor he sought a modern equivalent to the strictly disciplined compositions of the ancients. But the severity and force, the discipline and expressive mobility, which relieved and complemented each other in his sculptures, also informed the woodcuts which he made in this early period (e.g. his 'Song of Wayland'). Marcks did not accompany the Bauhaus to Dessau. In 1925 he obtained a teaching post at the School of Art in Burg Giebichenstein near Halle (Saale) and in 1928 was made Director of the school. In 1933, when he was dismissed, he withdrew to Ahrenshoop on the Baltic ; as a 'degenerate' artist he was not allowed to participate in cultural activities. In 1946 he was offered a post as a Professor at the State School of Art in Hamburg and taught there until 1950, when he retired and moved to Cologne. Marcks travelled extensively and was a prominent figure at international competitions and exhibitions, especially in his later years.

Literature : Klaus Leonhardi, 'Gerhard Marcks – Arbeiten geistlichen Inhalts' (Gerhard Marcks – Works of Spiritual Import), Hamburg 1949. Günter Busch, 'Gerhard Marcks', Recklinghausen 1959. For a full bibliography see Vollmer, Vol.3, Leipzig 1956. A catalogue of Marcks's prints is being prepared by Rudolf Hoffmann, Hamburg.

MARCOUSSIS, LOUIS (Etching II/2)

Born (as Louis Markus) 14 November 1883 in Warsaw, died 22 October 1941 in Cusset (France). Marcoussis gave up his law studies in order to become a painter. He first attended the School of Art in Krakow and then, in 1903, went to Paris to complete his training, working in Jules Lefebvre's studio for a period of three months (Académie Julian). In 1907 he threw off the impressionist influences, which had been the dominant feature of his work until then, and joined the cubists, exhibiting with them in the *Salon des Indépendants;* in 1912 he associated himself with the *Section d'or* and in 1913 contributed to the 'First German Autumn Salon' in Berlin. From 1923 onwards he exhibited in the *Salon des Tuileries*. Marcoussis travelled extensively in central and southern Europe, north Africa and – in 1933 – North America. His output included both paintings and graphic works and his lyrical talent was best suited to still-life-type compositions.

Literature : J. Lafranchis, 'Marcoussis, sa vie, son œuvre' (Marcoussis, his Life and Works), Paris 1961 (with a catalogue of works and a bibliography).

MENSE, CARL(O) (Lithograph V/9)

46 Born 13 May 1886 in Rheine (Westphalia), died 11 August 1965 in Honnef on

the Rhine. Mense attended the Academy of Art in Düsseldorf from 1905 to 1908, then studied under Lovis Corinth in Berlin in 1909. In 1911 he became a member of the Rhenish Secession in Cologne and contributed to the exhibition staged there by the *Sonderbund* in the following year. In 1913 he exhibited in the 'First German Autumn Salon' in Berlin. In 1914 he visited Ascona. In 1918 he joined the *Novembergruppe* and in 1922 exhibited with the *Valori Plastici* in Milan. In 1923 he visited Hungary and Italy and from then onwards his work was associated more and more with the movement which G. F. Hartlaub called the 'New Objectivity'. In 1925 Mense was made a Professor at the Art Academy in Breslau and remained there until 1932. In 1933 he was awarded the *Prix de Rome*. Then, in 1937, all works of his in public museums and galleries in Germany were confiscated by the state. In 1945 he settled in Honnef. Mense's work, which has enjoyed a revival of recent years, includes paintings, water-colours, drawings, and a considerable number of prints. His favourite graphic medium was the linoleum cut.

Literature: Hugo Zeder, 'Carl Mense', published in *Deutsche Graphik des Westens* (edited by H. von Wedderkop, Weimar 1922). K. F. Ertel, 'Carlo Mense — Eine Monographie', Ringenberg 1960. Catalogue of the Mense exhibition in the Falken-hof Museum, Rheine (Westphalia) 1961 (with a bibliography). For further bibliography see Vollmer, Vol.3, Leipzig 1956.

MOLZAHN, JOHANNES (Woodcut III/10)

Born 21 May 1892 in Duisburg, died 31 December 1965 in Munich. Molzahn was a self-taught painter. From 1909 to 1914 he lived in Switzerland and from 1915 to 1917 served with the German forces. In 1918 he moved to Weimar, where he established friendly relations with the masters of the Bauhaus. At this time he exhibited in the *Sturm* in Berlin and also joined the *Novembergruppe*. In 1920 he moved to Soest. In 1923 he was asked to teach at the Industrial School of Art in Magdeburg and in 1928 was made a Professor at the Breslau Academy, where he remained until his dismissal in 1933. From then until 1938 he lived in Berlin and then emigrated to the United States. There he taught at the University of Seattle and at Moholy-Nagy's 'School of Design' before settling in New York. In 1959 he returned to Germany. Molzahn began to paint abstracts at a remarkably early stage in his career, but subsequently incorporated more and more surrealist trends into his work.

Literature: Catalogues of the Molzahn exhibitions in the State Museum of the Province of Hesse in Darmstadt in 1956 and in the Wilhelm Lehmbruck Museum in Duisburg in 1964. For bibliography see Vollmer, Vol.3, Leipzig 1956.

MUCHE, GEORG (Etching I/9; Etching I/10)

Born 8 May 1895 in Querfurt, now living in Lindau-Bad Schachen on the Lake of Constance. Muche spent his childhood and youth in the western part of the Hessian mountains. His father was a weekend artist. From 1913 to 1915 he studied painting in Munich and in Berlin, where he established contact with Herwarth Walden. From 1916 onwards Muche exhibited in the *Sturm*, sometimes on his own, some-times jointly (with Max Ernst, Paul Klee, and Archipenko). From 1917 to 1920, when he was asked to join the Bauhaus, he taught at the *Sturm*'s School of Art. At the Bauhaus in Weimar and, subsequently, in Dessau he was a 'Master of Form' 47

and artistic director of the weaving shop. During the Weimar period he also gave some of the classes on basic principles (in which he followed Itten's theories). In 1924 he made an educational visit to America and in 1927 left the Bauhaus to join Itten's private School of Art in Berlin. In 1931 the Breslau Academy offered him a post as a Professor, which he held until his dismissal in 1933. He then returned to Berlin, where he studied fresco techniques. In 1942 he worked with Schlemmer and Baumeister at the 'Institut für Malstoffkunde' (Institute for Research into paint) in Dr Herberts' paint factory in Wuppertal-Elberfeld. In 1939 he had already been appointed head of the 'master' class for textile design at the School for Textile Engineers in Krefeld, a post which he held until his retirement in 1959. Although he was one of the first German abstract painters, following his Weimar period Muche turned back to objective art. He also worked as an architect (Show house at the Weimar Bauhaus, Steel house in Dessau-Törten) and as an art theorist (especially in later years).

Literature: Georg Muche, 'Buon Fresko — Briefe aus Italian über Handwerk und Stil der echten Freskomalerei' (Buon Fresco — Letters from Italy on the Craftsmanship and Style of Genuine Fresco Painting), Berlin 1938; 'Bilder — Fresken — Zeichnungen' (Pictures — Frescoes — Drawings), Tübingen 1950; 'Blickpunkt Sturm, Dada, Bauhaus, Gegenwart' (Viewpoint: *Sturm*, Dada, Bauhaus, Present Day), Munich 1961. Horst Richter, 'Georg Muche', Recklinghausen 1960. For bibliography see Vollmer, Vol.3, Leipzig 1956.

PECHSTEIN, MAX (Woodcut V/10)
Born 31 December 1881 in Zwickau, died 29 June 1955 in Berlin. Pechstein received a thorough grounding in painting as an apprentice before attending the Industrial School of Art in Dresden in 1900. He subsequently transferred to the Dresden academy, where he completed his training. In 1906 he met the members of *die Brücke* and joined their association. In 1907 he visited Italy, where he received the *Prix de Rome*, and Paris. In 1908 he moved to Berlin. When his pictures were rejected by the exhibition jury of the Berlin Secession in 1910 he helped found the 'New Secession' and became its first chairman. In 1911 he revisited Italy and from 1911 to 1912 collaborated with Kirchner at the short-lived Muim Institute, which they had founded (MUIM—Moderner Unterricht im Malen—Modern Training in Painting). In 1912 he left the *Brücke* Association. Between 1913 and 1914 he made a voyage to the Pacific and stayed on the Palau islands. At the outbreak of war he was interned by the Japanese but managed to escape and returned to Germany, where he served in the forces from 1916 to 1918. From 1919 onwards he again lived in Berlin, where he became a founder-member of the *Novembergruppe*. In the 1920's he made various journeys through central and southern Europe. In 1923 he became a member of the Prussian *Akademie der Künste,* but was deprived of his membership in 1933. After Hitler came to power Pechstein was forbidden to exhibit and his 'degenerate' works were removed from public museums and galleries in Germany. He retired to the fishing village of Leba in Pomerania, where he remained until 1945, when the *Hochschule für bildende Künste* (College of Fine Arts) in Berlin offered him a teaching post as Professor of Art. In his youth Pechstein was one of the most determined exponents of expressionism and was regarded by many as a painter of great natural talent, but after the

first world war he turned more and more towards a modified form of academic painting, in which he pursued purely decorative effects.

Literature: Max Osborn, 'Max Pechstein', Berlin 1922. Paul Fechter, 'Das graphische Werk Max Pechsteins' (Max Pechstein's Graphic Work), Berlin 1921. Lothar Günther Buchheim, 'Die Künstlergemeinschaft Brücke' (*Die Brücke*, an Association of Artists), Feldafing 1956 (contains a section on Pechstein and a bibliography). For further bibliography see Vollmer, Vol.3, Leipzig 1956.

PRAMPOLINI, ENRICO (Lithograph IV/10)

Born 20 April 1896 in Modena (Emilia), died 17 June 1956 in Rome. After being expelled from the Academy of Art for his unorthodox ideas Prampolini joined the futurist movement between 1913 and 1914. At that time he was a frequent visitor to Balla's studio. In 1914 he took part in the 'Mostra libra futurista' in Rome and in 1915 published an article entitled 'Pittura assoluta' (absolute painting), which was intended as a reply to Kandinsky. He participated in the undertakings of the Zürich Dada group and in 1917 founded the journal *Noi* in order to propagate the theoretical premises of Dadaism in Italy. In 1919 he joined the Berlin *Novembergruppe*. In 1922 he visited Weimar, where he met Kandinsky and others. He also met Mondrian in Paris and in 1925 went to live there, remaining until 1937. During this Paris period Prampolini created his artistic 'Interviste con la materia' (Interviews with the material). In 1929 he gave his signature to the manifesto of the 'aeropittura', in 1931 he joined the *cercle et carré* and in 1932 the *abstraction – création* groups. After 1937 he again lived in Rome. His late works include the 'serie bioplastica' (1953/4), which is one of his most important productions.

Literature: Enrico Prampolini, 'Arte Polimaterica', Rome 1944. Pierre Courthion, 'Prampolini', Rome 1958. For full bibliography see Vollmer, Vol.3, Leipzig 1956.

ROHLFS, CHRISTIAN (Linoleum Cut V/11)

Born 22 December 1849 in Nierendorf near Leezen (Holstein), died 8 January 1938 in Hagen (Westphalia). Rohlfs was a farmer's son. In 1864, when he was 14, he fell from a tree and spent two years in hospital. Theodor Storm, the writer, saw drawings of Rohlfs and advised his father to have him trained. The boy attended the School of Art in Berlin and subsequently Weimar. In 1872 he was again ill and in 1874 his right leg was amputated. He then continued his studies in Weimar, interrupting them for occasional visits to Berlin. In 1901 Karl Ernst Osthaus invited him to come to Hagen, where the Folkwang Museum was about to be opened. Rohlfs spent the summers of 1905 and 1906 in Soest, where he met Nolde, and from 1910 to 1912 he lived in Munich and the Tyrol. From 1920 to 1926 he travelled every summer to Bavaria, central Germany, or the Baltic, and from 1927 onwards passed nine months of each year in Ascona and the remaining three in Hagen. He received many honours: in 1903 he was awarded the title of Professor, in 1921 he was made an honorary doctor of engineering, and in 1924 an honorary doctor of philosophy; in 1924 he was also given the freedom of the city of Hagen. Consequently the defamation to which he was later subjected as a 'degenerate' artist must have been all the more painful for him. In 1937 his works were removed from public museums and galleries and confiscated by the state. After starting as a follower of Corot, Rohlfs progressed via impressionism and neo-impressionism to expressionism; in 49

each successive phase of this development his work appears to have been enhanced and its artistic potential and diversity increased.

Literature: Paul Vogt, 'Christian Rohlfs, Oeuvrekatalog der Druckgraphik' (Christian Rohlfs, Catalogue of Graphic Works) (no place of publication given but probably Göttingen), 1950; 'Christian Rohlfs, Aquarelle und Zeichnungen' (Christian Rohlfs, Water-colours and Drawings), Recklinghausen 1958 (with a bibliography). For further bibliography see Vollmer, Vol.4, Leipzig 1958.

SCHARFF, EDWIN (Lithograph V/12)

Born 21 March 1887 in Neu-Ulm, died 18 May 1955 in Hamburg. Scharff began his career as a painter, training first at the Industrial School of Art and subsequently, from 1904 to 1907, at the Academy of Art in Munich. It was during a stay in France, between 1911 and 1913, that he turned to sculpture. His first exhibition of plastic works was staged in Munich in 1913. In the same year he became a founder-member of the 'New Secession' in Munich. In 1915 he joined the forces, was wounded and, after spending some time in hospital, was invalided out in 1917. During this period Scharff came to terms with the artistic problems posed by cubism. In 1923 he was asked to teach at the *Hochschule für bildende Künste* in Berlin. By that time he was one of the best known sculptors of his day and was asked to exhibit in various important institutes and galleries. In 1933 he left the college in Berlin and moved to Düsseldorf, where he taught at the Academy of Art until 1937, when he was dismissed from his post and forbidden to work as an artist. His works were also removed from the public museums. Towards the end of the war Scharff was able to resume work as a sculptor in the sacristy of a derelict church in Düsseldorf and in 1946 he returned to teaching (at the State School of Art in Hamburg). W. Schmalenbach has spoken of the 'noble classicality' of his sculptures.

Literature: Gottfried Sello, 'Edwin Scharff', Hamburg 1956. Catalogue of the retrospective exhibition staged in memory of Scharff by the Hamburg *Kunstverein*, Hamburg 1956 (contains a catalogue of works in chronological order). For bibliography see Vollmer, Vol.4, Leipzig 1958.

SCHLEMMER, OSKAR (Lithograph I/12)

Born 4 September 1888 in Stuttgart, died 13 April 1943 in Baden-Baden. Schlemmer trained at the Stuttgart Academy and in 1912 entered the 'masters' class' run by Adolf Hölzel, who exercised the major influence on his development. In 1914 he, Baumeister, and Stenner each painted a mural for the Cologne *Werkbund* exhibition. In the same year he contributed to various exhibitions and also visited Amsterdam, London, and Paris. In September 1914 he volunteered and served on the Western front until he was wounded, then on the Eastern front, and finally (from 1916 to 1918) in Germany. In 1916 he contributed to the exhibition, 'Hölzel and his Circle', which was put on in Freiburg im Breisgau and Frankfurt/Main, while in Stuttgart parts of his 'Triadic Ballet' were produced. After the war he returned to the 'masters' class' at the Stuttgart Academy. In 1919 he painted a number of pictures, which were extremely important for his subsequent artistic development (Design with Figures), and also created his first sculptures. In 1920 he left the Academy in order to concentrate on the 'Triadic Ballet'. He then moved to Cannstadt, made contact with Hindemith and Herwarth Walden and exhibited both in Dresden (*Galerie Arnold*)

and Berlin (*Sturm*). In 1920 he was invited to join the Bauhaus in Weimar, where he gave life classes. He was also made artistic director of murals and subsequently — from 1922 onwards — of sculpture. Schlemmer remained with the Bauhaus until 1929 and in Dessau he was placed in charge of the theatre workshop (Bauhaus theatre), which he had already been running on a *de facto* basis since 1923. During his final years at the Institute he gave more theoretical instruction ('Der Mensch' [Man]). In both his pedagogical and his creative work Schlemmer combined artistic and choreographic methods. In 1922 a complete version of the 'Triadic Ballet' was put on in Stuttgart and further performances followed in Weimar and Leipzig in 1923. On the occasion of the Bauhaus exhibition in Weimar in 1923 Schlemmer decorated the staircase of the workshop building with murals and reliefs. In 1924 he produced a number of outstanding and significant paintings and also wrote the text for the book *Die Bühne im Bauhaus* (The Theatre at the Bauhaus), which was published in 1925. He then designed stage sets for theatrical performances in Berlin (Volksbühne) and other cities. Between 1927 and 1929 he rehearsed a number of his own plays in the Bauhaus theatre, which were subsequently sent out on tour. In 1929 he accepted a post at the Breslau Academy and from 1932 to 1933 taught at the *Vereinigte Staatsschulen* in Berlin-Charlottenburg. Following his dismissal he had to earn a living as best he could from occasional work, which he found partly in his native southern Germany (Eichberg in the Black Forest, Stuttgart, Sehringen in Baden) and partly in Wuppertal-Elberfeld, where Dr Herberts, the paint manufacturer, provided him (and also Baumeister and Muche) with a livelihood. During the closing phase of his life Schlemmer was seriously ill.

Literature: Oskar Schlemmer, 'Briefe und Tagebücher' (Letters and Diaries), Munich 1958. Hans Wildebrandt, 'Oskar Schlemmer', Munich 1952 (contains a catalogue of all works except the prints and also has a bibliography); 'Oskar Schlemmer, Zeichnungen und Graphiken' (Oskar Schlemmer: Drawings and Prints), Stuttgart 1965. Hans M. Wingler, 'Das Bauhaus 1919–1933', Bramsche and Cologne 1962 (Contains sections on Schlemmer's theatre work). For full bibliography see Vollmer, Vol.4, Leipzig 1958.

SCHMIDT-ROTTLUFF, KARL (Woodcut V/13)

Born 1 December 1884 in Rottluff near Chemnitz, now living in Berlin. Like Heckel he began to study architecture in Dresden (1905), but his enthusiasm for painting soon brought him into contact with Heckel, Kirchner, and Bleyl, and together they founded the *Brücke* association. Shortly afterwards he devoted himself entirely to painting. In 1906 he stayed on Alsen with Nolde, whom he invited to join the *Brücke*. In 1911 he moved to Berlin, after having been asked to contribute to the exhibition of the 'New Secession' staged there in the previous year. In 1912 he took part in the *Sonderbund* exhibition staged in Cologne and the exhibition of prints put on by the *blaue Reiter*. In 1913 the *Brücke* was dissolved and in 1915 Schmidt-Rottluff joined the forces, serving as a soldier until 1918. After the war he made his home in Berlin, although he travelled extensively in the 1920's (in Italy, France, Dalmatia, and north-eastern Germany) and paid a lengthy visit to Rome in 1930. In 1931 he was made a member of the Prussian Academy, only to have his membership withdrawn two years later. Subsequently, in 1937, over 600 of his works, which were in 51

public ownership, fell foul of the new laws against 'degenerate' art. In 1941 he was officially forbidden to paint. In 1943 his Berlin home was destroyed in an air raid. But then, in 1947, he was appointed Professor at the Berlin Academy of Fine Arts and has since received many marks of distinction. Although Schmidt-Rottluff has always maintained a high standard of work, in his graphic output the early wood-cuts — in which he reveals a preference for fetishistic heads, religious motifs, and landscapes — have been singled out for special commendation.

Literature: Will Grohmann, 'Karl Schmidt-Rottluff', Stuttgart 1956. Rosa Schapire, 'Karl Schmidt-Rottluffs graphisches Werk bis 1923' (Karl Schmidt-Rottluff's Graphic Work up to 1923), Berlin 1924. For full bibliography see Vollmer, Vol.4, Leipzig 1958.

SCHREYER, LOTHAR (Coloured lithograph I/13;
 Coloured lithograph I/14)

Born 19 August 1886 in Blasewitz near Dresden, died 18 June 1966 in Hamburg. After reading for the bar and passing his law examinations Schreyer turned to the theatre and subsequently to painting. He was dramaturge from 1911 to 1918 at the *Deutsches Schauspielhaus* and from 1919 to 1921 at the *Kampfbühne* in Hamburg. From 1916 to 1928 he worked both as contributor and editor for Herwarth Walden's *Sturm* magazine. From 1917 to 1921 he was also director of the *Sturm* theatre in Berlin, which he himself had created. In 1923 he exhibited his abstracts in the *Sturm* gallery. In the same year he left the Bauhaus, where he had spent two years developing the theatre workshop along expressionist lines, which eventually came into conflict with the general approach adopted by the Bauhaus. During this period Schreyer produced a considerable number of graphic works, whose motifs reflect his interest in the theatre. Christian mysticism was the dominant feature of his thinking at that time. From 1924 to 1927 he taught at the *Wegschule* in Berlin and Dresden, after which he settled in Hamburg, where he was employed as a *Lektor* (publisher's reader with editorial responsibilities) until 1931 and then worked as a freelance author and painter.

Literature: Nell Walden and Lothar Schreyer, 'Der Sturm', Baden-Baden 1954. Lothar Schreyer, 'Erinnerungen an Sturm und Bauhaus' (Memories of *Sturm* and Bauhaus), Munich 1956. Catalogue of the exhibition, 'Der Sturm', staged by the German National Gallery in the *Orangerie* of *Schloss Charlottenburg* in 1961. For full bibliography see Vollmer, Vol.4, Leipzig 1958.

SCHWITTERS, KURT (Lithograph III/11)

Born 20 June 1887 in Hanover, died 8 January 1948 in Ambleside (England). From 1909 to 1914 Schwitters studied at the Academy in Dresden, then transferred to the Academy in Berlin. In 1915 he settled in Hanover, where he experimented with expressionist and cubist techniques, while earning a living as a portrait painter. In 1918 he exhibited his abstract works in the *Sturm* and began to contribute to the *Sturm* magazine; this then led to two further exhibitions. From 1918 to 1919 Schwitters studied architecture at the Technical College in Hanover. In 1919 he created his first *Merz* picture, *Merz* being his own personal mode of Dadaism. At this time he was working on pictures, collages, and poems. In 1920 he met Hans Arp and established friendly relations with the Bauhaus, which he maintained for

more than a decade. From time to time he visited the Institute and occasionally appeared there as a guest speaker. Between 1922 and 1923 he visited Holland, collaborated with van Doesburg and contributed to the journal *Mecano*. From 1923 onwards he published his own magazine, *Merz*, and in 1924 began to assemble his first *Merz* construction in his house in Hanover. He continued working on this fantastic, pillar-like structure until the mid-1930's, by which time it was three storeys high. In 1929 he collaborated with the *Cercle et Carré* and in 1930 with the *Abstraction-Création* groups. From 1930 onwards he spent part of each year in Norway and settled there in 1935, after having fled from Germany, where his works were soon to be branded as 'degenerate'. In Norway he again earned his living by painting portraits and landscapes but later – in 1937 – he set to work on a second *Merz* construction in Lysaker. This was never completed, for, when the Germans invaded Norway, Schwitters sought refuge in England. After spending seventeen months in an internment camp he established himself in London in 1941. In 1943 his first *Merz* construction, which he had left behind in Hanover, was destroyed in an air raid. A grant from the Museum of Modern Art in New York enabled Schwitters to continue with his experimental work in England. In 1945 he went to live in Little Langdale, where he began his third *Merz* construction at Cylinder's farm near Langdale. Schwitters died before he was able to complete it.

Literature : Kate T. Steinitz, 'Kurt Schwitters, Erinnerungen aus den Jahren 1918 bis 1930' (Memories of Kurt Schwitters between 1918 and 1930), Zürich 1963. Catalogues of the exhibitions of Schwitters' works in the Berggruen Gallery, Paris 1954 and 1963. For bibliography see Willy Verkauf, 'Dada, Monographie einer Bewegung' (Dada, Monograph of a Movement), Teufen 1957, and Vollmer, Vol.4, Leipzig 1958.

SEVERINI, GINO (Lithograph IV/11)

Born 7 April 1883 in Cortona (Tuscany), died 27 February 1966 in Meudon near Paris. In 1901, when he was in Rome, he met Balla, who then became his teacher, and Boccioni, with whom he later collaborated. In 1906 he moved to Paris, where he came into contact with Braque, Dufy, Modigliani, and Picasso. After an initial Pointillist phase Severini moved on to futurism. In 1910 he joined Balla, Boccioni Carrà, and Russolo as a signatory to the Futuristic Manifesto and in 1912 he contributed to the futuristic exhibition put on by Bernheim-Jeune in Paris. In 1913 he took part in Herwarth Walden's 'First German Autumn Salon' in Berlin and had a one-man show in the *Sturm* Gallery, which was repeated in the following year. Around about 1915 he turned towards cubism in search of a new line of development and began to align himself with the *Section d'or*. Then, as a result of his preoccupation with the problems of proportion, he joined Picasso and the *Valori Plastici* when they went over to neo-classicism. Severini also published a book, in which he justified this step. He had an exhibition in the Stieglitz Gallery in New York and in the following year was commissioned to execute murals and mosaics in Switzerland, France and Italy. Around about 1930 he again adopted certain cubist techniques and subsequently a number of futuristic elements, which he had used in his early work. In the course of time these retrospective trends asserted themselves more and more. In 1946 he published his memoirs and in 1950 was awarded a prize at the Venice Biennale.

Literature: Gino Severini, 'Du Cubisme au Classicisme' (From Cubism to Classicism), Paris 1921; 'Ragionamenti Sulle Arte Figurative' (Discussion of Figurative Art), Milan 1936; 'Tutta la vita di un pittore' (The Life of a Painter), Milan 1940. Pierre Courthion, 'Gino Severini', Milan 1945. Jacques Lassaigne, 'Les dessins de Severini' (Severini: Designs), Paris 1947. For bibliography see Vollmer, Vol.4, Leipzig 1958.

STUCKENBERG, FRITZ (Lithograph III/12)
Born 16 August 1881 in Munich, died 18 May 1944 in Füssen (Lech). Stuckenberg spent his childhood in Delmenhorst and went to school in Bremen and Oldenburg. In 1900 he studied architecture for one term in Brunswick. From 1901 to 1903 he worked as a scene painter in Leipzig, studying portrait painting in his free time. From 1903 to 1905 he attended the *Grossherzoglich Sächsisches Kunstgewerbeschule* in Weimar. In 1904 he visited Italy, accompanied by Emil Nolde and Ludwig Hofmann. In 1905 he enrolled at the Academy of Fine Arts in Munich, where he remained until 1907. The major part of the next five years was spent in Paris, where he established friendly relations with Uhden, Levy, and Artaval and became an admirer of Monet, Pissarro, Sisley, and Puvis de Chavannes. In 1908 he visited Brittany and in 1910 Cassis near Marseilles. It was at this time that he came under the influence of Cézanne. In 1912 he contributed to the *Salon d'Automne,* the *Salon des Indépendants,* and a number of other exhibitions. After seeing works by Picasso, Metzinger, Dérain, and Léger, Stuckenberg revised his views on art. In Berlin, where he lived from 1912 to 1919, he made contact with the members of the *Sturm* and followed its expressionist trend. In 1914 he met Marc and Campendonk in Munich. In 1916 he contributed to the exhibition of 'German Expressionists' organized by the *Sturm,* But then, after taking part in two further exhibitions, he broke with the *Sturm* in 1918. In the following year he joined the *Novembergruppe* and went to live in Seeshaupt on the Starnberger See, where he remained for three years before settling in Delmenhorst. There Stuckenberg was taken seriously ill. Later, in the second half of the 1920's, he was asked to send works to large exhibitions in Paris, New York. and other cities. The paintings which he produced around 1930 contain elements which seem to anticipate tachisme. In 1937 a number of his works were confiscated. In 1941, by which time he was a permanent invalid, Stuckenberg retired to Horn near Füssen. In the closing phase of his life he was tied to his wheelchair and eventually to his bed.
Literature: Catalogue of the Stuckenberg Exhibition in the Landesmuseum für Kunst und Kulturgeschichte (State Museum of Art and the History of Culture), Oldenburg 1961 (with a bibliography). Catalogue of the exhibition, 'Der Sturm', staged by the German National Gallery in the *Orangerie* of *Schloss Charlottenburg,* Berlin 1961. For further bibliography see Thieme-Becker, Vol.32, Leipzig 1938.

SURVAGE, LÉOPOLD (Woodcut II/3)
Born 12 August, 1879 in Willmannstrand (Finland), now living in Paris. Survage trained as a cabinet-maker but, after seeing works by Cézanne and Gauguin, transferred to painting. He attended the School of Art in Moscow and joined with Ssudeikin and others in founding *La rose bleue.* In 1908 he went to live in Paris,

where he studied under Matisse. In 1911 he moved towards cubism and in 1912 contributed to the *Salon des Indépendants*. He exhibited in Paris, Milan, and elsewhere with considerable success, especially after the first world war. Survage tried to establish a modified form of cubism. By introducing new formal elements he sought to reduce the structural tension of the cubist composition, thus rendering it capable of emotional expression. To some extent at least he incorporated 'real space' into the composition of his pictures. In his choice of subjects he preferred still lifes to landscapes. He also had an aptitude for decorative work, which was recognized by Dhiagilev, who asked him to create the décor for a ballet ('Mavra'). The principal works of Survage's late period were the murals which he painted for the International Exhibition in 1937. These no longer exist.

Literature: L. G. Buchheim (Ed.), 'Knaurs Lexikon moderner Kunst' (Knaurs' Dictionary of Modern Art), Munich and Zürich 1955. For bibliography see Vollmer, Vol.4, Leipzig 1958.

TOPP, ARNOLD (Woodcut III/13)

Born 8 March 1887 in Soest (Westphalia), resident in Brandenburg on the Havel during the second world war, declared dead by the Lower Court in Soest in 1960. Topp was a friend of Wilhelm Morgner from boyhood onwards. After attending a Teachers' Training College and obtaining his diploma he became a village schoolmaster in the Sauerland. He was interested in philosophy and also in the paintings of Segantini, Millet, and van Gogh. In 1910 he' went to study under Lothar von Kunowski at the Düsseldorf Academy in order to obtain an art diploma, which would enable him to teach drawing. After passing his examination he did his year's compulsory military service and was then given a post as a teacher of drawing in Brandenburg on the Havel. Topp was conscripted at the outbreak of war and from his wartime experience he received lasting impressions of both people and landscapes, especially in Serbia. After being wounded he was sent back to Germany. In 1915, 1917, 1918, and 1919 collections of his works were shown in the Berlin *Sturm*. In 1919 he was also represented at a Dadaist exhibition and at the exhibition of 'Unbekannte Architekten' (Unknown Architects) put on by I. B. Neumann in Berlin. Topp's inventive art found expression, not only in drawings and prints, but also in *verres églomisées*.

Literature: Adolf Behne, 'Arnold Topp', published in *Deutsche Graphik des Westens,* edited by H. von Wedderkop, Weimar 1922. Catalogue of the exhibition, 'Der Sturm', staged by the German National Gallery in the *Orangerie* of *Schloss Charlottenburg* in Berlin in 1961. For further bibliography see Vollmer, Vol.4, Leipzig 1958.

WAUER, WILLIAM (Lithograph III/14)

Born 26 October 1866 in Oberwiesenthal (Erzgebirge), died 10 March 1962 in Berlin. Wauer studied at the Academies in Berlin, Dresden and Munich. He spent a year in Rome (1896–97). Then, in 1906, he was engaged as a producer by the *Deutches Theater* in Berlin. In 1910 he entered into close contact with the *Sturm* and from then onwards contributed articles to its magazine and made propaganda for it in his critical writings. In Walden's circle he was highly thought of, not only as a sculptor and painter, but also as a man of the theatre, an author, and a critic. In

view of his diverse activities Wauer's literary output was surprisingly prolific. Of his sculptures one in particular – a futuristic portrait bust of Herwarth Walden – has often been reproduced. Wauer had exhibitions in the *Sturm* gallery in 1918, 1919, and 1923. From 1924 to 1933 he was chairman of the 'International Association of Expressionists, Cubists, Futurists and Constructivists' (i.e. the Abstracts). During the Hitler period he was under constant 'attack and in 1941 was forbidden to paint. After the second world war works of his were included in various exhibitions both in Berlin and elsewhere.

Literature: William Wauer, 'Der Kunst eine Gasse' (Art: One Path), Berlin 1906; 'Das Theater als Kunstwerk' (The Theatre as an Art Form), Berlin 1914. Lothar Schreyer, 'Erinnerungen an Sturm und Bauhaus' (Memories of the *Sturm* and the Bauhaus), Munich 1956 (contains a chapter on Wauer). Catalogue of the Exhibition, 'Der Sturm', staged by the German National Gallery in the *Orangerie* of *Schloss Charlottenburg* in Berlin in 1961. For bibliography see Vollmer, Vols.5 and 6, Leipzig 1961 and 1962.

ILLUSTRATIONS

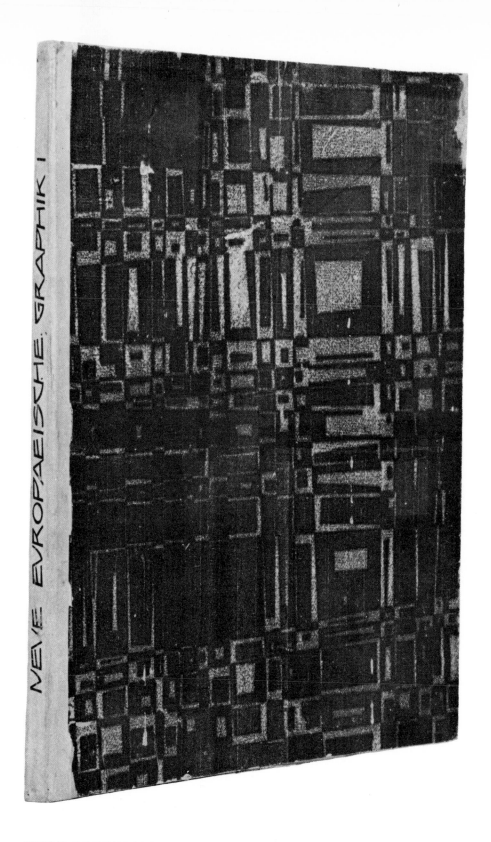

FIRST PORTFOLIO 1/Cover (Design by Feininger)

PLATE 1

DEM STAATLICHEN BAUHAUS IN WEIMAR
SCHENKTEN DIESE WERKE

L, FEININGER/JOHANNES ITTEN
PAUL KLEE/GERHARD MARCKS
GEORG MUCHE/OSKAR SCHLEMMER
LOTHAR SCHREYER

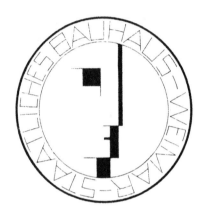

DIESE MAPPE TRÄGT DIE NUMMER

1/Colophon

PLATE 2

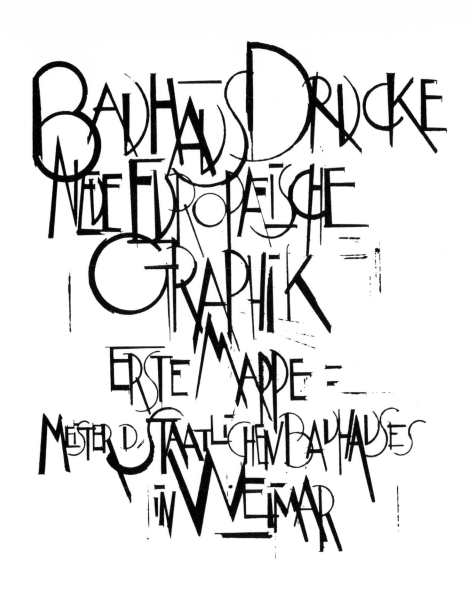

I / Title Page

PLATE 3

DIESE ZWEITE VERÖFFENTLICHUNG DES STAATLICHEN BAUHAUSES IN WEIMAR ERSCHIEN IN 5 MAPPEN ALS EINMALIGE NUMMERIRTE AUFLAGE IN 110 EXEM= PLAREN _____

NR. 1—10 AUF JAPAN HANDGEDRUCKT, DIE MAPPE IN GANZ=PERGAMENT HANDGE= ARBEITET _____

NR. 11—110 AUF DEUTSCHEM PAPIER HANDGEDRUCKT, DIE MAPPE IN HALBPERGAMENT, HANDGEARBEITET _____

ALLE GRAPHISCHEN BLÄTTER SIND IN DER DRUCKEREI DES STAATLICHEN BAUHAUSES MIT DER HAND GEDRUCKT, JEDES BLATT IST VOM KÜNSTLER SELBST SIGNIERT, DIE MAPPE WURDE IN DER BUCHBINDEREI DES STAATLICHEN BAUHAUSES HANDGE= ARBEITET _____

1 / Imprint

PLATE 4

DIE ERSTE MAPPE / MEISTER DES STAATLICHEN BAUHAUSES IN WEIMAR / ENTHÄLT 14 BLÄTTER UND ZWAR

BLATT 1 LYONEL FEININGER: VILLA AM STRAND _ _ _ _ _ _ HOLZSCHNITT
 2 SPAZIERGÄNGER _ _ _ _ _ _ _ "
 3 JOHANNES ITTEN: SPRUCH _ _ _ _ _ _ _ _ _ _ _ _ LITHOGRAPHIE
 4 HAUS DES WEISSEN MANNES _ _ _ _ "
 (ARCHITEKTONISCHE STUDIE)
 5 PAUL KLEE: DIE HEILIGE VOM INNEREN LICHT _ _ _ _ "
 6 HOFFMANNESKE SCENE _ _ _ _ _ _ _ "
 7 GERHARD MARCKS: DIE KATZEN _ _ _ _ _ _ _ _ _ _ HOLZSCHNITT
 8 DIE EULE _ _ _ _ _ _ _ _ _ _ _ _ "
 9 GEORG MUCHE: TIERKOPF _ _ _ _ _ _ _ _ _ _ _ _ RADIERUNG
 10 RADIERUNG _ _ _ _ _ _ _ _ _ _ _ "
 11 OSKAR SCHLEMMER: FIGUR H 2 _ _ _ _ _ _ _ _ _ _ LITHOGRAPHIE
 12 FIGURENPLAN K 1 _ _ _ _ _ _ _ _ _ _ "
 13 LOTHAR SCHREYER: FARBFORM 6 AUS BÜHNEN =
 WERK „KINDSTERBEN" _ _ _ _ _ _ BEMALTER STEINDRUCK
 14 FARBFORM 2 AUS BÜHNEN =
 WERK „KINDSTERBEN" "

I / Table of Contents

PLATE 5

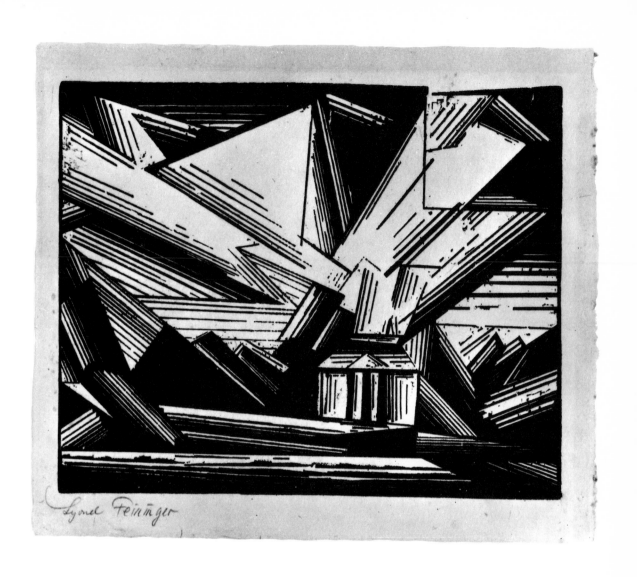

I/1 FEININGER: 'Villa am Strand' (Villa on the Shore)

PLATE 6

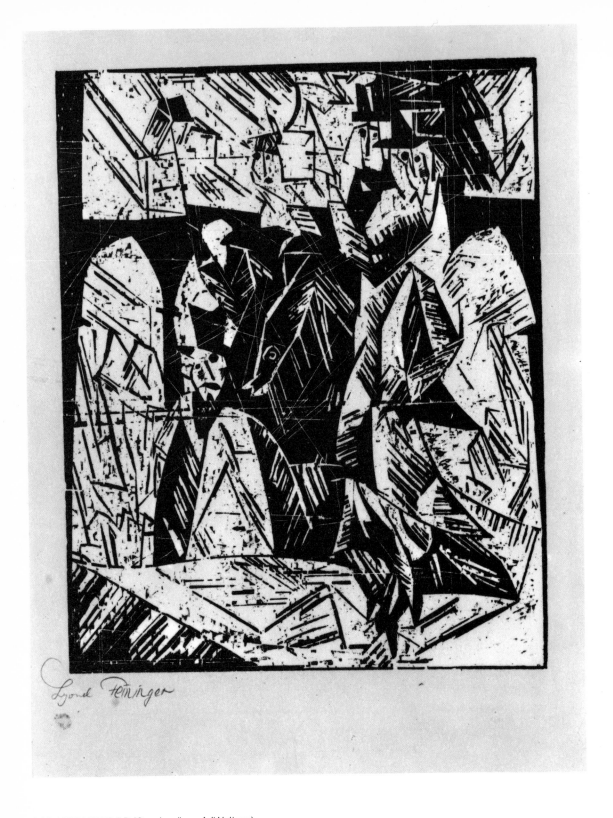

I/2 FEININGER 'Spaziergänger' (Walkers)

PLATE 7

PLATE 8

I/3 ITTEN: 'Spruch' (Dictum)

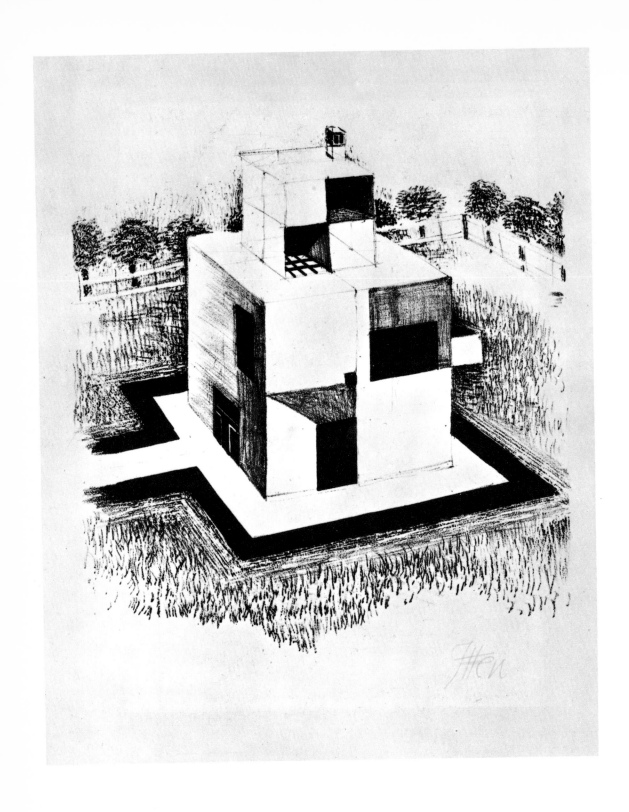

I / 4 ITTEN : 'Haus des weissen Mannes' (House of the White Man)

PLATE 9

PLATE 10

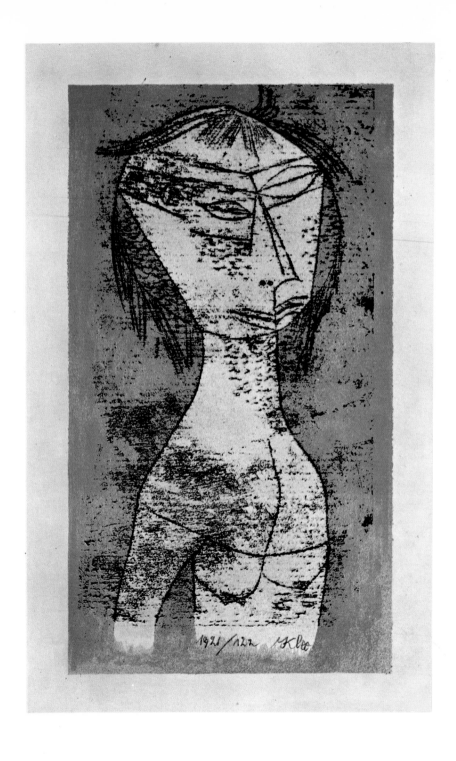

I/5　KLEE: 'Die Heilige vom inneren Licht' (The Saint of the Inner Light)

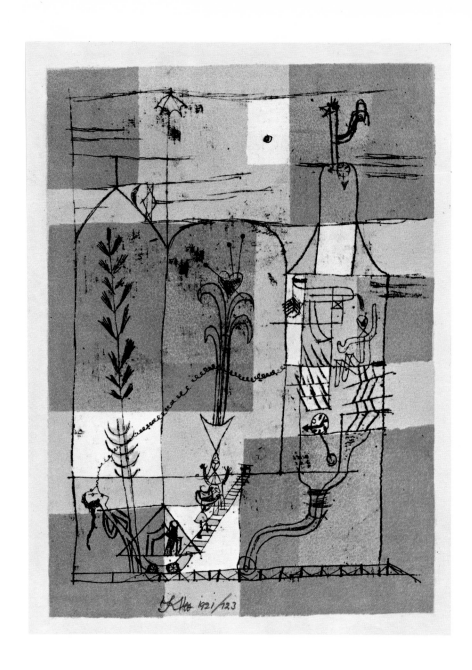

I/6 KLEE: 'Hoffmanneske Szene' (Hoffmannesque Scene)

PLATE 11

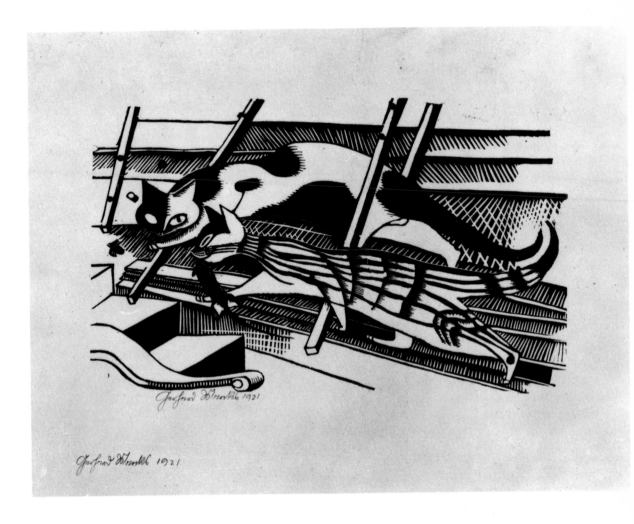

I/7 MARCKS: 'Die Katzen' (The Cats)

PLATE 12

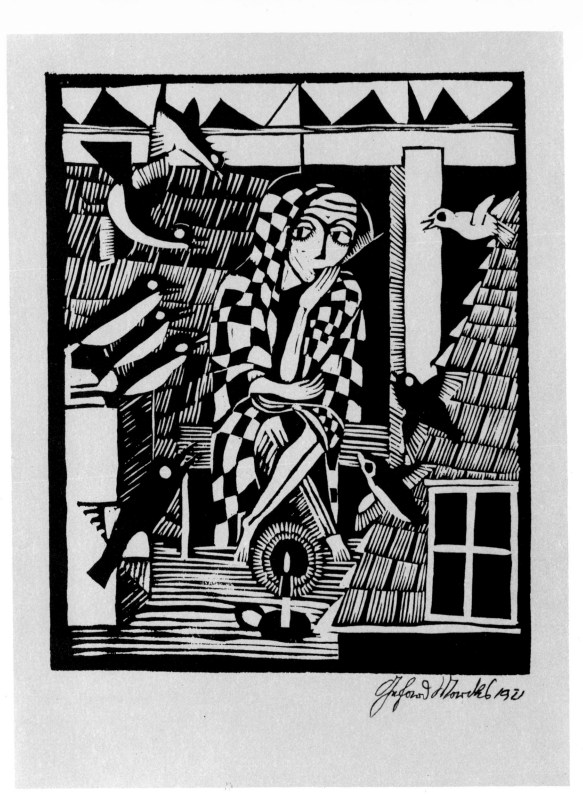

I/8 MARCKS: 'Die Eule' (The Owl)

PLATE 13

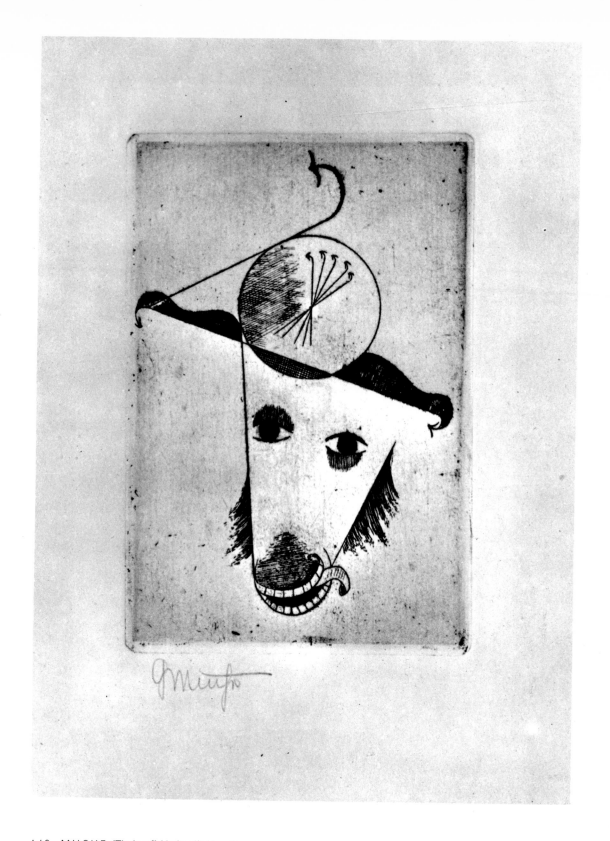

I/9 MUCHE: 'Tierkopf' (Animal's Head)

PLATE 14

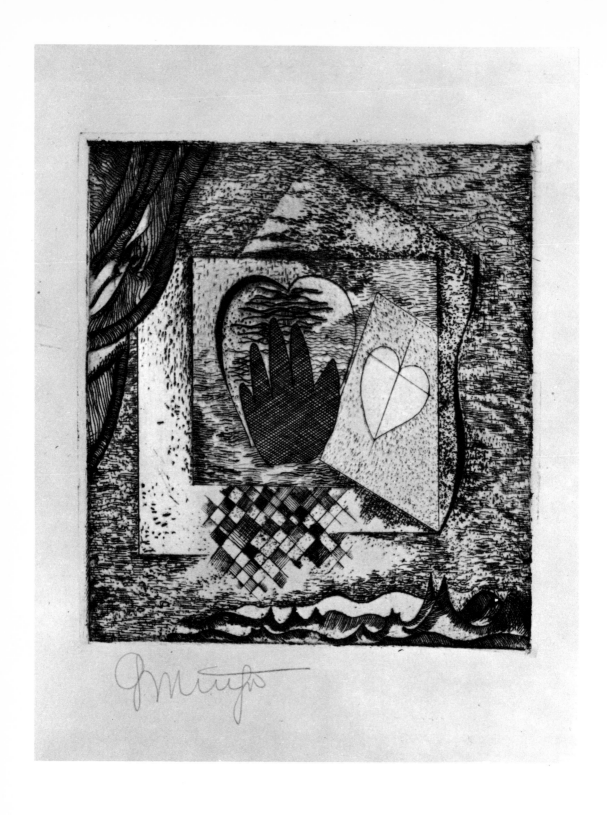

I/10 MUCHE: 'Radierung' (Etching)

PLATE 15

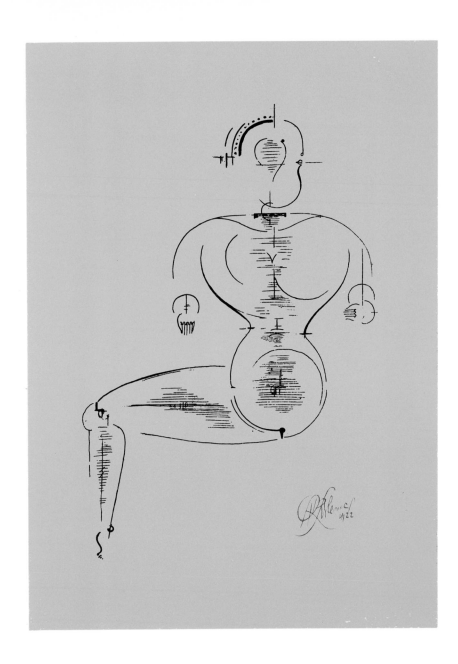

I/11 SCHLEMMER: 'Figur H 2' (Figure H 2)

PLATE 16

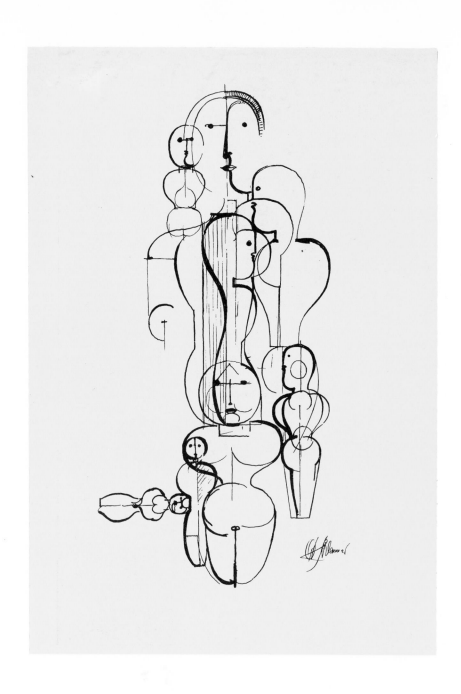

I/12 SCHLEMMER: 'Figurenplan K 1' (Figure Design K 1)

PLATE 17

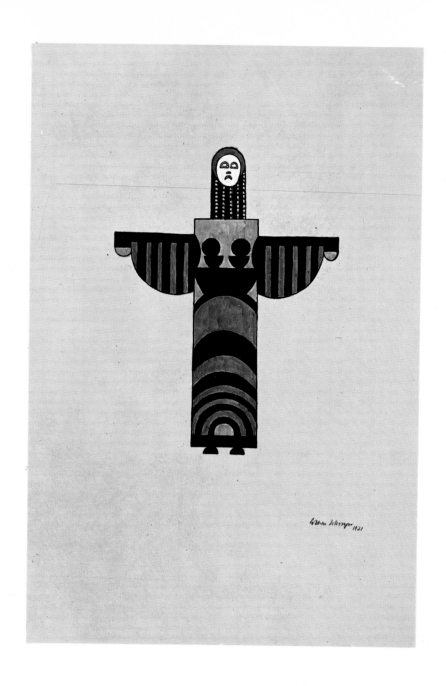

I/13 SCHREYER: 'Farbform 6 aus Bühnenwerk "Kindsterben"'
 (Colour Design 6 from the stage play 'Child - Dying')

PLATE 18

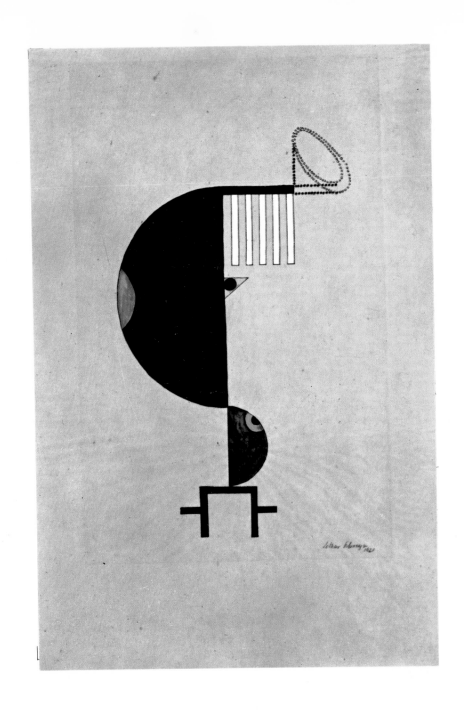

I/14 SCHREYER: 'Farbform 2 aus Bühnenwerk "Kindsterben"'
(Colour Design 2 from the stage play 'Child-Dying')

PLATE 19

SECOND PORTFOLIO

FRENCH ARTISTS
(FRAGMENT)

No Cover
II / (1)　C O U B I N E : Weiblicher Akt. (nicht identifiziert)
　　　　　　　　　　(Female Nude [not identified])

PLATE 20

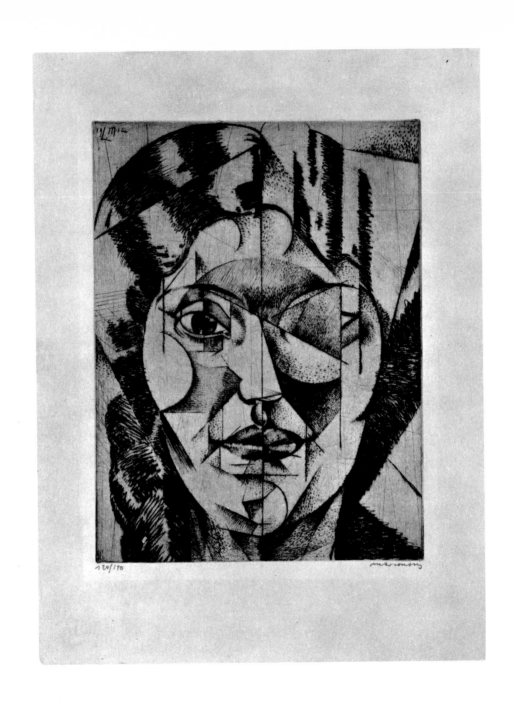

II / (2) MARCOUSSIS: Weiblicher Kopf (Head of Woman)

PLATE 21

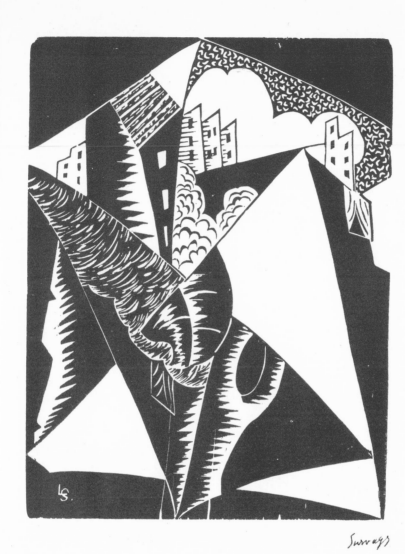

II / (3) SURVAGE: Komposition aus Dreiecken und Häuserformen
(Composition : Triangles and House Shapes)

PLATE 22

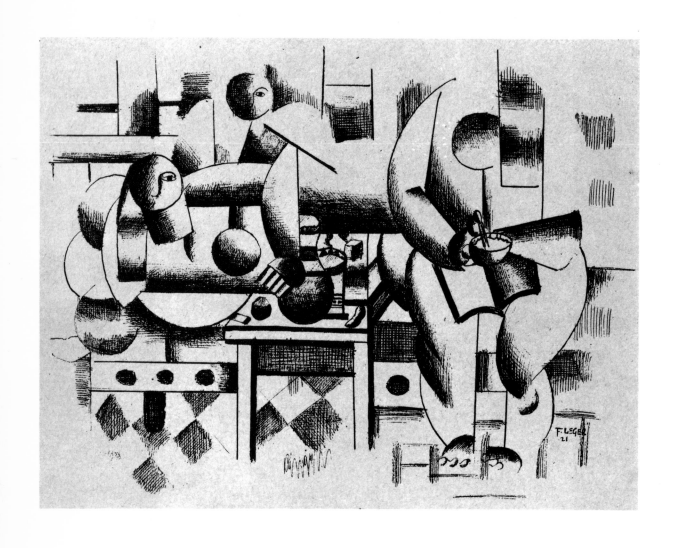

II / (4) LÉGER: Komposition (drei weibliche Figuren und Tisch) (Composition [Three Female Figures and a Table])

PLATE 23

THIRD PORTFOLIO III / Cover (Design by Klee)

PLATE 24

DEM STAATLICHEN BAUHAUS IN WEIMAR
SCHENKTEN DIESE WERKE

RUDOLF BAUER | HEINRICH CAMPENDONK
WILLI BAUMEISTER | WALTER DEXEL
MAX ERNST | OSKAR FISCHER
JACOBA van HEEMSKERCK | AUGUST MACKE (NACHLASS)
FRANZ MARC (NACHLASS) | JOHANNES MOLZAHN
KURT SCHWITTERS | FRITZ STUCKENBERG
ARNOLD TOPP | WILLIAM WAUER

DIESE MAPPE TRÄGT DIE NUMMER

III / Colophon

PLATE 25

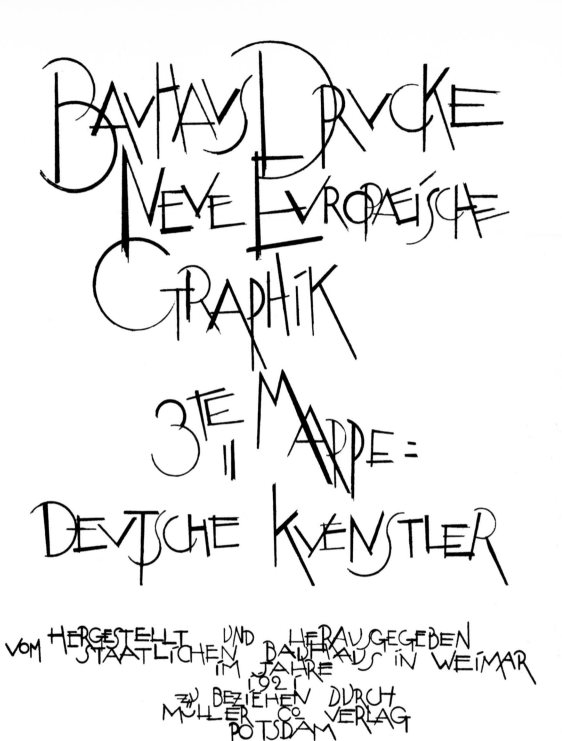

BAUHAUS DRUCKE
NEUE EUROPAEISCHE
GRAPHIK
3TE MAPPE =
DEUTSCHE KUENSTLER

VOM HERGESTELLT UND HERAUSGEGEBEN
STAATLICHEN BAUHAUS IN WEIMAR
IM JAHRE
1921
ZU BEZIEHEN DURCH
MÜLLER CO VERLAG
POTSDAM

III / Title Page

PLATE 26

DIESE ZWEITE VERÖFFENTLICHUNG DES STAATLICHEN BAUHAUSES IN WEIMAR
ERSCHIEN IN 5 MAPPEN ALS EINMALIGE NUMMERIRTE AUFLAGE IN 110 EXEM=
PLAREN _____

NR. 1 — 10 AUF JAPAN HANDGEDRUCKT, DIE MAPPE IN GANZ=PERGAMENT, HANDGE=
ARBEITET _____

NR. 11 — 110 AUF DEUTSCHEM PAPIER HANDGEDRUCKT, DIE MAPPE IN HALBPERGAMENT,
HANDGEARBEITET _____

ALLE GRAPHISCHEN BLÄTTER SIND IN DER DRUCKEREI DES STAATLICHEN BAUHAUSES
MIT DER HAND GEDRUCKT, JEDES BLATT IST VOM KÜNSTLER SELBST SIGNIERT,
DIE MAPPE WURDE IN DER BUCHBINDEREI DES STAATLICHEN BAUHAUSES HANDGE=
ARBEITET _____

III / Imprint

PLATE 27

DIE 3. MAPPE ENTHÄLT 14 BLÄTTER UND ZWAR

BLATT 1 RUDOLF BAUER _____ STEINDRUCK
 2 WILLI BAUMEISTER _____ "
 3 HEINRICH CAMPENDONK ____ HOLZSCHNITT
 4 WALTER DEXEL _____ "
 5 OSKAR FISCHER _____ STEINDRUCK
 6 JACOBA VAN HEEMSKERCK _ HOLZSCHNITT
 7 BERNHARD HOETGER _____ STEINDRUCK
 8 AUGUST MACKE (NACHLASS) __ LINOLEUMSCHNITT
 9 FRANZ MARC (NACHLASS) ___ HOLZSCHNITT
 10 JOHANNES MOLZAHN _____ "
 11 KURT SCHWITTERS _____ STEINDRUCK
 12 FRITZ STUCKENBERG _____ "
 13 ARNOLD TOPP _____ HOLZSCHNITT
 14 WILLIAM WAUER _____ STEINDRUCK

PLATE 28

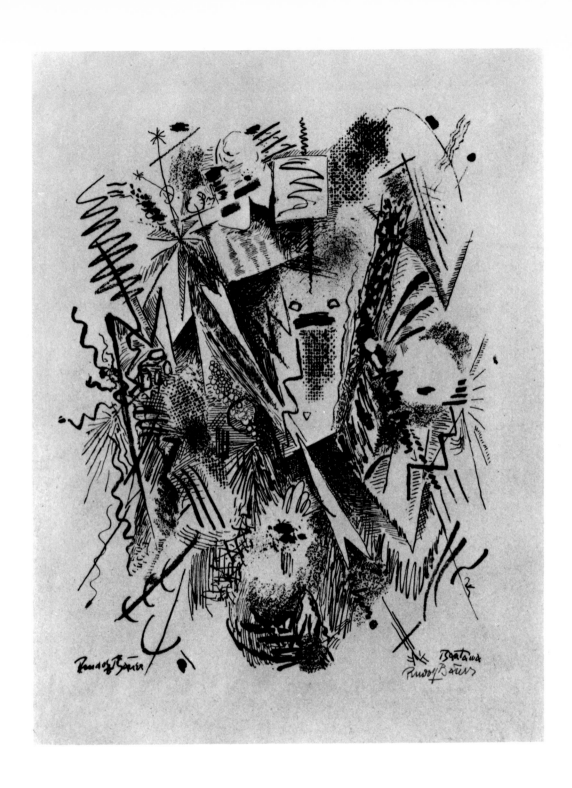

III/1 BAUER: 'Bantama'

PLATE 29

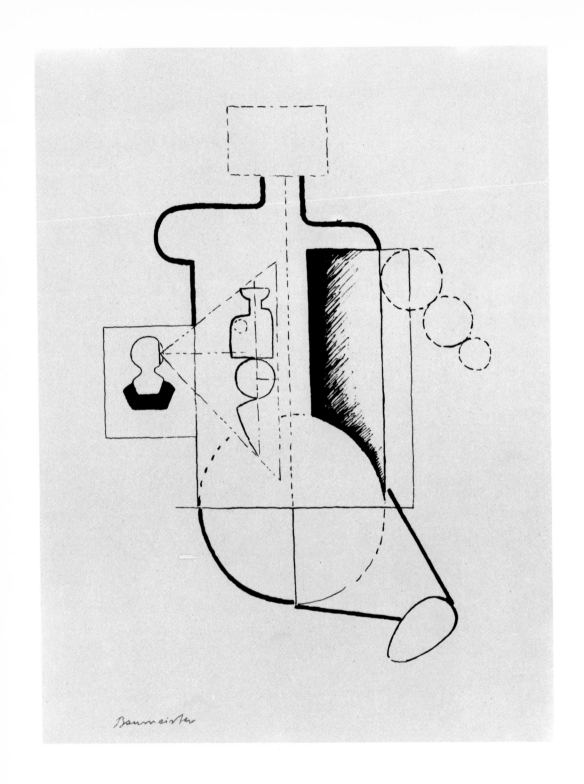

III / 2 BAUMEISTER : Abstrakte Sitzfigur (Abstract Seated Figure)

PLATE 30

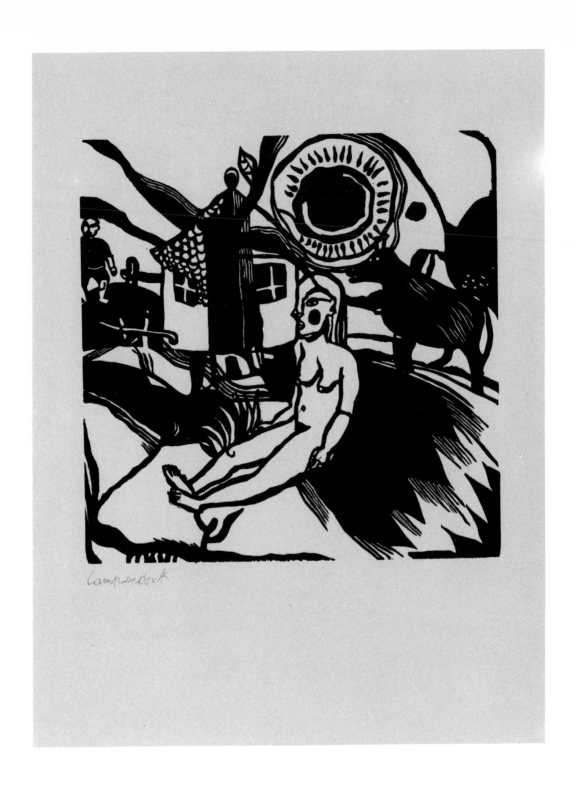

III/3 CAMPENDONK: Weiblicher Akt vor Bauernhof (Female Nude in front of Farmyard)

PLATE 31

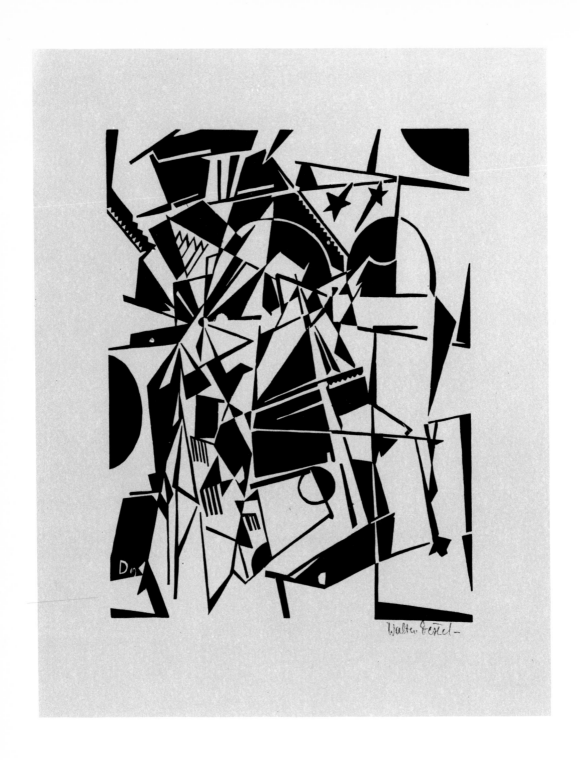

III / 4 D E X E L : Abstrakte Komposition (Abstract Composition)

PLATE 32

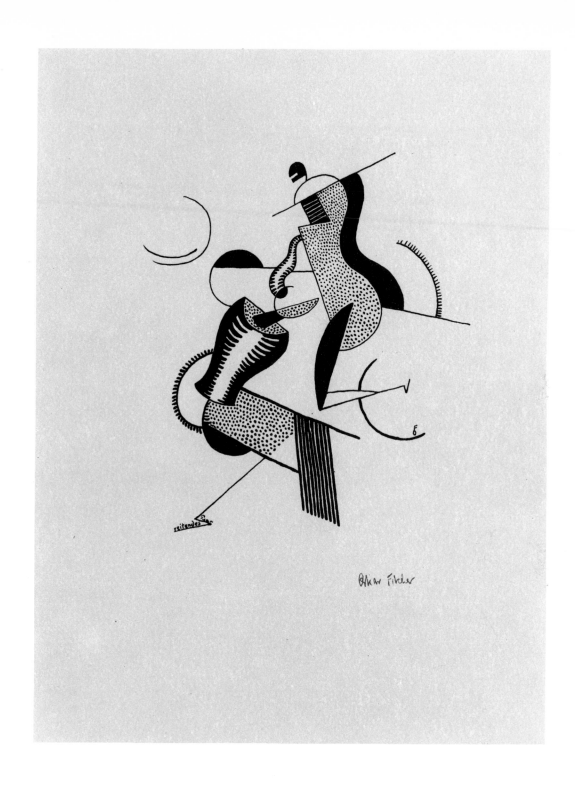

III / 5 FISCHER : 'Reitendes Paar' (Couple on Horseback)

PLATE 33

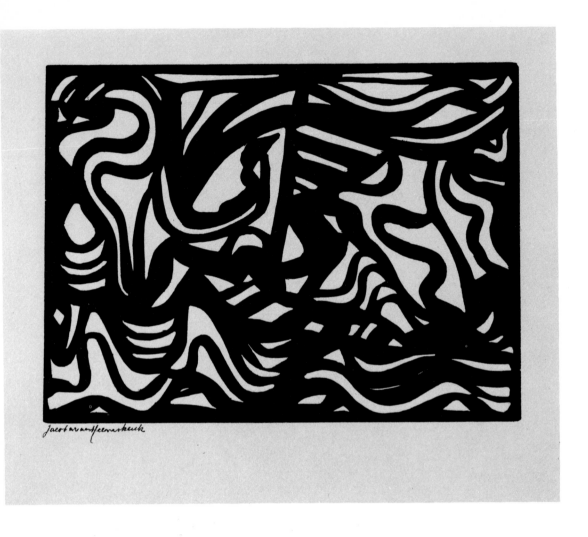

III / 6 VAN HEEMSKERCK: Komposition (Composition)

PLATE 34

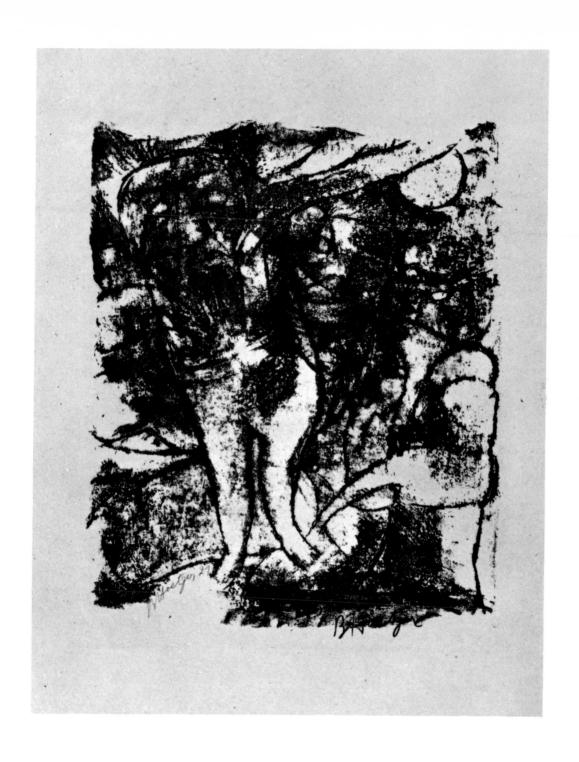

III / 7 H O E T G E R : Figürliche Komposition (Figure Composition)

PLATE 35

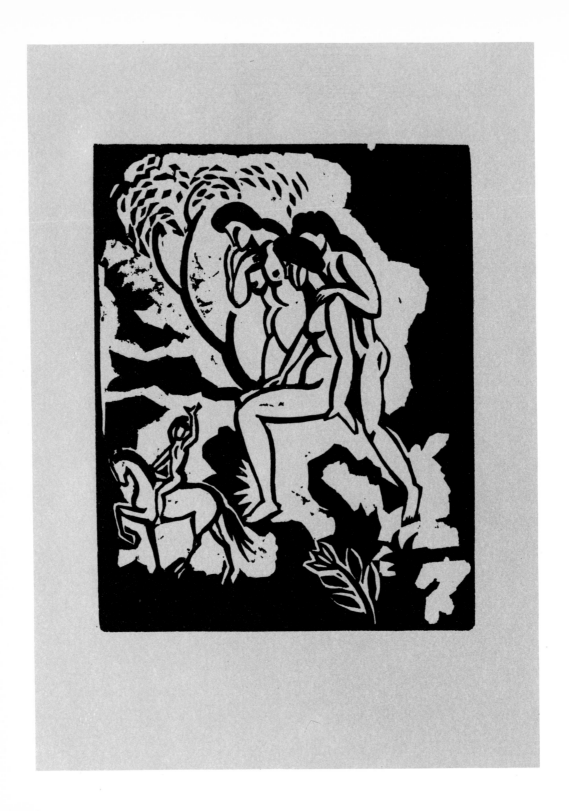

III / 8 M A C K E : 'Begrüssung' (Greeting)

PLATE 36

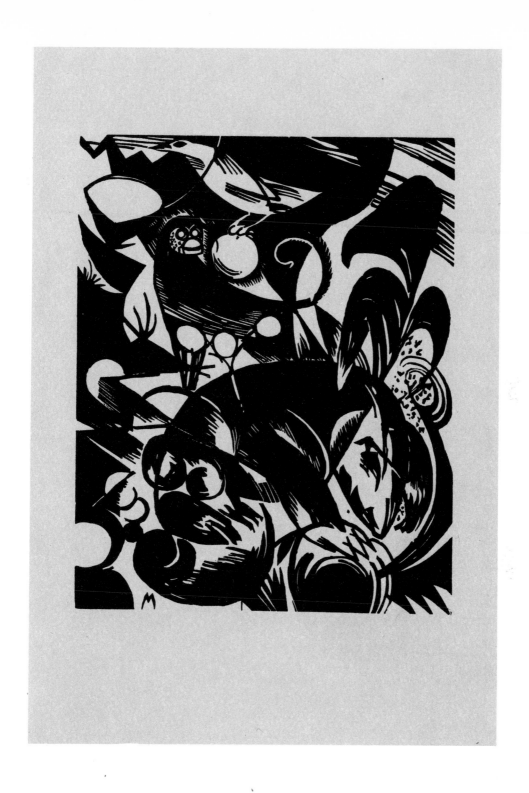

III / 9 MARCK: 'Shöpfungsgeschichte 1' (Creation 1)

PLATE 37

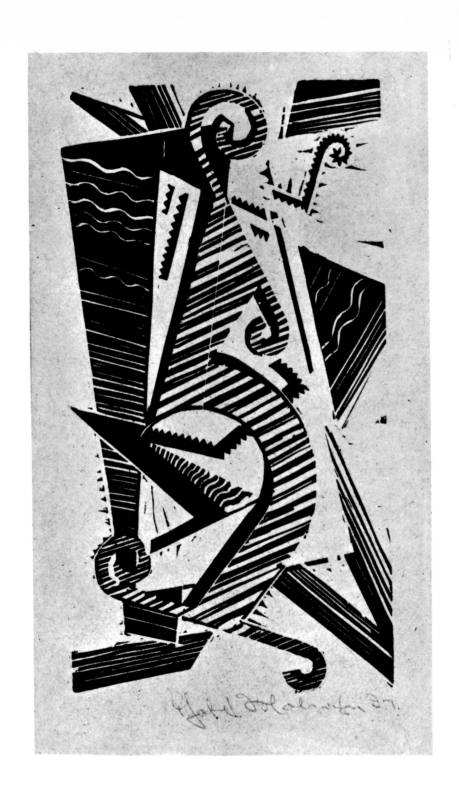

III/10 MOLZAHN: Komposition (Composition)

PLATE 38

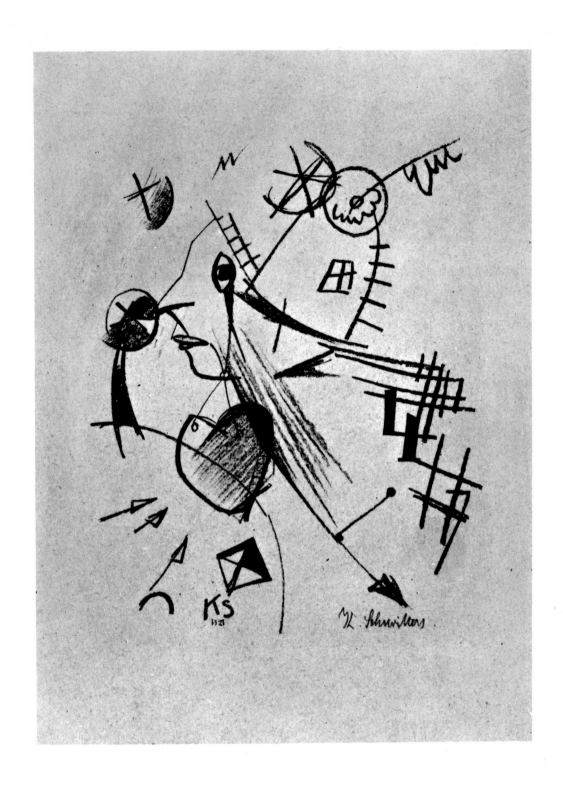

III / 11 SCHWITTERS: Komposition mit Kopf im Profil (Composition with Profile)

PLATE 39

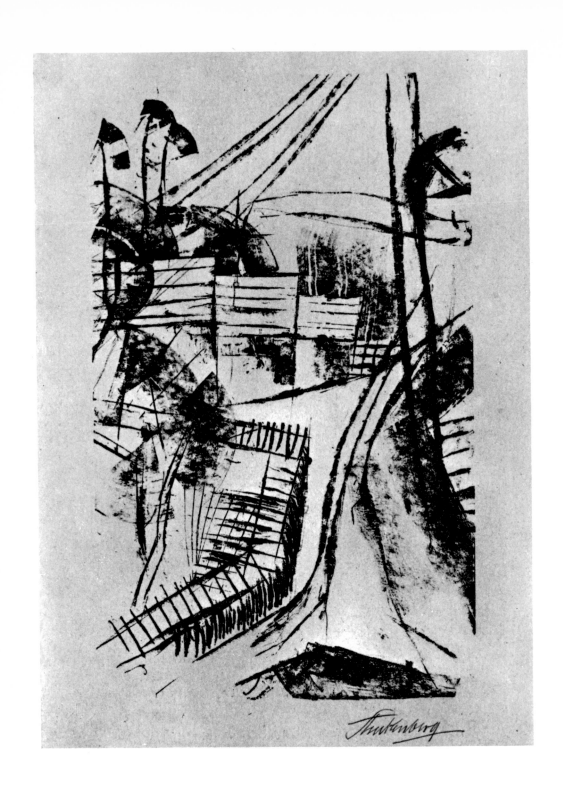

III/12 STUCKENBERG: Strasse mit Häusern (Road with Houses)

PLATE 40

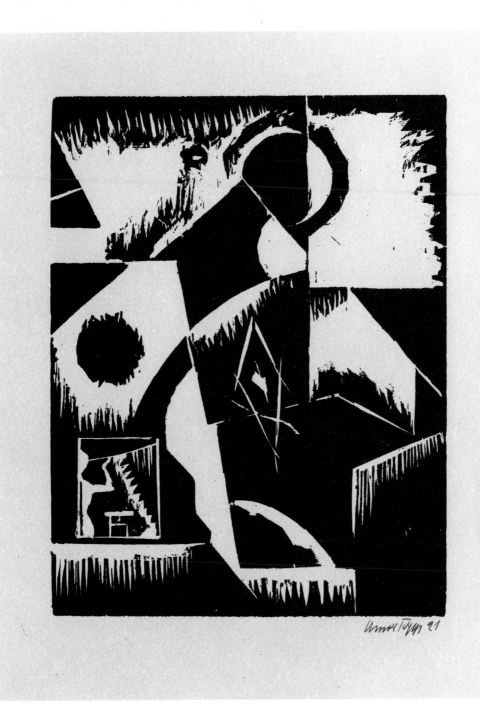

III / 13 TOPP : Abstrakte Komposition (Abstract Composition)

PLATE 41

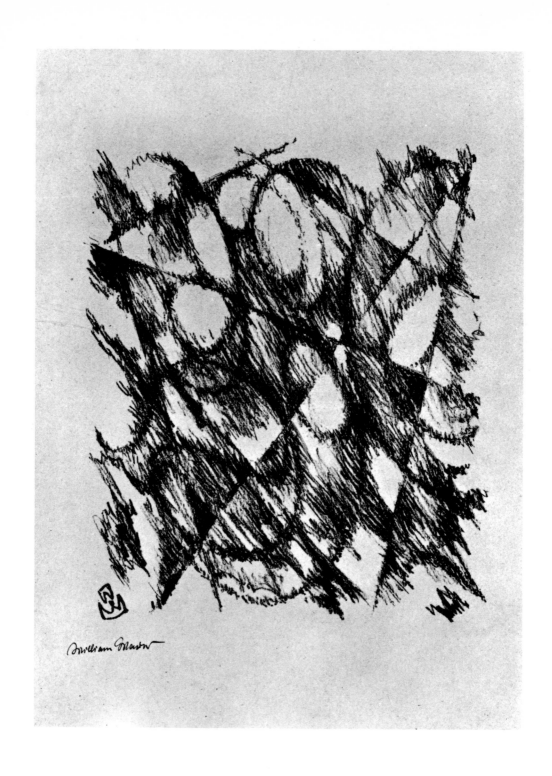

III / 14 WAUER : Komposition mit Ovalen (Composition with Ovals)

PLATE 42

FOURTH PORTFOLIO IV / Cover (Design by Hirschfeld)

PLATE 43

DEM STAATLICHEN BAUHAUS IN WEIMAR
SCHENKTEN DIESE WERKE

ALEXANDER ARCHIPENKO / ALEXEI v.JAWLENSKY
VMBERTO BOCCIONI / WASSILI KANDINSKY
CARLO CARRA' / M. LARIONOW
MARC CHAGALL / ENRICO PRAMPOLINI
GIORGIO de CHIRICO / GINO SEVERINI
Mme N, GONTSCHAROWA / ARDENGO SOFFICI

DIESE MAPPE TRÄGT DIE·NUMMER

IV / Colophon

PLATE 44

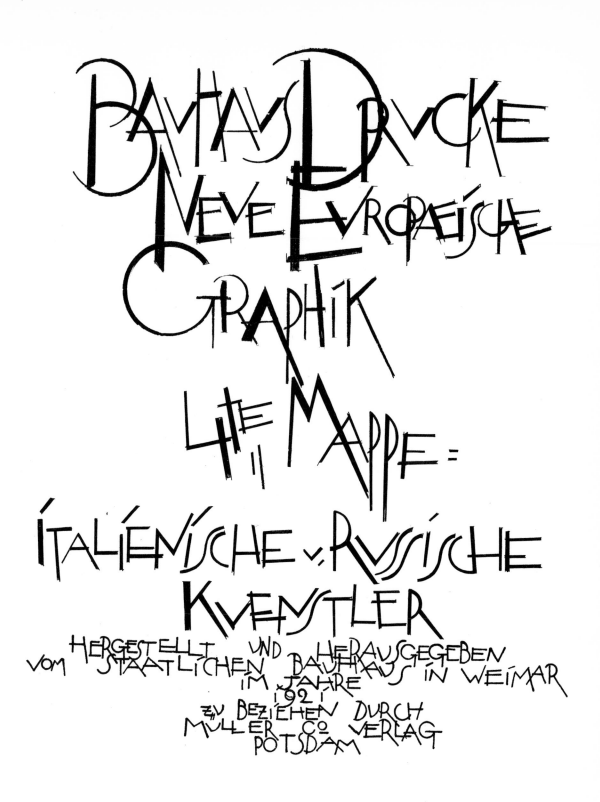

BAVHAVS DRVCKE
NEVE EVROPAEISCHE
GRAPHIK
4TE MAPPE =
ITALIENISCHE v. RVSSISCHE
KVENSTLER
VOM HERGESTELLT UND HERAUSGEGEBEN
STAATLICHEN BAVHAVS IN WEIMAR
IM JAHRE
1921
ZV BEZIEHEN DURCH
MVLLER CO VERLAG
POTSDAM

IV / Title Page

PLATE 45

DIESE ZWEITE VERÖFFENTLICHUNG DES STAATLICHEN BAUHAUSES IN WEIMAR
ERSCHIEN IN 5 MAPPEN ALS EINMALIGE NUMMERIRTE AUFLAGE IN 110 EXEM=
PLAREN _____

NR. 1 – 10 AUF JAPAN HANDGEDRUCKT, DIE MAPPE IN GANZ=PERGAMENT, HANDGE=
ARBEITET _____

NR. 11 – 110 AUF DEUTSCHEM PAPIER HANDGEDRUCKT, DIE MAPPE IN HALBPERGAMENT,
HANDGEARBEITET _____

ALLE GRAPHISCHEN BLÄTTER SIND IN DER DRUCKEREI DES STAATLICHEN BAUHAUSES
MIT DER HAND GEDRUCKT, JEDES BLATT IST VOM KÜNSTLER SELBST SIGNIERT,
DIE MAPPE WURDE IN DER BUCHBINDEREI DES STAATLICHEN BAUHAUSES HANDGE=
ARBEITET _____

IV / Imprint

PLATE 46

DIE 4. MAPPE ENTHÄLT 12 BLÄTTER UND ZWAR

BLATT 1 ALEXANDER ARCHIPENKO STEINDRUCK
 2 UMBERTO BOCCIONI "
 3 CARLO CARRÀ "
 4 MARC CHAGALL RADIERUNG
 5 GIORGIO DE CHIRICO STEINDRUCK
 6 MME N. GONTSCHAROWA "
 7 ALEXEI von JAWLENSKY "
 8 WASSILI KANDINSKY "
 9 M. LARIONOW "
 10 ENRICO PRAMPOLINI "
 11 GINO SEVERINI "
 12 ARDENGO SOFFICI "

PLATE 47

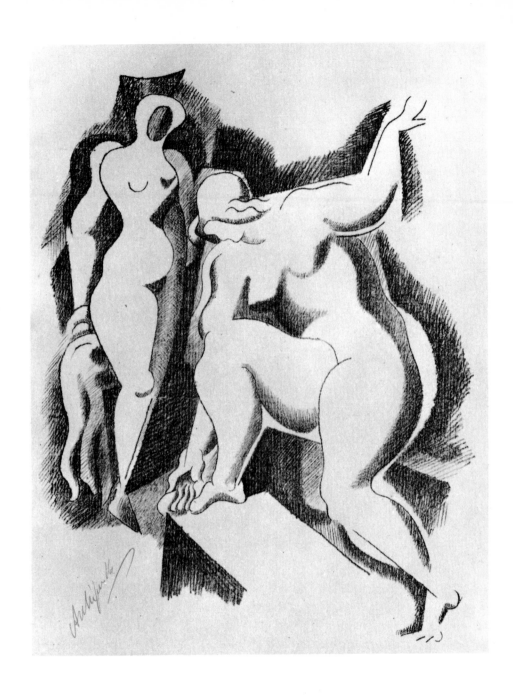

IV/1 ARCHIPENKO: Zwei weibliche Akte (Two Female Nudes)

PLATE 48

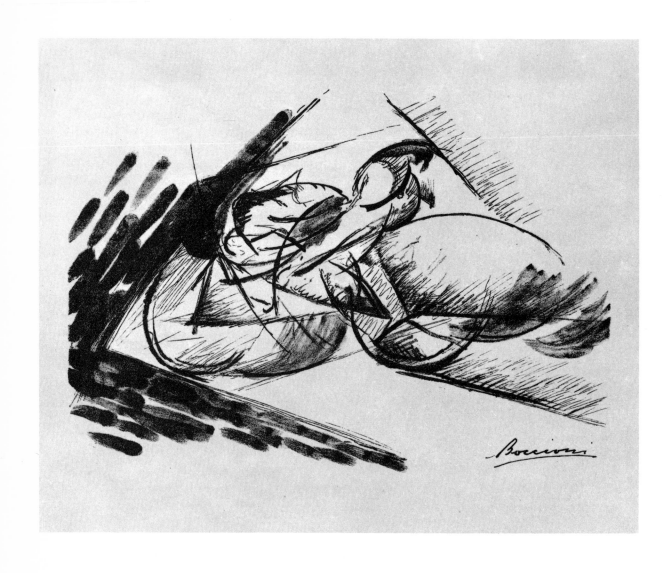

IV / 2 B O C C I O N I : Fortbewegung (Forward Movement)

PLATE 49

PLATE 50

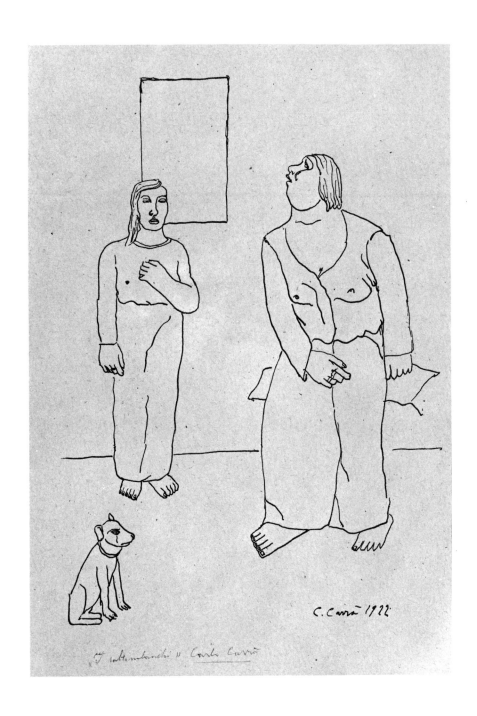

IV/3 CARRÀ: I Saltimbanchi (The Acrobats)

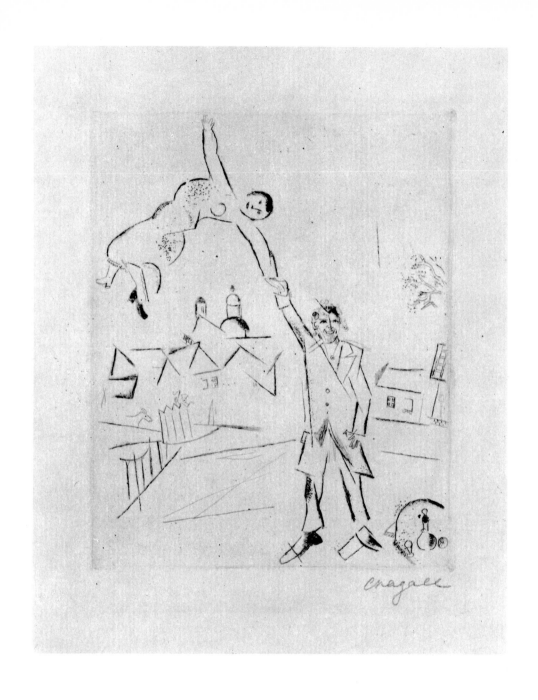

IV / 4 CHAGALL: Selbstbildnis mit Frau (Self-portrait with Woman)

PLATE 51

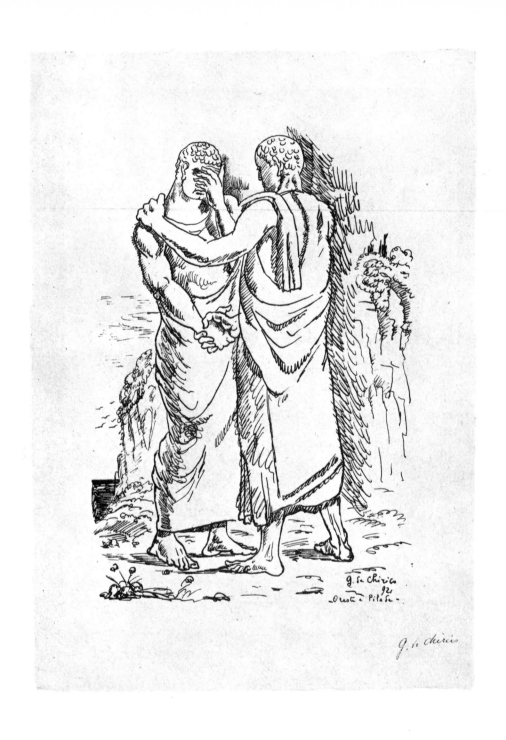

IV/5 DE CHIRICO: 'Oreste e Pilades' (Orestes and Pylades)

PLATE 52

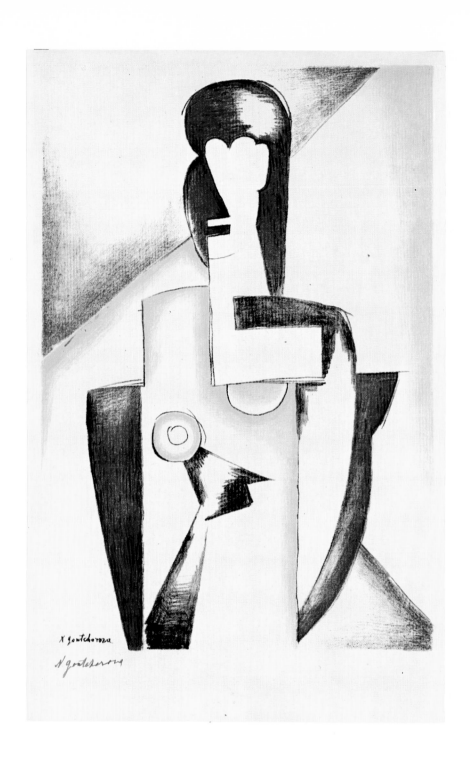

IV / 6 GONTCHAROVA: Weibliche Halbfigur (Half-length Female Figure)

PLATE 53

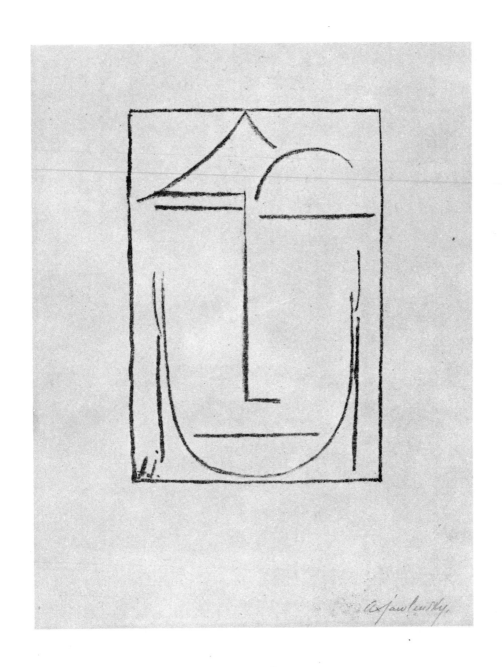

IV/7 VON JAWLENSKY: Kopf (Head)

PLATE 54

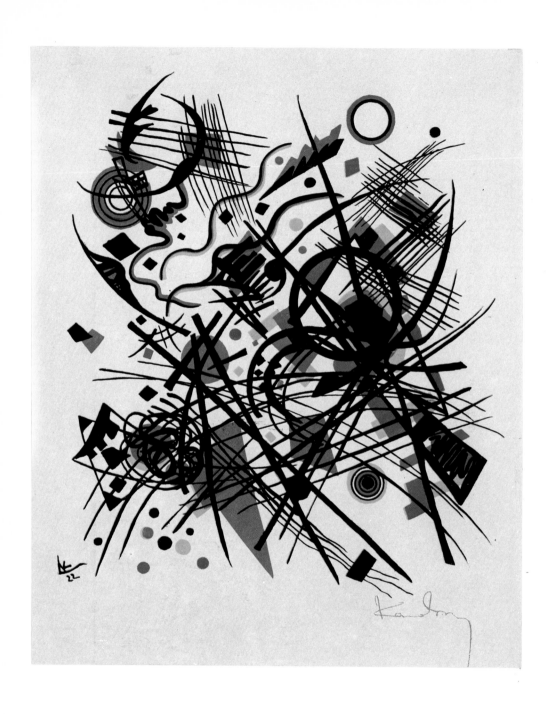

IV / 8 KANDINSKY: Komposition (Composition)

PLATE 55

PLATE 56

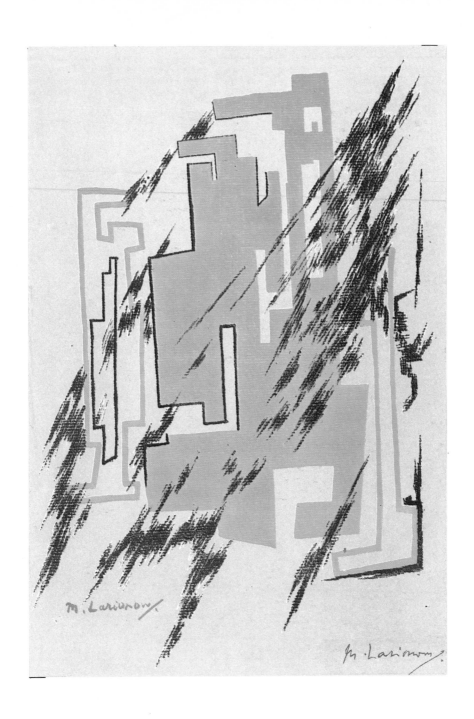

IV / 9 LARIONOV: Komposition (Composition)

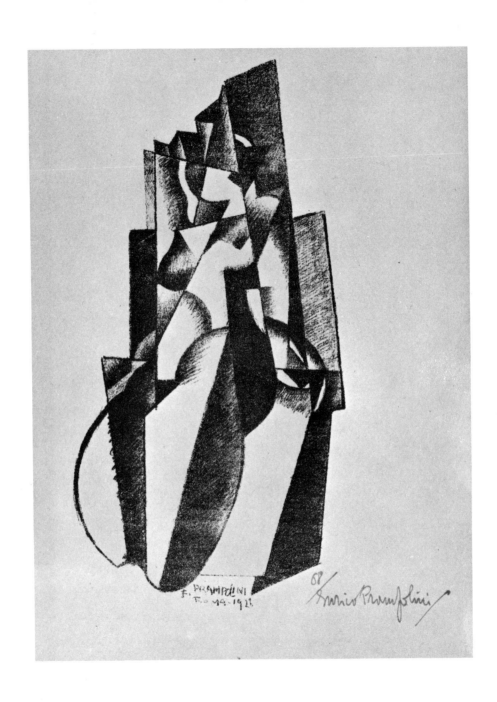

IV/10 PRAMPOLINI: Figürliches Motiv (Figure Motif)

PLATE 57

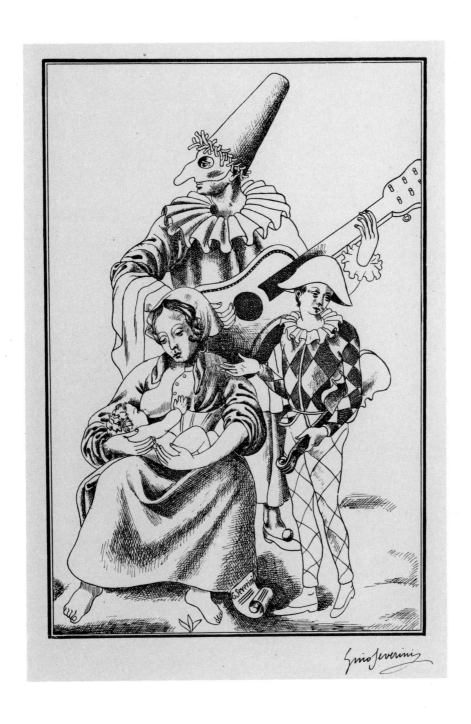

IV / 11 SEVERINI: Harlekin-Familie (Harlequin Family)

PLATE 58

FIFTH PORTFOLIO V / Cover (Design by Albers)

PLATE 59

DEM STAATLICHEN BAUHAUS IN WEIMAR
SCHENKTEN DIESE WERKE

MAX BECKMANN // MAX BURCHARTZ
OTTO GLEICHMANN // GEORGE GROSZ
ERICH HECKEL // E. L. KIRCHNER
OSKAR KOKOSCHKA // ALFRED KUBIN
CARL MENSE // MAX PECHSTEIN
CHRISTIAN ROHLFS / EDWIN SCHARFF
KARL SCHMIDT-ROTTLUFF

DIESE MAPPE TRÄGT DIE NUMMER

V / Colophon

PLATE 60

BAVHAVS DRVCKE
NEVE EVROPAEISCHE
GRAPHIK
5TE MAPPE:
DEVTSCHE KVENSTLER

VOM HERGESTELLT UND HERAUSGEGEBEN
STAATLICHEN BAUHAVS IN WEIMAR
IM JAHRE
1921
ZU BEZIEHEN DURCH
MÜLLER CO VERLAG
POTSDAM

V / Title Page

PLATE 61

DIESE ZWEITE VERÖFFENTLICHUNG DES STAATLICHEN BAUHAUSES IN WEIMAR
ERSCHIEN IN 5 MAPPEN ALS EINMALIGE NUMMERIRTE AUFLAGE IN 110 EXEM=
PLAREN _____

NR. 1 — 10 AUF JAPAN HANDGEDRUCKT, DIE MAPPE IN GANZ=PERGAMENT, HANDGE=
ARBEITET _____

NR. 11 — 110 AUF DEUTSCHEM PAPIER HANDGEDRUCKT, DIE MAPPE IN HALBPERGAMENT,
HANDGEARBEITET _____

ALLE GRAPHISCHEN BLÄTTER SIND IN DER DRUCKEREI DES STAATLICHEN BAUHAUSES
MIT DER HAND GEDRUCKT, JEDES BLATT IST VOM KÜNSTLER SELBST SIGNIERT,
DIE MAPPE WURDE IN DER BUCHBINDEREI DES STAATLICHEN BAUHAUSES HANDGE=
ARBEITET _____

V / Imprint

PLATE 62

DIE FÜNFTE MAPPE/DEUTSCHE KÜNSTLER/ENTHÄLT 13 BLÄTTER
UND ZWAR:

BLATT 1 MAX BECKMANN RADIERUNG
 2 MAX BURCHARTZ LITHOGRAPHIE
 3 OTTO GLEICHMANN "
 4 GEORGE GROSZ
 5 ERICH HECKEL HOLZSCHNITT
 6 E L KIRCHNER "
 7 OSKAR KOKOSCHKA LITHOGRAPHIE
 8 ALFRED KUBIN "
 9 CARL MENSE
 10 M. H. PECHSTEIN HOLZSCHNITT
 11 CHRISTIAN ROHLFS LINOLEUMSCHNITT
 12 EDWIN SCHARFF LITHOGRAPHIE
 13 KARL SCHMIDT=ROTTLUFF HOLZSCHNITT

PLATE 63

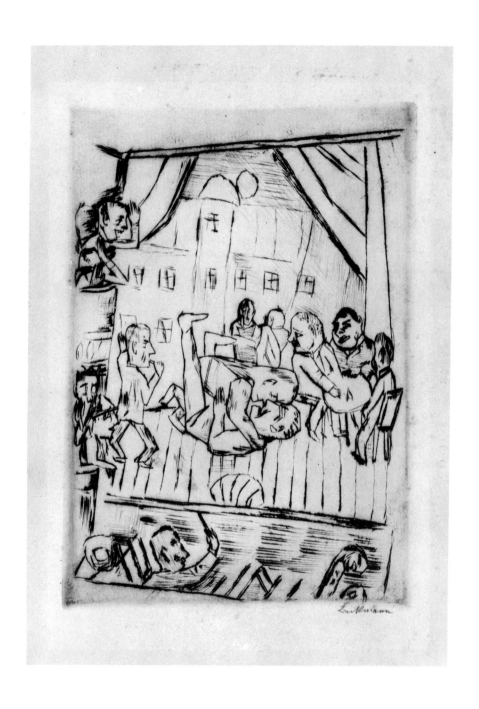

V / 1 B E C K M A N N : 'Ringkampf' (Wrestling Match)

PLATE 64

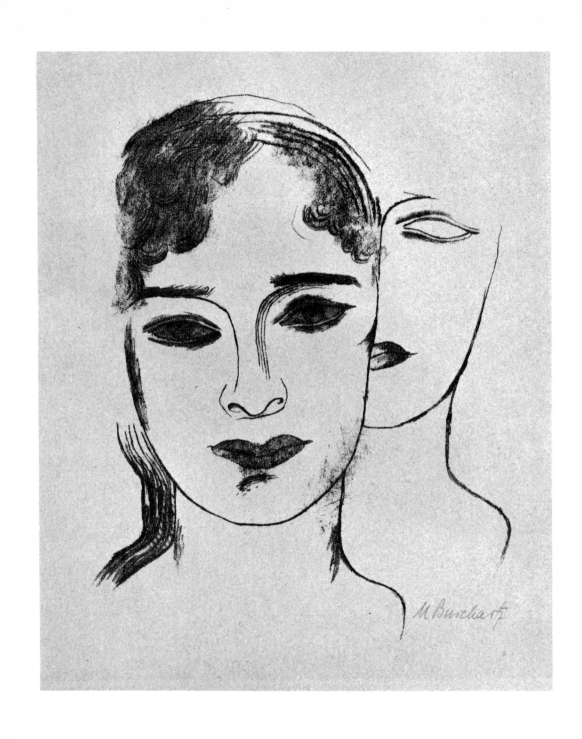

V / 2 BURCHARTZ: Mädchenköpfe (Girls' Heads)

PLATE 65

PLATE 66

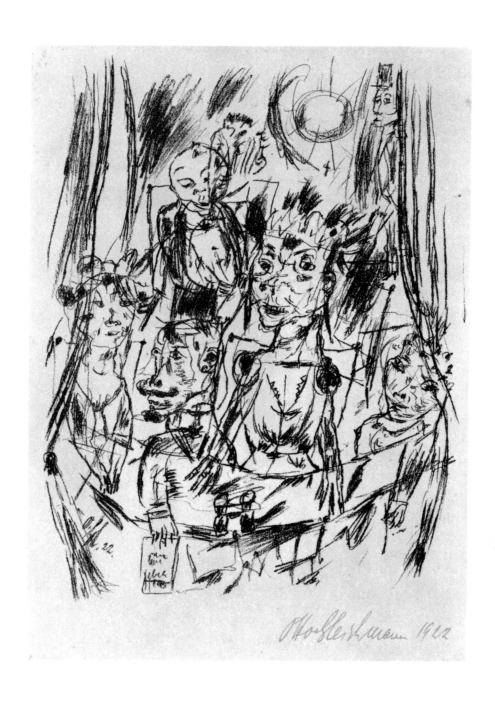

V/3 GLEICHMANN: Theaterloge (Theatre Box)

PLATE 66

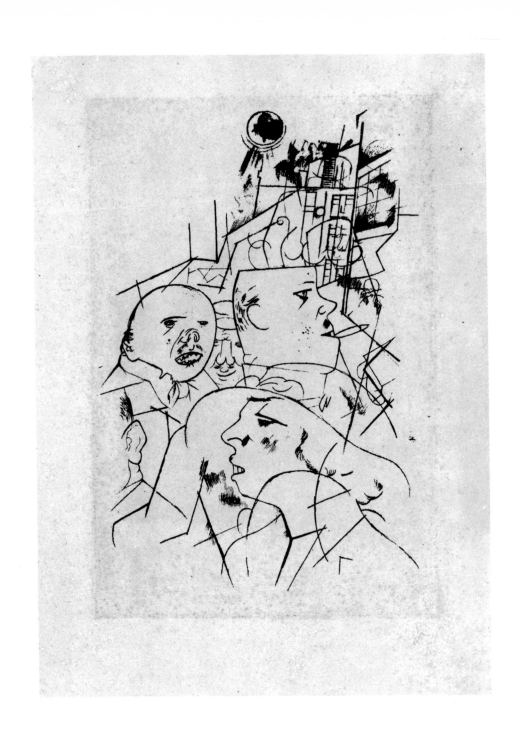

V / 4 G R O S Z : Strassenszene (Street Scene)

PLATE 67

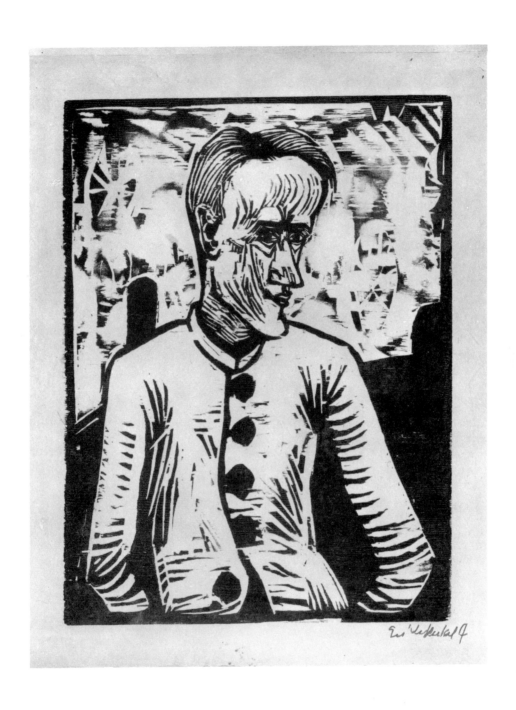

V/5 HECKEL: Männliche Halbfigur (Half-length Male Figure)

PLATE 68

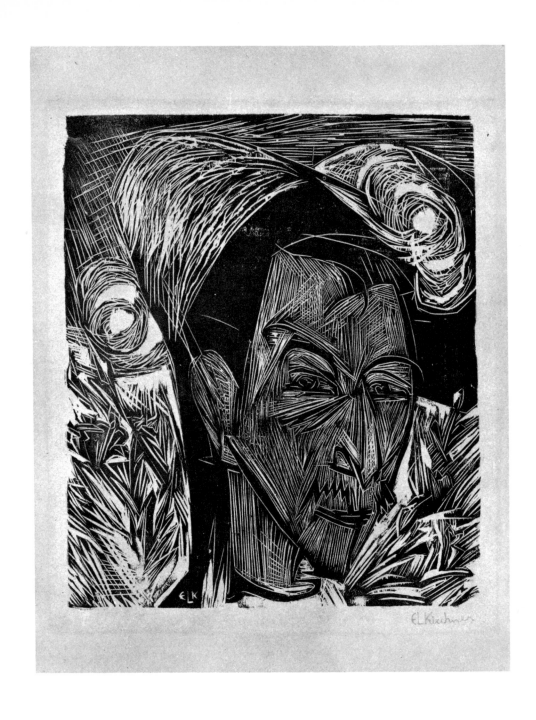

V/6 KIRCHNER: Bildnis David M. (Portrait David M.)

PLATE 69

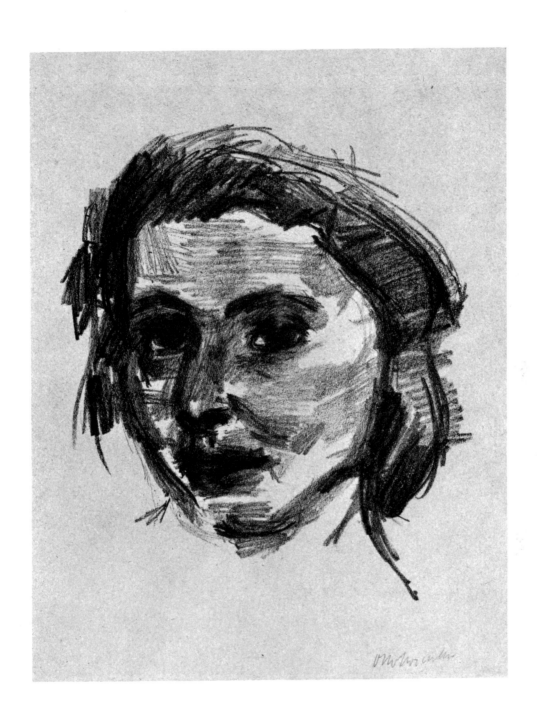

V/7 KOKOSCHKA: Mädchenkopf (Girl's Head)

PLATE 70

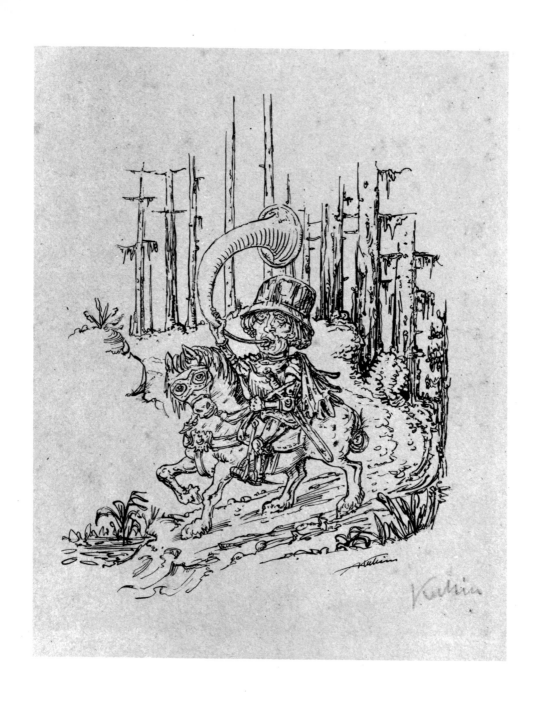

V/8 KUBIN:'Ritter Roland' (Knight Roland)

PLATE 71

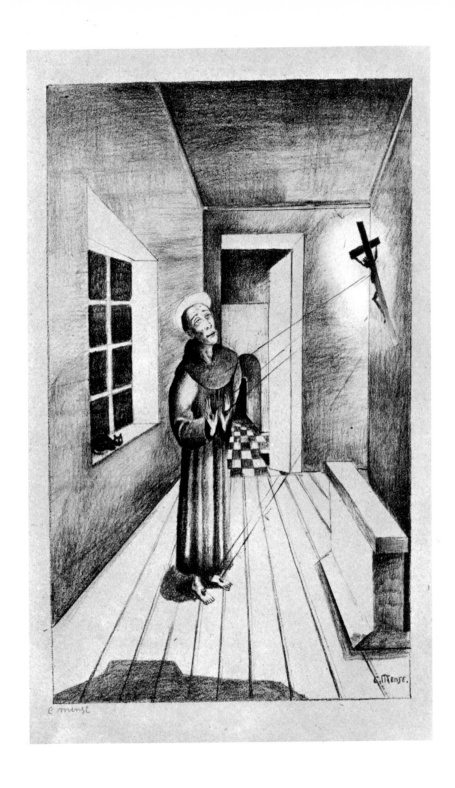

V/9 MENSE: Die Stigmatisation des Hl. Franziskus (The Stigmatisation of St Francis)

PLATE 72

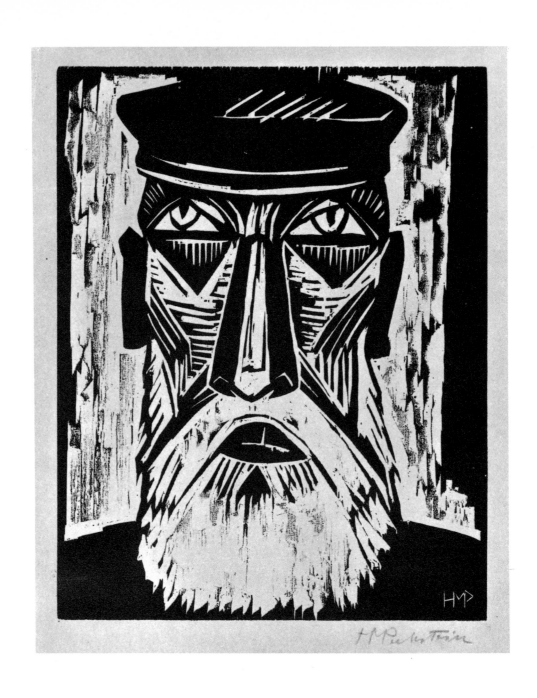

V/10 PECHSTEIN: Kopf eines bärtigen Fischers (Head of a Bearded Fisherman)

PLATE 73

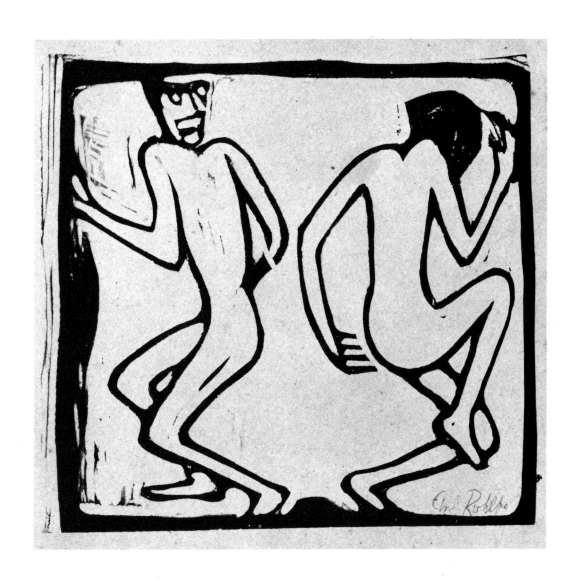

V/11 R O H L F S : Tanzendes Paar (Dancing Couple)

PLATE 74

V/12 SCHARFF: Figürliche Komposition (Figure Composition)

PLATE 75

PLATE 76

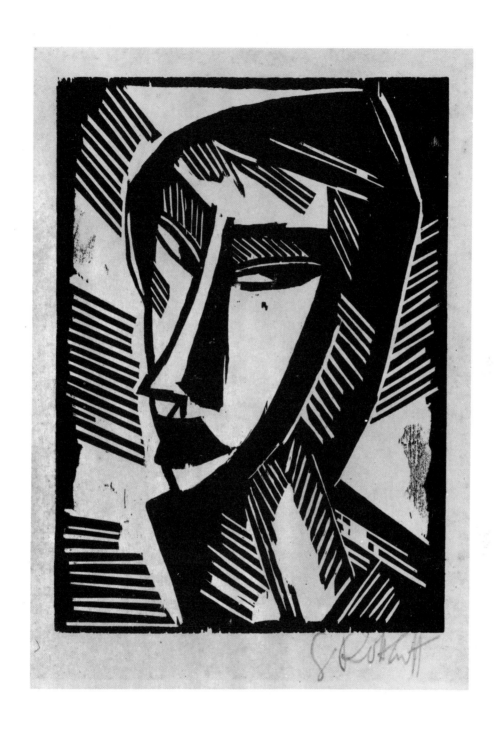

V/13 SCHMIDT-ROTTLUFF: Mädchenkopf (Girl's Head)

Collaborator: Christa Thebus

The prints in the five portfolios have been reproduced in the sequence adopted by the original editors, i.e. the Bauhaus. This is not the sequence in which they were created, many of the artists having designed their prints before the 'New European Graphics' were even conceived. Consequently we have to distinguish between the date of production on the one hand and the date of processing or date of publication on the other.

Most of the production dates attributed to the individual prints are based on information furnished by the artists themselves. Others have been obtained from files or similar sources and these have been enclosed in square brackets. Where two dates are given (separated by an oblique) the first refers to the production and the second to the processing of the print.

All titles furnished either by the artists themselves or by the Bauhaus editors have been placed in inverted commas.

All measurements are in centimetres.

The first pair of figures gives the size of the actual print or – in the case of etchings – the size of the plate. The second pair of figures, which is enclosed in brackets [], gives the size of the paper.

The first figure in each pair refers to the height, the second to the width.

The types of paper listed were those normally used for the *de luxe* edition and the standard edition.

The only bibliographical references are to the standard catalogues of works (e.g. the catalogues of Klee's graphic works) and the monograph edited by Heinz Peters, 'Die Bauhaus-Mappen' (The Bauhaus Portfolios), Cologne 1957.

Abbreviations:

Spec.	=	Specification = Names, dates, etc. which form an integral part of the portfolios.
Sign.	=	Signature. (Note: Nearly all of the signatures were added by hand and some tend to vary from print to print.)
B St.	=	Blind Stamp. The Bauhaus Stamp was not always applied in the same place and was sometimes omitted altogether.
de luxe	=	*de luxe* edition.
std	=	standard edition.
l	=	left; r = right; t = top; b = bottom: c = centre.

The reproductions were taken from original prints in the possession of the Staatliche Kunstschule der Freien Hansestadt Bremen (portfolio III) and the Bauhaus–Archiv in Darmstadt (portfolios I, II, IV and V).

FIRST PORTFOLIO:
MASTERS OF THE STATE BAUHAUS IN WEIMAR 1921

Produced and published by the State Bauhaus in Weimar.
Distribution by Müller & Co. in Potsdam.
Cover (portfolio) containing fourteen individual mounted prints, a title page and a table of contents (size of mounts 56·5 × 45 cm).
De luxe edition Nos.1–10, portfolio in vellum, prints on Japanese paper. Standard edition Nos.11–110, portfolio in half vellum, prints on German paper; plus twenty presentation copies (standard edition I–XX) for the artists and a few unnumbered copies.
Planned and printed in October 1921, bookbinding w.e.f. November 1921, delivery to the distributor, w.e.f. January 1922 (see excerpts from the files).

PLATE 1 I/Cover [1921]
Portfolio with hard covers
Produced in the Bauhaus bookbinding shop under the direction of Otto Dorfner
57·4 × 45·8 cm (cover) × 2·2 cm (back)
a) *de luxe* edition (10 copies) in vellum
Spec. on the back based on a design by Lyonel Feininger:
NEUE EUROPAEISCHE GRAPHIK 1 (NEW EUROPEAN GRAPHICS 1)
b) Standard edition (100 plus XX copies) in half vellum
Spec. on the back based on a design by Lyonel Feininger:
NEUE EUROPAEISCHE GRAPHIK 1 (NEW EUROPEAN GRAPHICS 1)
The design by Lyonel Feininger on the front and rear covers of the half vellum copies (dark brown abstract shapes on a beige ground) was printed in the Bauhaus printing shop using the starch paste technique. This design, which Feininger first carved on a woodblock, was probably transferred to a lithographic stone before being printed..
Cf. Meeting of the Masters' Council of 31 October 1921 and Feininger's letters to his wife of 15 and 17 November 1921. Cf. also oral statements by Ludwig Hirschfeld and Leona Prasse concerning the similarity between this design and Feininger's 'Fugue' (woodcut 1922).

PLATE 2 I/Colophon on the inside of the rear cover of the portfolio [1921]
Script designed by Lyonel Feininger, Bauhaus Signet designed by Oskar Schlemmer
Lithograph in black and light brown on smooth-grained paper, which was pasted to the cover
27·7 × 23·6 cm (56·7 × 44·5 cm)
Spec. (in capitals):
These works were dedicated to
the State Bauhaus in Weimar by
L. Feininger / Johannes Itten
Paul Klee / Gerhard Marcks
Georg Muche / Oskar Schlemmer
Lothar Schreyer

(Signet) State Bauhaus Weimar
This portfolio is No.....

I/Title Page [1921] PLATE 3

Script designed by Lyonel Feininger
Lithograph (presumably transferred to the stone from an original woodcut),
machine-made paper
49·5×39·8 cm (56·5×45 cm)
Spec. (in capitals) :
Bauhaus Prints
New European
Graphics
First Portfolio
Masters of the State Bauhaus
in Weimar
Produced and published
by the State Bauhaus in Weimar
in the year
1921
Obtainable from
Müller & Co. Publishers
Potsdam

I/Imprint [1921] PLATE 4

Script designed by Lyonel Feininger
(This page is printed on both sides. Reverse side : Table of Contents)
Lithograph, machine-made paper
9·8×20·4 cm (56·5×45 cm)
Spec. (in capitals) :
This second publication by the State Bauhaus in Weimar consists of five
portfolios and appears in a single edition of 110 numbered copies –
Nos.1–10 hand-printed on Japanese paper, the portfolio bound by hand in
vellum.
Nos.11–110 hand-printed on German paper, the portfolio bound by hand in
half vellum.
All the prints have been produced by hand in the printing shop at the State
Bauhaus. Each print has been signed by the artist. The portfolios have been
bound by hand in the bookbinding shop at the State Bauhaus.

I/Table of Contents [1921] PLATE 5

Script designed by Lyonel Feininger
(This page is printed on both sides. Reverse side : Imprint)
Lithograph, machine-made paper
31·2×14·3 cm (56·5×45 cm)
Spec. (in capitals) :
The first portfolio / Masters of the State Bauhaus in Weimar / contains
fourteen prints, namely :

Print	1	Lyonel Feininger :	Villa am Strand (Villa on the Shore)	Woodcut	
	2		Spaziergänger (Walkers)	Woodcut	143

3	Johannes Itten	Spruch (Dictum)	Lithograph
4		Haus des weissen Mannes (House of the White Man)	Lithograph
5	Paul Klee	Die Heilige vom inneren Licht (The Saint of the Inner Light)	Lithograph
6		Hoffmanneske Szene (Hoffmannesque Scene)	Lithograph
7	Gerhard Marcks	Die Katzen (The Cats)	Woodcut
8		Die Eule (The Owl)	Woodcut
9	Georg Muche	Tierkopf (Animal's Head)	Etching
10		Radierung (Etching)	Etching
11	Oskar Schlemmer	Figur H 2 (Figure H 2)	Lithograph
12		Figurenplan K 1 (Figure Design K 1)	Lithograph
13	Lothar Schreyer	Farbform 6 aus Bühnenwerk 'Kindsterben' (Colour Design 6 from the stage play 'Child-Dying')	Painted Lithograph
14		Farbform 2 aus Bühnenwerk 'Kindsterben' (Colour Design 2 from the stage play 'Child-Dying')	Painted Lithograph

PLATE 6 I/1 Print 1 [1920] / [1921]
Lyonel Feininger: 'Villa am Strand' (Villa on the Shore)
Woodcut on Japanese paper (*de luxe*) and imitation
Japanese paper (std)
26·5×34 cm (32·7×38·2 cm)
No spec.; Sign. b l: Lyonel Feininger
According to Miss Leona Prasse (Cleveland) Feininger had designed this
woodcut as early as 1920. It seems, however, that it was not processed until
the portfolio was produced.
Peters monograph I/1

PLATE 7 I/2 Print 2 [1918] / [1921]
Lyonel Feininger: 'Spaziergänger' (Walkers)
Woodcut on Japanese paper (*de luxe*) and imitation Japanese paper (std)
37·1×29·5 cm (48·3×34·7 cm)
No spec.; Sign. b l: Lyonel Feininger
B St. b l
According to Miss Leona Prasse (Cleveland) Feininger had designed this
woodcut as early as 1918. It seems, however, that it was not processed until
the portfolio was produced.

144 Peters monograph I/2

I/3 Print 3 [1921] PLATE 8
 Johannes Itten : 'Spruch' (Dictum)
 Five-colour lithograph (yellow, red, green, blue, black) on Japanese paper
 (*de luxe*) and on white cartridge paper, smooth-grained on one side (std)
 29·6×23 cm (35×24·7 cm)
 Spec.: Gruss und Heil den Herzen welche von dem Licht der Liebe erleuchtet
 und weder durch Hoffnungen auf einen Himmel noch durch Furcht vor
 einer Hölle irregeleitet werden O.Z. HANISH (Greeting and salutation to
 hearts which live illumined by the light of love and are not led astray either by
 hopes of a heaven or by fear of a hell O.Z. HANISH)
 Sign. b c : Itten
 Peters monograph I/3

I/4 Print 4 [1921] PLATE 9
 Johannes Itten : 'Haus des weissen Mannes' (House of the White Man)
 Lithograph on Japanese paper (*de luxe*) and on close- and smooth-grained
 paper (std)
 25·2×24·2 cm (35×28·1 cm)
 No spec. ; Sign. b r : Itten
 Peters monograph I/4

I/5 Print 5 1921 PLATE 10
 Paul Klee : 'Die Heilige vom inneren Licht' (The Saint of the Inner Light)
 Three colour lithograph (pale pink, red ochre, black) on Japanese paper (*de
 luxe*) and on close-grained vellum paper (std)
 31·1×17·5 cm (39×26·8 cm)
 No spec. ; Sign. b c : 1921/122 Klee
 Catalogues : Curt Valentin — Lily Klee in J. Th. Soby, 'The Prints of Paul Klee',
 New York 1945, No.68. E. W. Kornfeld, 'Paul Klee — Verzeichnis des graphis-
 chen Werkes' (Paul Klee — Catalogue of Graphic Works), Berne 1963, No 81.
 Peters monograph I/5

I/6 Print 6 1921 PLATE 11
 Paul Klee : 'Hoffmanneske Szene' (Hoffmanesque Scene)
 Three-colour lithograph (yellow, violet, black) on Japanese paper (*de luxe*)
 and on close-grained vellum paper (std)
 31·7×23 cm (35·5×26 cm)
 No spec. ; Sign. b c : Klee 1921/123
 Catalogues : Curt Valentin — Lily Klee in J. Th. Soby, 'The Prints of Paul Klee,'
 New York 1945, No.70. E. W. Kornfeld, 'Paul Klee — Verzeichnis des graphis-
 chen Werkes' (Paul Klee — Catalogue of Graphic Works), Berne 1963, No.82.
 Peters monograph I/6

I/7 Print 7 1921 PLATE 12
 Gerhard Marcks : 'Die Katzen' (The Cats)
 Woodcut on Japanese paper (*de luxe*) and on coarse-grained or machine-
 made paper (std)
 23·6×38·7 cm (38×55 cm)
 No spec. ; Sign. b l : Gerhard Marcks 1921
 B St b l
 Peters monograph I/7 145

PLATE 13 I/8 Print 8 1921
 Gerhard Marcks: 'Die Eule' (The Owl)
 Woodcut on Japanese paper (*de luxe*) and on coarse-grained or machine-
 made paper (std)
 28·3×23·8 cm (38×28·1 cm)
 No spec.; Sign. b r : Gerhard Marcks 1921
 B St b l
 Peters monograph I/8

PLATE 14 I/9 Print 9 [1921]
 Georg Muche: 'Tierkopf' (Animal's Head)
 Etching on Japanese paper (*de luxe*) and on white plate paper (std)
 15×10 cm (30×20 cm)
 No spec.; Sign. b c : G Muche
 B St b l
 Peters monograph I/9

PLATE 15 I/10 Print 10 [1921]
 Georg Muche: 'Radierung' (Etching)
 Etching on Japanese paper (*de luxe*) and on white plate paper (std)
 14·8×13·4 cm (30×20 cm)
 No spec.; Sign. b c : G Muche
 B St b c
 Peters monograph I/10

PLATE 16 I/11 Print 11 [1921]
 Oskar Schlemmer: 'Figur H 2' (Figure H 2)
 Lithograph on Japanese paper (*de luxe*) and on smooth-grained pink paper
 (std)
 35·9×23·6 cm (48×34 cm)
 No spec.; Sign. b r : OskSchlemmer 1922
 B St b l
 Schlemmer will presumably have signed the prints at the end of 1921 and
 post-dated them to 1922.
 Catalogue: Bibliography (compiled by Tut Schlemmer) No.IV/2, in Hans
 Hildebrandt, 'Oskar Schlemmer', Munich 1952.
 Peters monograph I/11

PLATE 17 I/12 Print 12 [1921]
 Oskar Schlemmer: 'Figurenplan K 1' (Figure Design K 1)
 Lithograph on Japanese paper (*de luxe*) and on smooth-grained buff-
 coloured paper (std)
 39·7×19·3 cm (48·8×33·8 cm)
 No spec.; Sign, b r: OskSchlemmer
 B St b l
 Schlemmer will presumably have signed the prints at the end of 1921; a
 number of them were post-dated to 1922.
 Catalogue: Bibliography (compiled by Tut Schlemmer) No.IV/2, in Hans
 Hildebrandt, 'Oskar Schlemmer', Munich 1952.
 146 Peters monograph I/12

1/31 Print 13 1921 PLATE 18
 Lothar Schreyer: 'Farbform 6 aus Bühnenwerk "Kindsterben" ' (Colour
 Design 6 from the stage play "Child-Dying")
 Coloured lithograph (white, red, blue) on Japanese paper (*de luxe*) and on
 ochre coloured transparent paper (std)
 22·5×16·7 cm (45·2×30 cm)
 No spec.; Sign. b r : Lothar Schreyer 1921
 B St b l
 A few copies were dated 1922.
 The text of the stage play 'Kindsterben' (Child-Dying) has been printed in
 the journal 'Der Sturm', XIth year, Heft 11–12, p.148.
 Peters monograph I/13

1/14 Print 14 1921 PLATE 19
 Lothar Schreyer: 'Farbform 2 aus Bühnenwerk "Kindsterben" ' (Colour
 Design 2 from the stage play "Child-Dying")
 Coloured lithograph (white, yellow, red, blue) on Japanese paper (*de luxe*)
 and on ochre-coloured transparent paper (std)
 29·1×17·1 cm (45·1×30 cm)
 No spec.; Sign. b r : Lothar Schreyer 1921
 B St b r
 A few copies were dated 1922.
 The text of the stage play 'Kindsterben' (Child-Dying) has been printed in
 the journal 'Der Sturm', XIth year, Heft 11–12, p.148.
 Peters monograph I/14

SECOND PORTFOLIO:
FRENCH ARTISTS [1924]

Unpublished fragment.
Four prints belonging to this portfolio were processed in the printing shop of the
State Bauhaus. No cover, mounts or pages of text (Title Page, Table of Contents
etc.) were produced; it is not certain whether designs were made for the paper
binding and the script.
When the project was planned in the autumn of 1921 it was decided to devote this
portfolio to artists from the Latin countries (see list of names in the prospectus,
'Bauhaus Prints', in which the series was first announced) but subsequently, when
the make-up of portfolios II and IV was revised (presumably in 1922), it was
decided to reserve portfolio II for French artists and a number of foreign artists
living in France.
The last of the four contributions actually sent to Weimar was printed at the end of
1924. Meanwhile, however, the position of the Bauhaus had become so precarious
that any hope of completing the portfolio appeared illusory and in September 1924
Gropius had abandoned his attempt to obtain the remaining French contributions.
For further information see the excerpts from the files, especially those dated 12
October 1922 and September to December 1924.

II/[1] [Print 1] [*c.*1923] PLATE 20
 Othon Coubine: Weiblicher Akt (Female Nude)
 Etching, presumably 140 copies on plate paper
 Format unknown 147

It has not yet been possible to identify this print. When asked about it (1962) Coubine said that he was unable to recall his contribution to the 'New European Graphics'. We know, however, that his print was processed before 3 September 1924 (see letter from Gropius to Gleizes dated 3 September 1924). Ludwig Hirschfeld, who helped to process this work, remembered it as an etching of a female nude (verbal communication).

PLATE 21 II/[2] [Print 2] [1912] / [1924]
Louis Marcoussis : Weiblicher Kopf (Head of Woman)
Etching, numbered batch of 140 copies on plate paper
28·6×22 cm (40×29·9 cm)
Spec. b l : 19 L M 12
Sign. b r : Marcoussis
b l : figures (Print No.)
B St b l
The etching was delivered to the Bauhaus not earlier than 1922 and was processed and signed not later than the summer of 1924 (see letter from Gropius to Gleizes dated 3 September 1924). There are only a few known copies.
Catalogue: Jean Lafranchis, 'Marcoussis', Paris 1961, No G 29 ('La belle Martiniquaise')

PLATE 22 II/[3] [Print 3] [c.1923]
Léopold Survage : Komposition aus Dreiecken und Häuserformen (Composition : Triangles and House Shapes)
Woodcut in red, presumably ten copies on Japanese paper, at least 130 copies on imitation Japanese paper
30·3×23·2 cm (38·4×27·7 cm)
Spec. b l : LS
Sign. b r : Survage
B St b l
Survage's woodcut was delivered not earlier than 1922 and was processed and signed not later than the summer of 1924 (cf. letter from Gropius to Gleizes dated 3 September 1924). There are only a few known copies. These are all on imitation Japanese paper.

PLATE 23 II/[4] [Print 4] 1921/1924
Fernand Léger : Komposition (drei weibliche Figuren und Tisch) (Composition [Three Female Figures and a Table])
Lithograph, ten copies on genuine or imitation Japanese paper (for the *de luxe* edition), 130 copies on quality German paper (for the standard edition) and at least 4 sample prints on imitation Japanese paper
21·2×28·8 cm (27·8×38·2 cm)
Spec. b l : F. LEGER 21
Thematically this print is a variant of the sketches which Léger made for his painting 'The Breakfast' (1921). The design, which was drawn on transfer paper, was delivered to the Bauhaus not later than September 1924 (see letter from Gropius to Gleizes dated 3 September 1924). According to the workshop reports the design was transferred to the lithographic stone in October 1924. Four sample prints were then made and sent to the artist for his comments. A complete batch was produced in December (see the excerpts

from the files). Whether the prints from this batch were then signed seems doubtful. The only copy discovered so far is an unsigned sample print, which has been identified by Ludwig Hirschfeld.

THIRD PORTFOLIO:
GERMAN ARTISTS 1921

Produced and published by the State Bauhaus in Weimar.
Distribution by Müller & Co in Potsdam.
Cover (portfolio) containing 14 individual mounted prints, a title page and a table of contents (size of mounts 56·5×45 cm).
De luxe edition Nos.1–10, portfolio in vellum, prints on Japanese paper. Standard edition Nos.11–110, portfolio in half vellum, prints on German paper; plus twenty presentation copies (standard edition I–XX) for the artists and a few unnumbered copies.
Planned and advertised in October 1921, completed by the end of 1921 or – at the very latest – the beginning of 1922, when the first despatch note was sent to the distributor (see the excerpts from the files). In February 1922 the portfolio was reviewed by E. Wiese in 'Der Cicerone'.

III/Cover [1921] PLATE 24
 Portfolio with hard covers
 Produced in the Bauhaus bookbinding shop under the direction of Otto Dorfner
 57·7×46 cm (cover) ×2·2 cm (back)
 a) *de luxe* edition (ten copies) in vellum
 Spec. on the back designed by Lyonel Feininger:
 NEUE EUROPAEISCHE GRAPHIK III (NEW EUROPEAN GRAPHICS III)
 b) Standard edition (100 plus XX copies) in half vellum
 Spec. on the back based on a design by Lyonel Feininger:
 NEUE EUROPAEISCHE GRAPHIK III (NEW EUROPEAN GRAPHICS III)
 The design by Paul Klee on the front and rear covers of the half vellum copies (in green and brown) was printed in the Bauhaus printing shop using the starch paste technique. The basic design was probably lithographed.
 Cf. Meeting of the Masters' Council of 31 October 1921. See also Klee's 'Fesselung' (Catalogue of Works 1920/168, Klee-Stiftung in Berne) for stylistic comparison.

III/Colophon on the inside of the rear cover of the portfolio [1921] PLATE 25
 Script designed by Lyonel Feininger, Bauhaus Signet designed by Oskar Schlemmer
 Lithograph in black and light brown on smooth-grained paper, which was pasted to the cover
 29·5×24·8 cm (56·5×44·6 cm)
 Spec. (in capitals):
 These works were dedicated to
 the State Bauhaus in Weimar by

Rudolf Bauer / Heinrich Campendonk
Willi Baumeister / Walter Dexel
Max Ernst / Oskar Fischer
Jacoba van Heemskerck / August Macke (posthumous publication)
Franz Marc (posthumous publication) / Johannes Molzahn
Kurt Schwitters / Fritz Stuckenberg
Arnold Topp / William Wauer
(Signet) State Bauhaus Weimar
This portfolio is No...
A buff-coloured erratum slip was attached to the bottom of this page. It read:
Due to technical difficulties it has not been possible to process the print by
Max Ernst in time for inclusion in portfolio II. The print by Bernhard Hoetger
has been published in its place.

PLATE 26 III/Title Page 1921
 Script designed by Lyonel Feininger
 Lithograph (presumably transferred to the stone from an original woodcut),
 machine-made paper
 50×39·8 cm (56·3×44·8 cm)
 Spec. (in capitals):
 Bauhaus Prints
 New European
 Graphics
 3rd portfolio
 German artists
 Produced and published
 by the State Bauhaus in Weimar
 in the year
 1921
 Obtainable from
 Müller & Co Publishers
 Potsdam

PLATE 27 III/Imprint [1921]
 Script designed by Lyonel Feininger
 (This page is printed on both sides. Reverse side: Table of Contents)
 Lithograph, machine-made paper
 9·7×20·5 cm (56·2×45 cm)
 Spec. (in capitals):
 This second publication by the State Bauhaus in Weimar consists of five
 portfolios and appears in a single edition of 110 numbered copies –
 Nos.1–10 hand-printed on Japanese paper, the portfolio bound by hand in
 vellum.
 Nos.11–110 hand-printed on German paper, the portfolio bound by hand in
 half vellum.
 All the prints have been produced by hand in the printing shop at the State
 Bauhaus. Each print has been signed by the artist. The portfolios have been
 bound by hand in the bookbinding shop at the State Bauhaus. Apart from
 insignificant variations in the ductus this imprint is identical with the im-
150 prints in the other portfolios.

Script designed by Lyonel Feininger
(This page is printed on both sides. Reverse side : Imprint)
Lithograph, machine-made paper
18·4×25·6 cm (56·2×45 cm)
Spec. (in capitals) :
The 3rd portfolio contains 14 prints, namely :

Print	1	Rudolf Bauer	Lithograph
	2	Willi Baumeister	,,
	3	Heinrich Campendonk	Woodcut
	4	Walter Dexel	,,
	5	Oskar Fischer	Lithograph
	6	Jacoba van Heemskerck	Woodcut
	7	Bernhard Hoetger	Lithograph
	8	August Macke (posthumous publication)	Linoleum cut
	9	Franz Marc (posthumous publication)	Woodcut
	10	Johannes Molzahn	,,
	11	Kurt Schwitters	Lithograph
	12	Fritz Stuckenberg	,,
	13	Arnold Topp	Woodcut
	14	William Wauer	Lithograph

III/1 Print 1 [*c*.1921] PLATE 29
Rudolf Bauer : 'Bantama'
Lithograph on Japanese paper (*de luxe*) and on tinted hand-made paper
(std)
39·8×31·5 cm (54·3×38·4 cm)
Spec. b l : Rudolf Bauer
b r : Bantama
Sign. b r : Rudolf Bauer
B St b l
Peters monograph III/1

III/2 Print 2 [*c*.1921] PLATE 30
Willi Baumeister : Abstrakte Sitzfigur (Abstract Seated Figure)
Lithograph on Japanese paper (*de luxe*) and on tinted hand-made paper
(std)
38·7×27·5 cm (50·3×37·9 cm)
No spec. ; Sign. b l : Baumeister
B St b l
Catalogue : Wilhelm F. Arntz, Katalog der Graphik Baumeisters (Catalogue
of Baumeister's Graphic Works) (Manuscript), Entry No.15 ('Sitzende
Figur'). Hans Spielmann, 'Willi Baumeister, Das graphische Werk' (Willi
Baumeister : Graphic Works) Jahrbuch der Hamburger Kunstsammlungen
(Annual of Hamburg Art Collections), Vol. 10 1965, Entry No.75.
Peters monograph III/2

III/3 Print 3 *c*.1921 PLATE 31
Heinrich Campendonk : Weiblicher Akt vor Bauernhof (Female Nude in
front of Farmyard)
Woodcut on Japanese paper (*de luxe*) and on tinted hand-made paper (std) 151

21·9×22 cm (37·6×31·3 cm)
No spec. ; Sign. b l : Campendonk
B St b l
Peters monograph III/3

PLATE 32 III/4 Print 4 1919/[1921]
Walter Dexel : Abstrakte Komposition (Abstract Composition)
Woodcut on Japanese paper (*de luxe*) and on tinted hand-made paper (std)
26·6×20 cm (37·8×31·6 cm)
Spec. b l : D 19
Sign. b r : Walter Dexel
B St b l
Dexel designed this woodcut in 1919 but the prints used in the portfolio
were all processed in the Bauhaus printing shop in 1921.
Peters monograph III/4

PLATE 33 III/5 Print 5 [*c.*1921]
Oskar Fischer : 'Reitendes Paar' (Couple on Horseback)
Lithograph on Japanese paper (*de luxe*) and on tinted hand-made paper
(std)
25×22 cm (48·8×38·9 cm)
Spec. b l : Reitendes Paar
 b c : OF
Sign b r : Oskar Fischer
B St b l
Peters monograph III/5

PLATE 34 III/6 Print 6 [*c.*1921]
Jacoba van Heemskerck : Komposition (Composition)
Linoleum cut on Japanese paper (*de luxe*) and on tinted hand-made paper
(std)
29·9×40·2 cm (37·6×53·6 cm)
No spec. ; Sign. b l : Jacoba van Heemskerck
B St b l
Wrongly listed as a woodcut in the Table of Contents
Peters monograph III/6

PLATE 35 III/7 Print 7 1921
Bernhard Hoetger : Figürliche Komposition (Figure Composition)
Lithograph on Japanese paper (*de luxe*) and on tinted hand-made paper
(std)
37·5×30·7 cm (49·6×38·6 cm)
Spec. b r : B. Hoetger
Sign. b l : BHoetger 21
B St b l
Judging by the erratum slip (at the foot of the dedication) this design was
not received until the work on the portfolio was well under way. It was
almost certainly the last to arrive in Weimar.
152 Peters monograph III/7

III/8 Print 8 1912/[1921] PLATE 36
August Macke : 'Begrüssung' (Greeting)
Linoleum cut on Japanese paper (*de luxe*) and on tinted hand-made paper
(std)
24·3×19·7 cm (38×27·6 cm)
No spec.
Handwritten note on the back :
Authenticated : Elisabeth Macke
August Macke Begrüssung
B St t r
The linoleum plate was placed at the disposal of the Bauhaus by Macke's
widow. The print had already been reproduced in the *Sturm* magazine in
1912 (III. Jhg., p.221).
Peters monograph III/8

III/9 Print 9 [1914]/[1921] PLATE 37
Franz Marc : 'Schöpfungsgeschichte I' (Creation I,)
Woodcut on Japanese paper (*de luxe* and std)
24×20 cm (35·2×25 cm)
Spec. b l : M
On the back of the woodblock there was a date stamp acknowledging
receipt and the signature : Frau Maria Marc
B St b l
The woodblock was placed at the disposal of the Bauhaus by Marc's
widow.
Catalogue : Alois Schardt, 'Franz Marc', Berlin 1936, Entry No.VII (1914) 1.
Peters monograph III/9

III/10 Print 10 1921 PLATE 38
Johannes Molzahn : Komposition (Composition)
Woodcut on Japanese paper (*de luxe*) and on beige-coloured hand-made
paper (std)
27·6×15·2 cm (38.5×27·8 cm)
No spec. ; Sign. b r : Johannes Molzahn 21
B St b l
Peters monograph III/10

III/11 Print 11 1921 PLATE 39
Kurt Schwitters : Komposition mit Kopf im Profil (Composition with Profile)
Lithograph on Japanese paper (*de luxe*) and on tinted hand-made paper
(std)
24×20 cm (38×27·6 cm)
Spec. b c : K S 1921
Sign. b r : K. Schwitters.
B St b l
Peters monograph III/11

III/12 Print 12 [*c*.1921] PLATE 40
Fritz Stuckenberg : Strasse mit Häusern (Road with Houses)
Lithograph on Japanese paper (*de luxe*) and on beige-coloured hand-made

paper (std) 153

33×21 cm (38·4×28 cm)
No spec.; Sign. b r : Stuckenberg
B St b l
Peters monograph III/12

PLATE 41 III/13 Print 13 1921
Arnold Topp : Abstrakte Komposition (Abstract Composition)
Woodcut on Japanese paper (*de luxe*) and on tinted hand-made paper (std)
27·8×21·5 cm (37·6×31·1 cm)
No spec.; Sign . b r: Arnold Topp 21
B St b l
Peters monograph III/13

PLATE 42 III/14 Print 14 [1921]
William Wauer : Komposition mit Ovalen (Composition with Ovals)
Lithograph on Japanese paper (*de luxe*) and on beige-coloured hand-made
paper (std)
34.7×28.6 cm (54.4×38.7 cm)
Spec. b l : stylized monogram WW
Sign. b l : William Wauer
B St b l
Peters Monograph III/14

FOURTH PORTFOLIO:
ITALIAN AND RUSSIAN ARTISTS [1924]

Produced and published by the State Bauhaus in Weimar.
Distribution by Müller & Co. in Potsdam.
Cover (portfolio) containing eleven individual mounted prints, a title page and a
table of contents (size of mounts 56·5×45 cm).
De luxe edition Nos.1–10, portfolio in vellum, prints on Japanese paper. Standard
edition Nos.11–110, portfolio in half vellum, prints on German paper; plus twenty
presentation copies (standard edition I–XX) for the artists and a few unnumbered
copies.
When the project was first planned in the autumn of 1921 it was decided to devote
this portfolio to the artists from the Slavonic countries listed in the prospectus
('Bauhaus Prints'). This plan was revised – apparently in 1922 – primarily because of
the difficulties encountered in the production of portfolio II. Although the major
part of the work on portfolio IV was carried out between 1922 and 1923 it was not
ready for delivery to the distributor until the beginning of 1924 (see the excerpts
from the files).

PLATE 43 IV/Cover [1923]
Portfolio with hard covers
Produced in the Bauhaus bookbinding shop under the direction of Otto
Dorfner
57·7×46 cm (cover) ×2·2 cm (back)
a) *de luxe* edition (ten copies) in vellum
Spec. on the back designed by Lyonel Feininger :
NEUE EUROPAEISCHE GRAPHIK IV(NEW EUROPEAN
154 GRAPHICS IV)

b) Standard edition (100 plus XX copies) in half vellum
Spec. on the back based on a design by Lyonel Feininger:
NEUE EUROPAEISCHE GRAPHIK IV (NEW EUROPEAN
GRAPHICS IV)
The design by Ludwig Hirschfeld on the front and rear covers of the half
vellum copies (in mid- and dark blue) was printed in the Bauhaus
printing shop using the starch paste technique. The basic design was
probably lithographed.
Hirschfeld has confirmed both verbally and in writing (letter of 13
February 1963) that he was responsible for the cover design, which must
have been completed by the summer of 1923, since it was reproduced in
the book, 'Staatliches Bauhaus Weimar 1919–1923' (p.140).

IV/Colophon on the inside of the rear cover of the portfolio [*c*.1923] PLATE 44
Script designed by Lyonel Feininger, Bauhaus Signet designed by Oskar
Schlemmer
Lithograph in black and light brown on smooth-grained paper, which was
pasted to the cover
30×24·9 cm (56·6×44·9 cm)
Spec. (in capitals):
These works were dedicated to
the State Bauhaus in Weimar by
Alexander Archipenko / Alexei von Jawlensky
Umberto Boccioni / Wassili Kandinsky
Carlo Carrà / M. Larionov
Marc Chagall / Enrico Prampolini
Giorgio de Chirico / Gino Severini
Mme N. Gontcharova / Ardengo Soffici
(Signet) State Bauhaus Weimar
This portfolio is No...
A red erratum slip was attached to the bottom of this page. It read:
It has not yet been possible to process the print by Soffici (Italy) due to the
artist's prolonged absence from home. This print will be sent to subscribers
on completion.

IV/Title Page [*c*.1923] PLATE 45
Script designed by Lyonel Feininger
Lithograph (presumably transferred to the stone from an original woodcut),
machine-made paper
50·3×39·9 cm (56·2×45·2 cm)
Spec. (in capitals):
Bauhaus Prints
New European
Graphics
4th portfolio
Italian and Russian
Artists
Produced and published
by the State Bauhaus in Weimar
in the year
1921 155

Obtainable from
Müller & Co Publishers
Potsdam
Like the title pages in the other portfolios this one is dated 1921 although in actual fact the earliest possible completion date would have been 1922, the year in which the composition of this portfolio was revised.

PLATE 46 IV/Imprint [*c.*1923]
Script designed by Lyonel Feininger
(This page is printed on both sides. Reverse side : Table of Contents)
Lithograph, machine-made paper
10×20·5 cm (56·2×45·2 cm)
Spec. (in capitals) :
This second publication by the State Bauhaus in Weimar consists of five portfolios and appears in a single edition of 110 numbered copies.
Nos.1–10 hand-printed on Japanese paper, the portfolio bound by hand in vellum.
Nos.11–110 hand-printed on German paper, the portfolio bound by hand in half vellum.
All the prints have been produced by hand in the printing shop at the State Bauhaus. Each print has been signed by the artist. The portfolios have been bound by hand in the bookbinding shop at the State Bauhaus.
Apart from insignificant variations in the ductus this imprint is identical with the imprints in the other portfolios.

PLATE 47 IV/Table of Contents [*c.*1923]
Script designed by Lyonel Feininger
(This page is printed on both sides. Reverse side : Imprint)
Lithograph, machine-made paper
17·1×27·1 cm (56·2×45·2 cm)
Spec. (in capitals) :
The 4th portfolio contains 12 prints, namely :

Print	1	Alexander Archipenko	Lithograph
	2	Umberto Boccioni	,,
	3	Carlo Carrà	,,
	4	Marc Chagall	Etching
	5	Giorgio de Chirico	Lithograph
	6	Mme N. Gontcharova	,,
	7	Alexei von Jawlensky	,,
	8	Wassili Kandinsky	,,
	9	M. Larionov	,,
	10	Enrico Prampolini	,,
	11	Gino Severini	,,
	12	Ardengo Soffici	,,

The fact that Soffici's print is listed here, although it was not printed, would suggest that Feininger wrote out the table of contents some time before the completion or, alternatively, the publication of the portfolio.

PLATE 48 IV/1 Print 1 [*c.*1922]
Alexander Archipenko : Zwei weibliche Akte (Two Female Nudes)
Lithograph on Japanese paper (*de luxe*) and on machine -made paper (std)
36·8×29·1 cm (49·4×34 cm)

No spec. ; Sign. b l : Archipenko
B St b l
According to a letter dated 30 June 1922 from the Bauhaus to Müller & Co. this print had already been processed at that time ; according to the monthly report for November 1922 it had not yet been processed (cf. the excerpts from the files).
Peters monograph IV/1

IV/2 Print 2 [c.1913] / [1922] PLATE 49
Umberto Boccioni : Fortbewegung (Forward Movement)
Lithograph on Japanese paper (de luxe) and on absorbent buff-coloured paper (std)
21×31 cm (29·4×38·3 cm)
Spec. b r : Boccioni ; No Sign.
B St b l
The design was placed at the disposal of the Bauhaus by Boccioni's executors. It was probably transferred to the lithographic stone by the photomechanical process and printed in 1922 (see letter of 30 June 1922 to Müller & Co.) A similar print – 'Dinamismo di un ciclista'(Dynamism of a Cyclist), 1913 – has been reproduced in 'Il Futurismo' by Raffaele Carrieri, Milan 1961, Plate 25.
Peters monograph IV/2

IV/3 Print 3 1922 PLATE 50
Carlo Carrà : 'I saltimbanchi' (The Acrobats)
Lithograph on Japanese paper (de luxe) and machine-made paper (std)
30×21·5 cm (38·6×27·6 cm)
Spec. b r : C. Carrà 1922
Sign. b l : 'I saltimbanchi' Carlo Carrà
B St b l
According to a letter dated 30 June 1922 from the Bauhaus to Müller & Co. the design had already been received at that time and it would seem that the complete batch was processed in 1922.
Peters monograph IV/3

IV/4 Print 4 [c.1922] / [1923] PLATE 51
Marc Chagall : Selbstbildnis mit Frau (Self -portrait with Woman)
Etching on machine-made paper (std and – apparently – de luxe)
17·4×14 cm (25×23·2 cm)
No spec. ; Sign. b r : Chagall
B St. b l
According to the monthly report from the printing shop for December 1922 this contribution had not been received at that time and the contrary assertion made by the Bauhaus in its letter to Müller & Co. of 30 June 1922 appears to be untrue.
Bolliger (see below) points out that this print is a variant of the line etching 'Der Spaziergang' (The Walk) created in 1922 and published in the supplement to 'Ma Vie' (Paris 1931). Chagall had already treated this theme in a painting of the same name in 1917.
Catalogue : Franz Meyer and Hans Bolliger, 'Marc Chagall – Das graphische Werk' (Marc Chagall – Graphic Works), Stuttgart 1957, p.150, Catalogue of 157

illustrated books and portfolios of original prints, No.2.
Peters monograph IV/4

PLATE 52 IV/5 Print 5 1921
Giorgio de Chirico : 'Oreste e Pilades' (Orestes and Pylades)
Lithograph on Japanese paper (*de luxe*) and machine-made paper (std)
28·9×20 cm (38·7×27·5 cm)
Spec. b r : G. de Chirico
 921
— Oreste e Pilades —
Sign. b r : G. de Chirico
B St b l
In its letter to Müller & Co. of 30 June 1922 the Bauhaus stated that the
design had already been received.
Peters monograph IV/5

PLATE 53 IV/6 Print 6 [*c.*1922]
Nathalie Gontcharova : Weibliche Halbfigur (Half-length Female Figure)
Three colour lithograph (yellow, blue and black) on Japanese paper (*de
luxe*) and on machine-made paper (std)
36·4×25·1 cm (50×33·7 cm)
Spec. b l : N. Gontcharova
Sign. b l : N. Gontcharova
B St b l
In its letter to Müller & Co. of 30 June 1922 the Bauhaus stated that the de-
sign had already been received.
Peters monograph IV/6

PLATE 54 IV/7 Print 7 [*c.*1922]
Alexei von Jawlensky : Kopf (Head)
Lithograph on Japanese paper (*de luxe*) and on smooth-grained, light
buff-coloured paper (std)
17·8×12·3 cm (30·1×22·8 cm)
Spec. b l : A. j.
Sign. b r : Axjawlensky
B St b l
In its letter to Müller & Co. of 30 June 1922 the Bauhaus stated that the
design had already been received.
Peters monograph IV/5

PLATE 55 IV/8 Print 8 1922
Wassily Kandinsky : Komposition (Composition)
Five-colour lithograph printed from four plates (yellow, red, blue, and black
plus green) on Japanese paper (*de luxe*) and on machine-made paper (std)
27·9×24·4 cm (36·1×31·4 cm)
Spec. b l (stylized) : K
 22
Sign. b r : Kandinsky
When the series was planned in the autumn of 1921 Kandinsky had not yet
joined the Bauhaus. Consequently, instead of being allocated to portfolio 1
(which was reserved for the Masters of the Bauhaus), his contribution was
designated for inclusion in portfolio 4. By the beginning of 1922, when the

Bauhaus first considered his appointment, and certainly by the summer of 1922, when it was ratified, it was too late to reverse this decision. Kandinsky's lithograph was probably processed at the end of 1922 (following the completion of his portfolio 'Little Worlds', which the printing shop had been working on during the autumn). We learn from the monthly report for November 1922 that Kandinsky still had to design his 'colour plates', which means that the claim made in the letter to Müller & Co. of 30 June 1922, namely that Kandinsky's contribution was ready, was quite untrue (see the excerpts from the files).

IV/9 Print 9 [c.1922] PLATE 56
Michel Larionov: Komposition (Composition)
Two-colour lithograph (pink and brown) on Japanese paper (de luxe) and on machine-made paper (std)
44 × 29·8 cm (50·2 × 33·6 cm)
Spec. b l : M. Larionov/.
Sign. b r : M. Larionov/.
B St b l
According to the dubious letter of 30 June 1922 to Müller & Co. the design for this print had already been received at that time. Later Larionov used this composition for other purposes including an exhibition poster.
Peters monograph IV/9

IV/10 Print 10 1923 PLATE 57
Enrico Prampolini: Figürliches Motiv (Figure Motif)
Lithograph on Japanese paper (de luxe) and on rather coarse-grained, ivory-coloured paper (std)
24·4 × 12·5 cm (46 × 29·4 cm)
Spec. B c : E. PRAMPOLINI ROMA–1923
Sign. b r : 68/Enrico Prampolini/
B St b l
This contribution was evidently one of those which arrived in Weimar long after the agreed date, thus contributing to the delay in publishing the portfolios. For further information on this point see the correspondence between the Bauhaus and Müller & Co. between January and April 1923. The statement by the Bauhaus in its letter of 30 June 1922 to the effect that the design had already been received was without substance. This is quite evident from the date (1923) in Prampolini's specification (see the excerpts from the files).

IV/11 Print 11 ([c.1L22] PLATE 58
Gino Severini: Harlekin-Familie (Harlequin Family)
Lithograph on Japanese paper (de luxe) and on machine-made paper (std)
30·3 × 20·4 cm (46·1 × 29·6 cm)
Spec. b (part of the design) : G. Severini
Sign. b r : Gino Severini
B St. b l
The statement made by the Bauhaus in its letter to Müller & Co. of 30 June 1922 to the effect that Severini's contribution had already arrived in Weimar was probably meaningless.

FIFTH PORTFOLIO:
GERMAN ARTISTS [1923]

Produced and published by the State Bauhaus in Weimar.
Distribution by Müller & Co. in Potsdam.
Cover (portfolio) containing thirteen individual mounted prints, a title page
and a table of contents (size of mounts 56·5×45 cm).
De luxe edition Nos.1–10, portfolio in vellum, prints on Japanese paper.
Standard edition Nos. 11–110, portfolio in half vellum, prints on German
paper; plus twenty presentation copies (standard edition I–XX) for the
artists and a few unnumbered copies.
Originally it was probably intended to publish fourteen prints in this
portfolio (as in portfolios I and III), although in the autumn of 1921, when
the series was first announced (see Prospectus), its contents had not yet
been determined. The majority of the prints were processed in 1922 and,
according to the files, distribution began in March 1923. In mid-July 1923
the portfolio was comprehensively reviewed in 'Der Cicerone'.

PLATE 59 V/Cover [1923]
 Portfolio with hard covers
 Produced in the Bauhaus bookbinding shop under the direction of Otto
 Dorfner
 57·5×46 cm (cover) ×2·2 cm (back)
 a) *de luxe* edition (10 copies) in vellum
 Spec. on the back designed by Lyonel Feininger:
 NEUE EUROPAEISCHE GRAPHIK V (NEW EUROPEAN
 GRAPHICS V)
 b) Standard edition (100 plus XX copies) in half vellum
 Spec. on the back based on a design by Lyonel Feininger:
 NEUE EUROPAEISCHE GRAPHIK V (NEW EUROPEAN
 GRAPHICS V)
 The design by Josef Albers on the front and rear covers of the half
 vellum copies (in mid- and dark grey-brown) was printed in the Bauhaus
 printing shop using the starch paste technique. The basic design was
 taken from a linoleum cut (relief printing).
 Albers has confirmed in his letter to the Bauhaus-Archiv of 20 April
 1964 that he was responsible for the cover design, which was first
 reproduced in the book, 'Staatliches Bauhaus Weimar 1919–1923'
 (p.140).

PLATE 60 V/Colophon on the inside of the rear cover of the portfolio [c.1923]
 Script designed by Lyonel Feininger, Bauhaus Signet designed by Oskar
 Schlemmer
 Lithograph in black and light brown on smooth-grained paper, which was
 pasted to the cover
 30·8×26·3 cm (56·4×44·5 cm)
 Spec. (in capitals):
 These works were dedicated to
 the State Bauhaus in Weimar by
 Max Beckmann / Max Burchartz
160 Otto Gleichmann / George Grosz

Erich Heckel / E. L. Kirchner
Oskar Kokoschka / Alfred Kubin
Carl Mense / Max Pechstein
Christian Rohlfs / Edwin Scharff
Karl Schmidt-Rottluff
(Signet) State Bauhaus Weimar
This portfolio is No...

V/Title Page [c.1923] PLATE 61
Script designed by Lyonel Feininger
Lithograph (presumably transferred to the stone from an original woodcut),
machine-made paper
50·5×40 cm (56·2×45·2 cm)
Spec. (in capitals) :
Bauhaus Prints
New European
Graphics
5th portfolio
German Artists
Produced and published
by the State Bauhaus in Weimar
in the year
1921
Obtainable from
Müller & Co. Publishers
Potsdam
Although the title page (like the title page of the other portfolios) is dated
1921 it will doubtless have been composed shortly before publication and
certainly not before the middle of 1922.

V/Imprint [c.1923] PLATE 62
Script designed by Lyonel Feininger
(This page is printed on both sides. Reverse side : Table of Contents)
Lithograph, machine-made paper
9·7×20·5 cm (56·2×45·2 cm)
Spec. (in capitals) :
This second publication by the State Bauhaus in Weimar consists of five
portfolios and appears in a single edition of 110 numbered copies.
Nos.1–10 hand-printed on Japanese paper, the portfolio bound by hand in
vellum.
Nos.11–110 hand-printed on German paper, the portfolio bound by hand in
half vellum.
All the prints have been produced by hand in the printing shop at the State
Bauhaus. Each print has been signed by the artist. The portfolios have been
bound by hand in the bookbinding shop at the State Bauhaus.
Apart from insignificant variations in the ductus this imprint is identical
with the imprints in the other portfolios.

V/Table of Contents [c.1923] PLATE 63
Script designed by Lyonel Feininger
(This page is printed on both sides. Reverse side : Imprint) 161

Lithograph, machine-made paper
13·7×36 cm (56·2×45·2 cm)
Spec. (in capitals)
The fifth portfolio / German Artists / contains thirteen prints, namely:

Print			
	1	Max Beckmann	Etching
	2	Max Burchartz	Lithograph
	3	Otto Gleichmann	,,
	4	George Grosz	,,
	5	Erich Heckel	Woodcut
	6	E. L. Kirchner	,,
	7	Oskar Kokoschka	Lithograph
	8	Alfred Kubin	,,
	9	Carl Mense	,,
	10	M. H. Pechstein	Woodcut
	11	Christian Rohlfs	Linoleum cut
	12	Edwin Scharff	Lithograph
	13	Karl Schmidt-Rottluff	Woodcut

PLATE 64 V/1 Print 1 [1921]
Max Beckmann: 'Ringkampf' (Wrestling Match)
Etching on white plate paper (*de luxe* and, apparently, std)
20·7×14·7 cm (30·1=29·9 cm)
No spec.; Sign. b r : Beckmann
B St b l
On a sample print now in R. Piper's collection Beckmann used the title
'Ringkampf' (The Wrestling Match). It is usually described as 'Die Ringer'
(The Wrestlers).
Catalogue: Curt Glaser (co-Editors: Meier-Graefe, Fraenger and Hausen-
stein), 'Max Beckmann', Munich 1924, Entry No.176. Klaus Gallwitz, 'Max
Beckmann, Die Druckgraphik' (Max Beckmann: Prints), Badischer Kunst-
verein Karlsruhe 1962, Entry No.173.
Peters monograph V/1

PLATE 65 V/2 Print 2 [1922]
Max Burchartz: Zwei Mädchenköpfe (Girls' Heads)
Lithograph on Japanese paper (*de luxe*) and either imitation Japanese
paper or machine-made paper (std)
32·1×25·4 cm (55·5×38·4 cm)
No spec.; Sign. b r : M Burchartz
B St b l
In a contemporary account H. von Wedderkop also ascribed this print to the
year 1922 (see 'Deutsche Graphik des Westens', Weimar 1922, Illus. on
p.91).
Peters monograph V/2

PLATE 66 V/3 Print 3 1922
Otto Gleichmann: Theaterloge (Theatre Box)
Lithograph on Japanese paper and on coarse-grained beige-coloured
paper (std)
30·5×24 cm (46·2×29·8 cm)
162 Spec. b l : O.Gl.22.

Sign. b r : Otto Gleichmann 1922
B St b l
Peters monograph V/3

V/4 Print 4 [c.1922] PLATE 67
George Grosz : Strassenszene (Street Scene)
Lithograph on Japanese paper (*de luxe*) and on either imitation Japanese or on machine-made paper (std)
38·9×26·9 cm (52·7×38·3 cm)
No spec. ; Sign. b r : Grosz
B St b l
Peters monograph V/4

V/5 Print 5 1917 / [1922] PLATE 68
Erich Heckel : Männliche Halbfigur (Half-length Male Figure)
Woodcut on Japanese paper (*de luxe*) and on either imitation Japanese or machine-made paper (std)
35·9×27·1 cm (41·2×32·6 cm)
No spec. ; Sign. b r : Erich Heckel 17
B St b l
This print is usually called 'Der Kranke' (The Invalid) or – as in the Dube catalogue – 'Der Narr' (The Fool). A few prints taken from an earlier version of this woodcut are still extant. According to Dube the lower line of the collar (on the viewer's left) was unbroken in this earlier version and the lines on the left-hand sleeve, which are foreshortened and tapered in the definitive version, were then broad and square-ended.
Catalogue : Annemarie and Wolf-Dieter Dube, 'Erich Heckel – Das graphische Werk, Band 1 : Holzschnitte' (Erich Heckel – Graphic Works Vol. 1 : Woodcuts), New York 1964, Entry No.309 (11).
Peters monograph V/5

V/6 Print 6 [1919] / [1922] PLATE 69
Ernst Ludwig Kirchner : Bildnis David M. (Portrait David M.)
Woodcut on Japanese paper (*de luxe*) and on buff-coloured cartridge paper (std)
34×29·3 cm (47·7×40·1 cm)
Spec. b c : ELK
Sign. (in blue with name stamp) b r : ELKirchner
The words 'Für Bauhaus-Mappe Weimar' (For the Bauhaus portfolio in Weimar) were stamped on the back of many of the prints. The subject, David Müller, was a farmer who owned a house near Frauenkirch not far from Davos. According to K. H. Gabler of Frankfurt/Main Kirchner rented a workroom from him in 1919. Very occasionally Kirchner would use a name stamp to sign batches of prints.
Catalogue : Gustav Schiefler, 'Die Graphik Ernst Ludwig Kirchners' (The Graphic Works of Ernst Ludwig Kirchner), Vol.2 (1917–27), Berlin-Charlottenburg 1931, Entry No.397. Hans Bolliger, Bibliography in the catalogue of the Kirchner exhibition staged by the Kunstverein für die Rheinlande und Westfalen, Düsseldorf 1960, Section No.57 on 'Original-beiträge in Mappen' (Original Works printed in Portfolios).
Peters monograph V/6 163

PLATE 70 V/7 Print 7 [1921]
Oskar Kokoschka: Mädchenkopf (Girl's Head)
Lithograph on Japanese paper (*de luxe*) and on imitation Japanese or machine-made paper (std)
30·5×27 cm (55·2×38·3 cm)
No spec.; Sign. b r : OKokoschka
B St b l
Catalogue: Wilhelm F. Arntz, 'Das graphische Werk Kokoschkas' (Kokoschka's Graphic Works) in: The Catalogue of the Kokoschka exhibition staged in the Haus der Kunst, Munich 1950, Entry No.130.
Hans M. Wingler, 'Oskar Kokoschka, Das Werk des Malers' (Oskar Kokoschka — The Painter's Work), Salzburg 1956, Bibliography V – 128.
Peters monograph V/7

PLATE 71 V/8 Plate 8 [1921]
Alfred Kubin: 'Ritter Roland' (Knight Roland)
Lithograph on Japanese paper (*de luxe*) and on imitation Japanese or machine-made paper (std)
25·9×20·4 cm (38·3×28 cm)
Spec. b r : AKubin
Sign. b r : Kubin
B St b l
The knight 'in armour rides along a forest track on a mail-clad horse, his sword Durendal at his side, a pot-shaped helmet on his outsize head, blowing his horn Oliphant' (Raabe). The lithograph is a variant of a watercolour, which has been dated to 1920 and is reproduced in the catalogue compiled by Raabe (opp. p.113).
Catalogue: Paul Raabe, 'Alfred Kubin, Leben, Werk, Wirkung' (Alfred Kubin, Life, Works and Influence), Hamburg 1957, Entry No.143.
Peters monograph V/8

PLATE 72 V/9 Print 9 [*c.*1922]
Carl Mense: Die Stigmatisation des Hl. Franziskus (The Stigmatization of St Francis)
Lithograph on Japanese paper (*de luxe*) and on imitation hand-made paper (std)
38·1×23 cm (54·8×37·7 cm)
Spec. b r : C. MENSE
Sign. b l : C. Mense
B St b l
Peters monograph V/9

PLATE 73 V/10 Plate 10 [1922]
Max Pechstein: Kopf eines bärtigen Fischers (Head of a Bearded Fisherman)
Woodcut on Japanese paper (*de luxe*) and on imitation hand-made paper std)
39·9×32 cm (50·1×37·6 cm)
Spec. b r : HMP
Sign. b r : HMPechstein
B St b l

Catalogue : No longer in Fechter.
Peters V/10

V/11 Plate 11 [c.1913] / [1922] PLATE 74
 Christian Rohlfs : Tanzendes Paar (Dancing Couple)
 Linoleum cut on Japanese paper (*de luxe*) and on imitation Japanese or
 machine-made paper (std)
 28·8×30·9 cm (37×38·2 cm)
 No spec. ; Sign. b r (in the design) : Chr Rohlfs
 B St b l
 Catalogue : Paul Vogt, 'Christian Rohlfs, Ouevrekatalog der Druckgraphik'
 (Christian Rohlfs, Catalogue of Prints), no place of publication given
 (Göttingen) 1950, Entry No.70 (where it is classified as a woodcut).
 Peters monograph V/11

V/12 Print 12 1921 PLATE 75
 Edwin Scharff : Figürliche Komposition (Figure Composition)
 Lithograph on Japanese paper (*de luxe*) and on imitation hand-made
 paper (std)
 23·2×18·3 cm (46·2×29·4 cm)
 Spec. b r (intertwined) : ES 1921
 Sign. b r : ES
 B St b l
 Peters monograph V/12

V/13 Print 13 [1915] / [1922] PLATE 76
 Karl Schmidt-Rottluff : Mädchenkopf (Girl's Head)
 Woodcut on Japanese paper (*de luxe*) and on glazed paper (std)
 24·8×17·9 cm (34·6×27·8 cm)
 No spec. ; Sign. b r : S Rottluff
 The type of paper used for the standard edition of this print is in marked
 contrast to the papers used for the other prints in the series. This, together
 with the fact that the woodcut was created as early as 1913, suggests that
 the batch may conceivably have been produced outside the Bauhaus.
 Schapire (see below) does not preclude the possibility that Schmidt-
 Rottluff 'processed the prints himself'.
 Catalogue : Rosa Schapire, 'Karl Schmidt-Rottluffs graphisches Werk bis
 1923' (Karl Schmidt-Rottluff's Graphic Works up to 1923), Berlin 1924,
 Entry No.180.
 Peters monograph V/13

LIST OF ILLUSTRATIONS INCLUDED IN THE TEXT

INDEX OF ARTISTS AND GROUPS

167